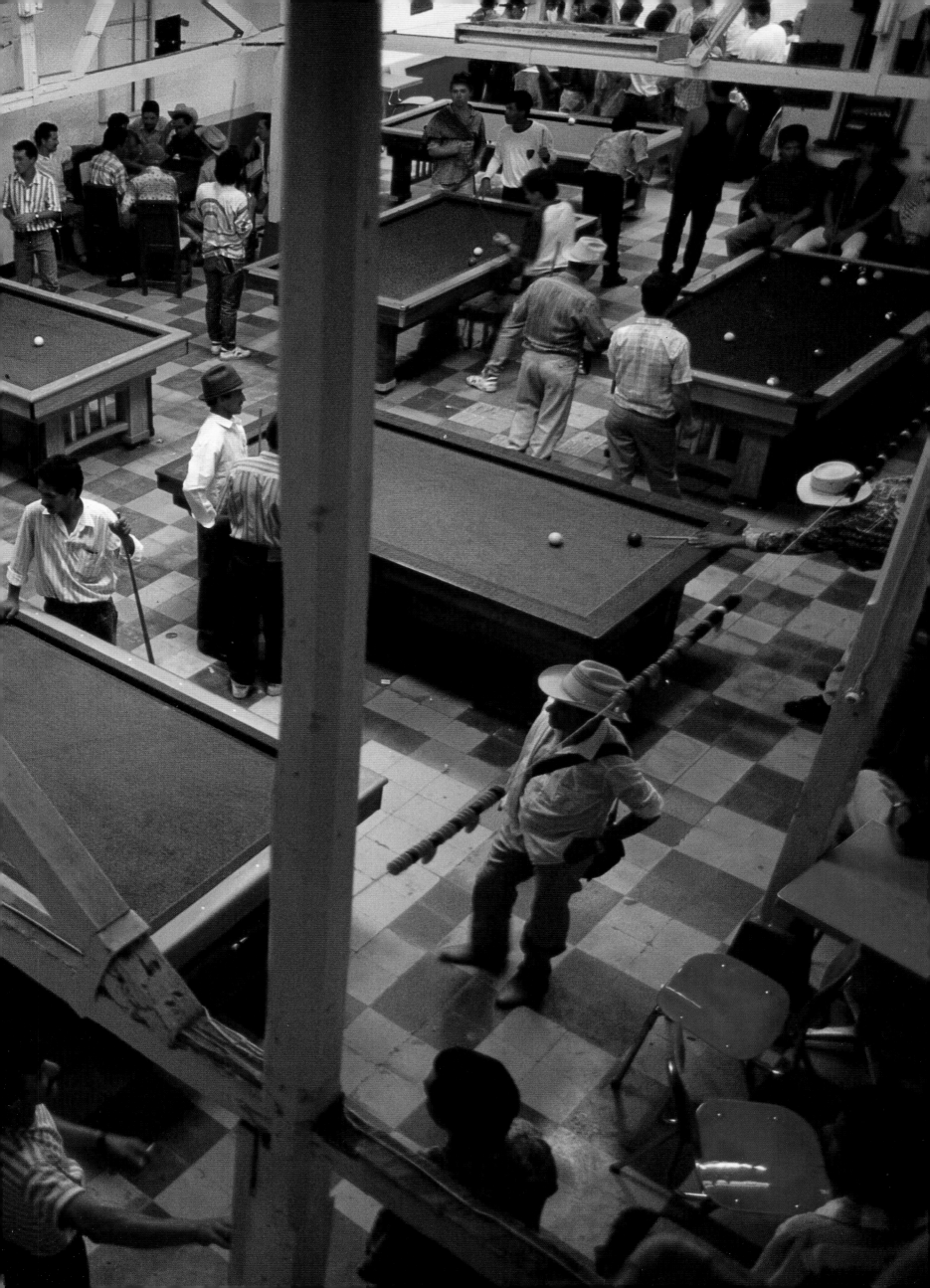

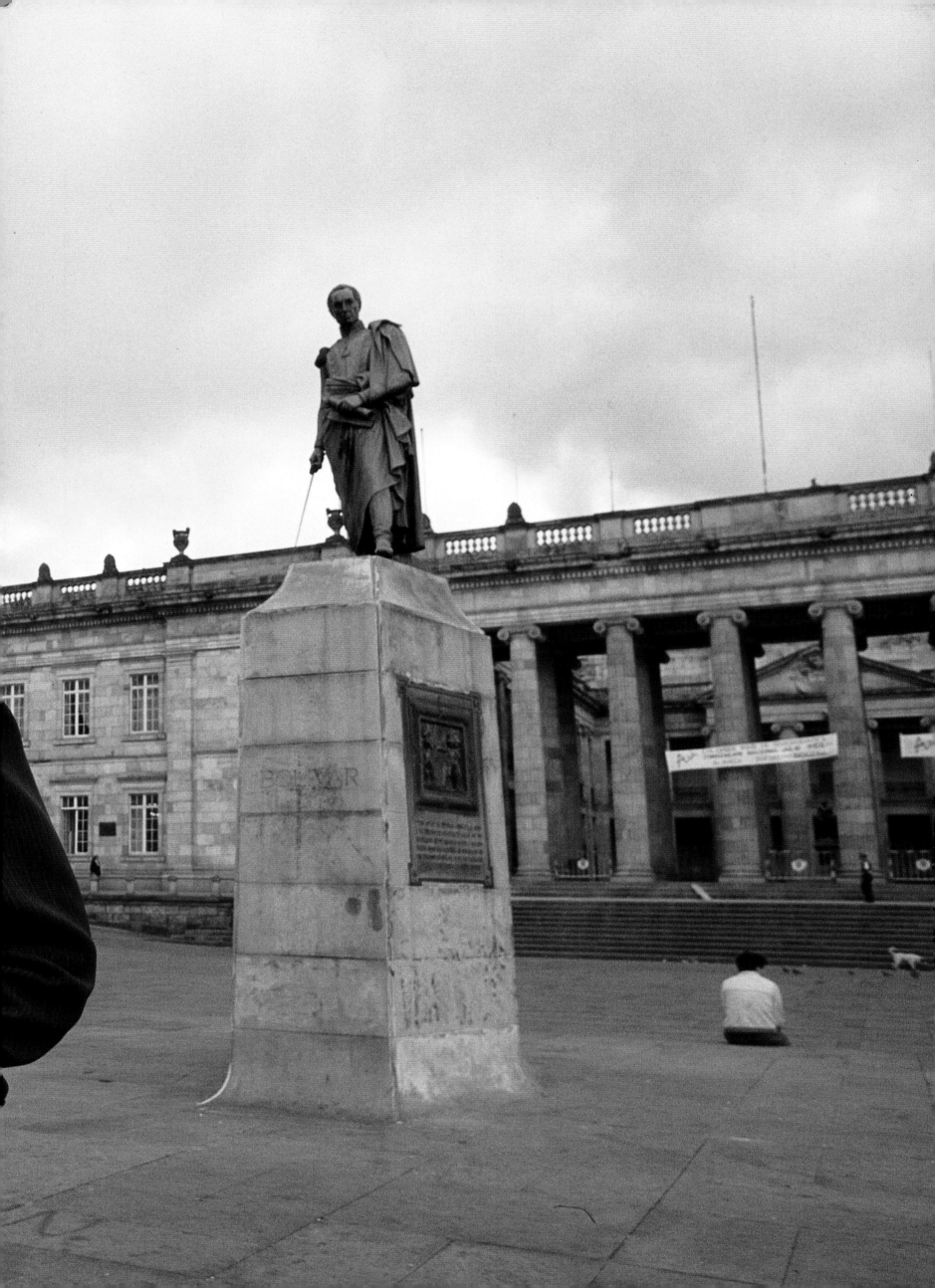

THE LIFE OF
COLOMBIA

Direction, design and edition
BENJAMIN VILLEGAS

Photography
JEREMY HORNER

Texts
GUSTAVO WILCHES-CHAUX

Villegas
editores

This book has been created, produced and published in Colombia by
BENJAMÍN VILLEGAS & ASOCIADOS
Avenida 82 No. 11-50, Interior 3
e-mail: villedi@cable.net.co
Telephone (57-1) 616 1788
Fax (57-1) 616 0020 / 616 0073
Bogotá, D.C., Colombia

© VILLEGAS EDITORES 1994

www.villegaseditores.com

Layout
MERCEDES CEDEÑO

English translation
DEPARTAMENTO DE LENGUAS MODERNAS
DE LA UNIVERSIDAD JAVERIANA

Revision
ANDREW ALEXANDER REID

First edition, November, 1994
Second edition, November, 1999
Third edition, February, 2001

ISBN
958-9138-99-3

The publisher particularly acknowledges the support given by
CEMENTO ARGOS, SEGUROS FENIX, CORREDORES ASOCIADOS
and BANCO MERCANTIL DE COLOMBIA
for the publication of the first institutional edition of this work.
He is also extremely grateful to
COMPAQ
for the sponsorship of the second edition of this book.

Photos on the first pages
Front jacket: *Vaquero at sunset in the Llanos Orientales, province of Casanare*
Back jacket: *Worker at Acerías Paz del Río, Belencito, Boyacá*
Page 1: *Páramo de Berlín, province of Santander*
Pages 2/3: *Reveille in the military station of Tolemaida, near Melgar, province of Tolima*
Pages 4/5: *Snooker parlour in the village of Bolívar, province of Antioquia*
Pages 6/7: *Plaza Bolívar, Bogotá*
Page 8: *Rodeolandia fun fair in Bogotá*
Page 11: *Terrace and interiors in the historical center of Cartagena, province of Bolívar.*

Horner Jeremy
 The life of Colombia / Photography Jeremy Horner;
Texts Gustavo Wilches-Chaux;
Director, designer and editor Benjamín
Villegas; English translation Departamento de
Lenguas Modernas de la Universidad
Javeriana. – 3rd. ed. – Bogotá : Villegas, 2001
 208 p. : ill. col. ; 25.4 x 35.6 cm.

 Original title: La vida en Colombia
 ISBN 958-9138-99-3

1. Colombia - Social life and customs -
Photography 2. Human geography - Colombia -
Photography I. Tit. II. Wilches-Chaux, Gustavo
III. Universidad Javeriana. Departamento de
Lenguas Modernas, tr. IV. Villegas, Benjamín, ed.

910.130 861 CDD
F2260 LC

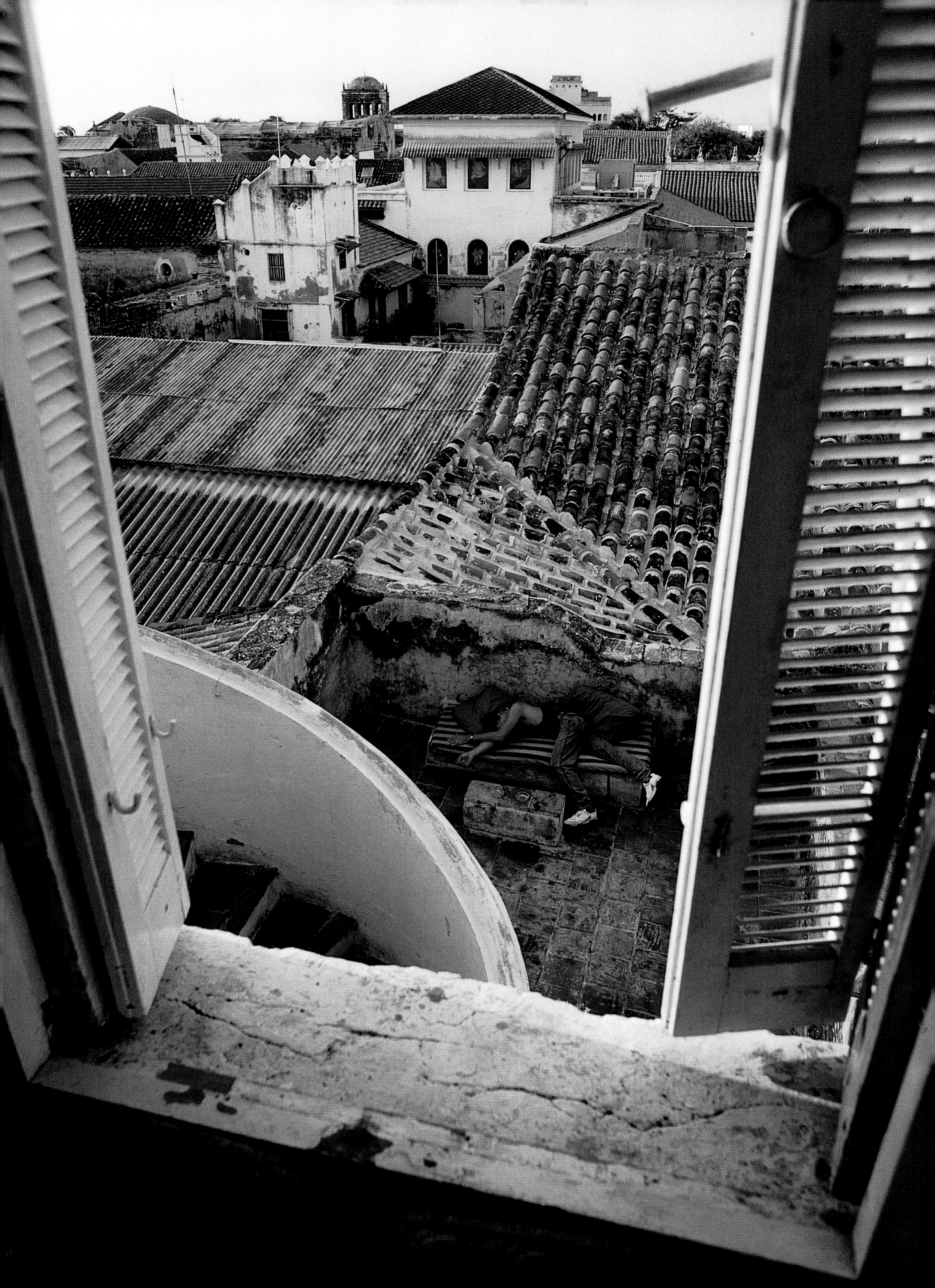

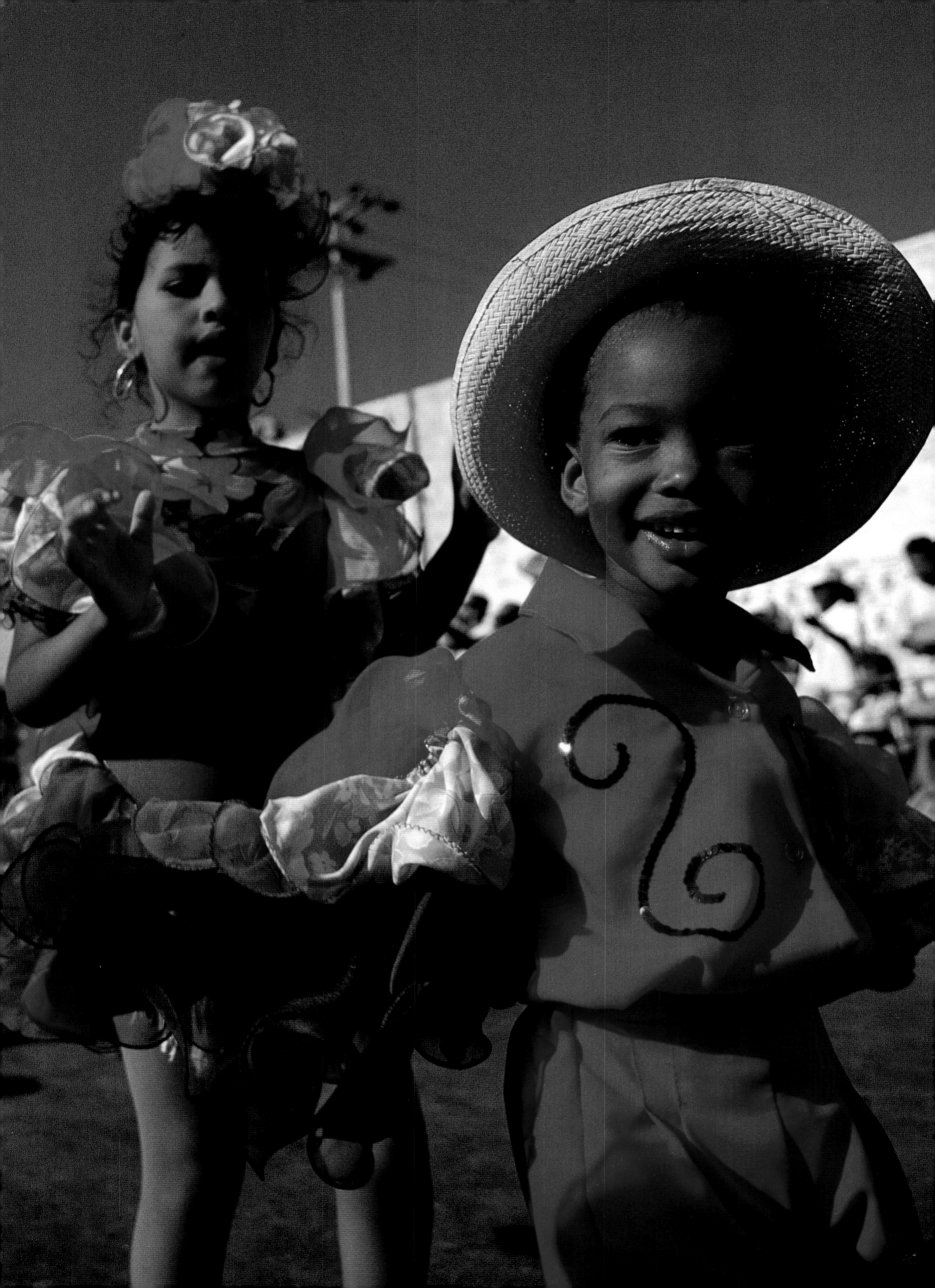

SUCH IS LIFE

Benjamín Villegas

*I*n 1910 Luis Carlos López published one of his small unforgettable poems, *Emoción Vesperal,* which, thanks to its epigraph, seems to be written with the sole purpose of divulging in Colombia a limpid verse of Peter Altenberg, the great Viennese poet of the second half of the XIX century, *Such is Sadness.*

What is sad for *El Tuerto* López is the fact that a delicate flower's fragrance has to live along with an intense smell of *fritanga,* of onion and cabbage. What is sad is that the long-haired husband of Dorotea, without a penny in his pocket, writes poetry and an editorial. What is sad is the stillness of the gun that does not say anything, while the owner of the sheepfold goes by reading a mass book. What is sad is the feeling of emptiness left by the moon when it goes down, it is the walled city where Rafael Nuñez, as well as Antonia, the young girl, were born. What is sad is the burden that oppresses the soul, weariness, fatigue, the fear of the future, the boredom of a never-ending summer. But nothing is eternal. Suddenly, a beautiful and proud stewardess crosses the bridge of the ship. So, we have a stewardess here? Good gracious! Then things are different.

Such is life. Life which hides in the surprise of the final verse, which is camouflaged around the corner. Which is in the scissor cuts of a village barber, as happy as a glass of muscatel wine. Life which is in music, in girls, in vermouth, even in Doctor Ross pills, in old shoes, in the

The Colombians' taste for music is often stimulated from childhood by taking part in musical bands and groups, where they express in simple fashion the rhythm they have in their blood during the country's carnivals and celebrations.

illness of Teresa de Jesús. Life lives in its parade of soutanes, soldiers and bullfighters, in the quack-quack of ducks, in Juana, as beautiful as she is scatterbrained, in *chorizos,* in the thingamajig called W.C., in four in the afternoon, in a street-vendor clamouring his fresh shrimp. And it rasps its throat and hides and sprouts uncontrollably anywhere, in & and &, in ***, between 0, between ¿ ?, between ! !, between " ", between – –, but invariably, beyond suspension marks.

This is the book of life. Life in Colombia. I thought about it when I read *El Tuerto* López on a trip to Cali, when horse-riding in Anapoima, during a low helicopter flight over Bogotá and the *Sabana,* at dawn after a sleepless night, on my lamp table while looking at a thousand and one or more photographs, in the shortcomings of theoretical texts and art works that are only related to beauty. Life in this book exceeds its own limitations, and the fact of not having been identical to *A day in the life of...,* where dozens of photographers scatter over one territory or another: Burundi, Mexico, Estonia, Formosa, the United States, to record local events with the speed of a news report destined to satisfy the voracity of a bunch of apathetic televiewers. None of this here. Here, Jeremy Horner and I dedicated ourselves to think beyond forms, to select substances and contents in such a way that cafés are first for conversing among friends before being a public place, Tolemaida a place where peace is underway before being a military training field, Mompox a method to attain inner life before being an eternal series of Holy Week stages, and so on *ad infinitum,* along with pool rooms, universities, the Amazon river, fields and pastures, roads and paths.

In this book Colombia speaks, laughs, works, lives and dies, Colombia sees herself in the mirror, and remains as she is, beautiful and affectionate like the splendid girls described by *El Tuerto* López. To observe it, Jeremy Horner has not fallen back into the old ways of a XIX century English traveler, instead he has the lucid stare of a person in love who has not yet conquered the beloved. The essential feeling of such a person in love is doubt. His decision is inexorable, but he is still assailed by reason, and reason has eyes to see, ears to hear, and questions to be answered. Before devoting himself in body and soul to the joy of love for a country that he travelled over painstakingly for several months, Jeremy Horner reflects. He does not make compromises. In these pages he gathers true realities rather than landscapes, work activities rather than professions, reasons rather than reasonings, bones hard to gnaw at beautifully dressed up for a party.

These are the occupations of people, these are people *in situ,* people as they are: here, the worker works, the pedestrian walks, the mother nurses her baby and does the laundry, the student studies. This is a book full of sounds, kisses, coughing; in its pages airplanes land, old cars clatter by, canoes sail, cows moo, neighbours chat, old men and women reminisce, children dream. Such is our life. Our current life, our everyday life, our life as passengers of jitneys, that Rogelio Echavarría described in masterly fashion:

> *...as soon as we are, we are no longer*
> *life is this bus rushing by*
> *which suddenly stopped and we've arrived.*

Besides the colonial attraction of the walled castle, Cartagena has beautiful, tropically-styled residences in the neighbourhood of Manga. President Rafael Nuñez lived in one of them at the end of the XIX century.

Restoration and painting of a chiva, *a typical rural bus, in Medellín, province of Antioquia*

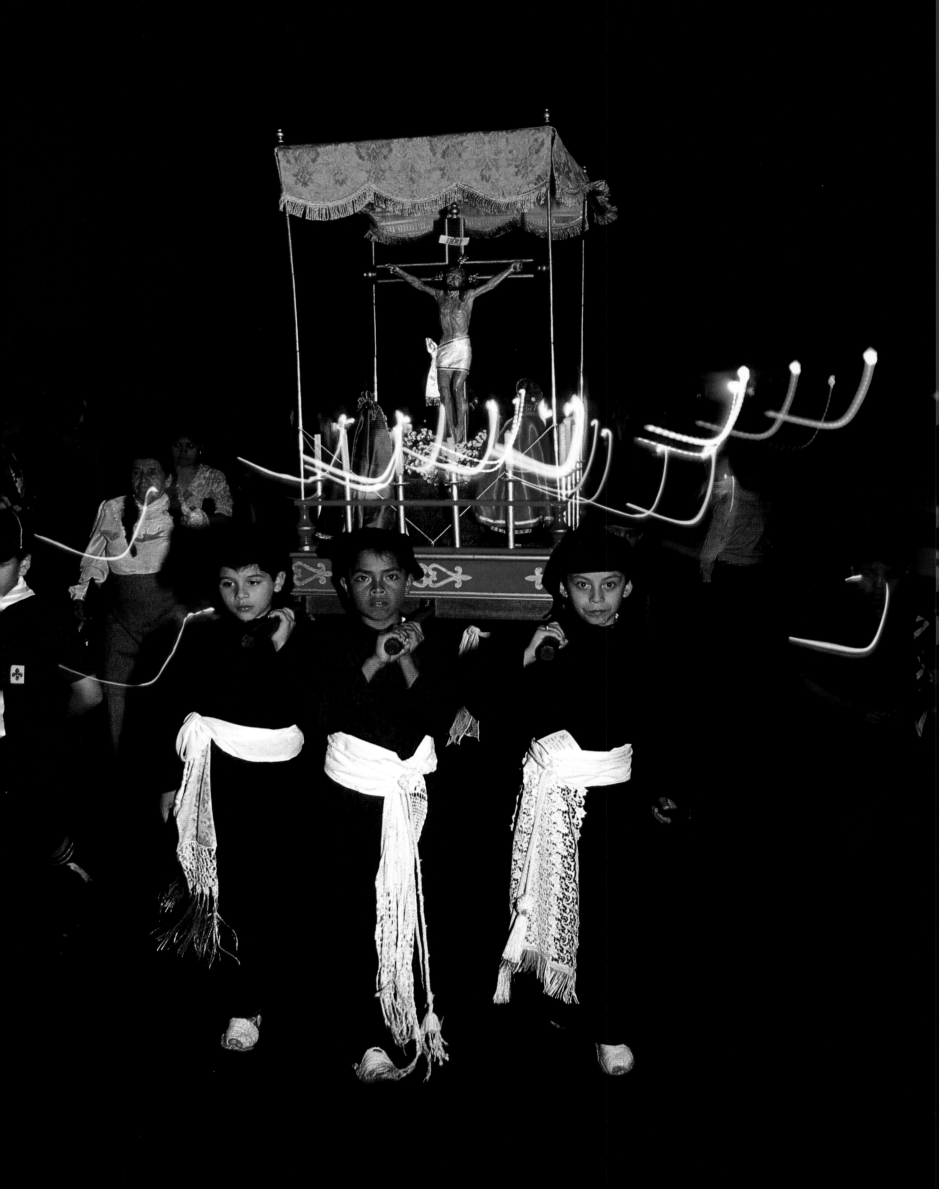

THE SCENERY

Gustavo Wilches-Chaux

*I*f the Colombian territory were rolled out like a carpet, it would only be possible to smoothe out –more or less– one part: the half corresponding to what is known as the Llanos Orientales or Orinoquia, and the Amazon region. The other half, consisting of the Andean region, Pacific coast and Caribbean plains would have to remain wrinkled.

This is basically the orography of the scenery for Colombian life: a country where the Andean cordillera penetrates from the south before bifurcating, trifurcating and branching off like the veins of a leaf or the roots of a mangrove tree, before finally flowing like a river in the Caribbean plains on the Atlantic coast.

Small *serranías*, apparently isolated from los Andes, rise up in the middle of the Guajira desert inhabited by the Wayúu Indians, in the region of Colombia which ventures furthest north of the equator.

A triangular pyramid of almost six thousand meters above sea level, the Sierra Nevada de Santa Marta is the sacred territory of the Arhuacos, Arsarios and Kogi Indians; it is the world's highest coastal mountain range, and it buries the roots of one of its flanks, the Tairona, in coral reefs.

Further on, the Caribbean plains, into which the Magdalena, Cauca, San Jorge and Sinú rivers flow before officially emptying their waters in the sea. Since pre-Columbian times, its inhabitants have developed amphibian cultures which are adapted to flood conditions prevail-

Water sports are a good reason to visit San Andrés Island, the principal territory of Colombia in the Caribbean. And tourists flock to the Andean town of Popayán, attracted by its centenary traditions.

ing several months of the year. To the west, the Pacific coast or Biogeographic Chocó, like a sidewalk parallel to the Andean cordillera, one of the rainiest, if not the rainiest, place on the planet and one of the most remarkable in biodiversity. It starts on the northern Ecuadorian coast and stretches up to Panama. The Atrato river, the most abundant river in the world in proportion to its length, connects the Pacific and the Atlantic coasts, like an umbilical cord, through the Urabá gulf.

Two large valleys are located in the middle of the three main branches of the Andean cordillera, known as the western, central and eastern cordilleras. The narrow valley of the Cauca river is located between the first two cordilleras. The wide Magdalena valley lies between the second and the third cordilleras. At least two thirds of Colombians live on these three cordilleras and in their valleys.

If one ascends from sea level to the snow-covered summits of the central and eastern cordilleras or of the Sierra Nevada de Santa Marta, one finds landscapes and climates equivalent to all the ecosystems existing on earth, between the poles and equator. That is why in Colombia, on less than one per cent of the planet's land surface, there is approximately ten per cent of all the known animal and plant species.

From the glaciers of the Cocuy, in the eastern cordillera, one can see the flat and vast Llanos Orientales, bathed by the large rivers flowing into the Orinoco.

Rivers tributary of the Amazon are born in the southern part of the eastern cordillera, in the Colombian Massif and in the *Nudo de los Pastos* (where the Andes branch out).

Characteristics of the Andes, Orinoquia and Amazon combine in the *Serranía de La Macarena*. This *serranía* and the small *Serranía de Chiribiquete* in the province of Guaviare are geologically related to the Venezuelan *tepuyes*.

At one time, in the XIX century, Colombia faced the world through the Llanos. The main commercial exchanges with Europe were carried out through the port of Orocué, on the Meta river, and then through the Orinoco and Ciudad Bolívar on to the Venezuelan coast. Later, the main gate on the Atlantic coast was opened, and Orinoquia and the Amazon were left behind. Until a few years ago, when the new oil prosperity in the Llanos began changing again the physiognomy of the zone.

The biggest Colombian cities are located in the Andean region and on the Atlantic coast: Santafé de Bogotá, possibly the most highly-populated city of the world at that altitude above sea level after the Mexican capital, occupies several thousands hectares of plateau. Barranquilla is the main port in the country, near the mouth of the Magdalena river on the Atlantic. Medellín is another mountain city. Cali lies in the level valley of the Cauca river, along its whimsical meanders and below the peaks of *Los Farallones*. Bucaramanga is located exactly on top of the spot in the earth's entrails where the South American plate, the Nazca plate and the Caribbean plate meet. Tremors are frequently felt in the zone.

The so-called intermediate cities are among others, Santa Marta, the most ancient city in the Americas; Cartagena de Indias, the walled city; Quibdó, the only province capital on the Pacific coast; Buenaventura, the main port of Colombia on the same coast; Pasto, on the foothills of the Galeras volcano, between the Ecuadorian border and the deep chasms of the Juanambú canyon; Popayán, a colonial city set in a small, rolling valley between the Puracé volcano and the Munchique hills. To the

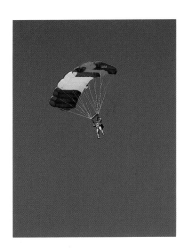

The colours of the parachutes can be deceiving as to the severity of the training received by the "Lancers" and parachutists of the Colombian Army, who are veterans of several decades of counter-guerrilla fighting in jungles and mountains. Their base is in Tolemaida on the border between the provinces of Tolima and Cundinamarca.

The old alchemy treatises state that patience is the stairway which leads to the doors of wisdom, and that humility is the key to open them. Certainly, the citizen of today is more concerned with the keys for his daily safety.

west lie Buga, Palmira, Tuluá and Cartago in the province of Valle. The capitals of the coffee region in the province of "Viejo Caldas" are Armenia, Pereira, Manizales, and Neiva on the Alto Magdalena, and Ibagué, which is located where streams from the Nevado del Tolima pour into the Magdalena river. Tunja on the *Cundiboyacense* high plateau; Cúcuta on the Venezuelan border; Valledupar, the capital of *vallenato* music, niched between the foothills of the Sierra Nevada de Santa Marta and the *Serranía de Perijá*. Villavicencio in the foothill plains; Yopal and Arauca, the oil capitals. Leticia is located in the southern part of the Amazon.

Yes: all those born in this scenery are called, by definition, Colombians.

Five hundred years ago, when the first Spanish conquerors arrived, several Colombian civilizations had already come and gone. "Tequendama Man", who 12,500 years ago left his traces on the plateau of Bogotá. Or the cultures which for some time existed in the mangrove swamps of the Biogeographic Chocó and that some archaeologists think have a kin relationship with remote Japanese cultures. Or those who left vestiges on the Caribbean plains, in the Mompox depression, or the stone sculptors of San Agustín, or the builders of the funeral chambers (subterranean naves for traveling to the other world) in the inaccessible inlands of Tierradentro.

One way or another, the Andean cultures and those of the Atlantic and Pacific coasts learned agricultural techniques –and, generally, coexistence with nature– from Amazonian jungle tribes. Such techniques are still preserved in some parts of Colombia.

Then Europe arrived, barely 20 to 25 generations ago. There were no Colombians because Colombia did not exist, but they were in the making.

Three hundred years ago –15 generations– the African Negroes started to arrive. And the mixture of cultures, races, gods, adrenalines, violence and potentials was enriched, multiplied and biodiversified. A few hours are still needed to ascend the few kilometers that separate the warm plains of the Valle de Upar from the hidden villages in the folds of the Sierra Nevada. After a while, the raucous din of *vallenatos* begins to recede, and one becomes aware of the wind carrying the meditations of the Arhuaco and Kogi *mamos*. The transition between our African and pre-Columbian roots is at the same time abrupt and subtle (African roots are also evident in Colombians from the Pacific coast, but they are expressed differently from those of the Atlantic coast. Each Colombian coast is a different universe). Territories on the Pacific coast are more or less equally shared, although the limits between the Indians and the Negroes are well-defined. Both races coexist, but distrust each other. A minority of Whites and *Mestizos*, with their destructive and dominating Andean concept of work, nature and progress also live there.

In the Andes, the *Mestizo* mixture is much more common, although there are provinces, such as Cauca and Putumayo, where Indian cultures still preserve their character to a higher or lesser degree. Even among the Indians of one province, diversity is great: those of Inca origin, such as the Guambianos and Yanaconas; and those of Carib or Pijao origin, such as the Paeces.

In some regions, such as Antioquia, Tolima, "Viejo Caldas" and Santander, white features seem to have prevailed in the *Mestizo* mixture, although other characteristics are also present. In Colombian blood flow genes from all the earth's latitudes and longitudes.

Colombians from the Amazon are, on the one hand, Indians from nearly 80 ethnic groups –including gatherers and hunters– and Indians who, as a result of their contact with *Mestizos* and Whites, have almost completely lost their identity and culture. On the other hand, there are settlers from different regions of Colombia, who came here to escape from the *Violencia* of the forties and fifties, or to look for opportunities of survival that the overpopulated Andean region denied them.

In the Llanos Orientales, colonization is also considerable, but the condition of the *llanero* has deeper roots. The 1819 Liberation Campaign was essentially fought by soldiers that Bolivar, Santander and Paéz recruited in the Llanos of Colombia and Venezuela.

One word, besides diversity, is needed to describe the Colombian condition: simultaneity. This is because all Colombians "are" at the same time, sometimes in faraway locations, sometimes in the same places.

The *Bogotano* or *Antioqueño* entrepreneur who goes from one city to the next in his own helicopter and the nomad Indian of the provinces of Vaupés and Casanare are both Colombians.

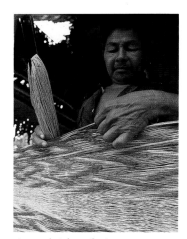

The black woman who pans for gold in a wooden washtub on the Pacific coast, and the general manager of companies extracting and transporting minerals from the world's largest open cast coal mines in La Guajira are both Colombians.

The Indians who represent their ethnic groups in Congress and those who have been manipulated by lobbyists of large economic groups are also Colombians.

The scientist who ventures into the frontiers of genetic engineering in university laboratories, and the *mamo* who feels the pulse of the universe on the peaks of the Sierra Nevada, and the wisest of all *mamos,* who never allows Whites to see him, are also Colombians.

The child who goes to school in big cities and the one who learns to paddle a canoe and mount a small colt on the rivers of the Pacific or to cast a fishing net on the Magdalena river and the swamps of the Atlantic coast are also Colombians.

Around eighty ethnic groups (which include tribes of hunters and gatherers who are little interested in the "civilized" world) and communities (which have almost entirely lost their culture because of their contact with mestizos *and whites) still live in the Colombian Amazoni region.*

The woman who has reached a high position in government and the one who has to walk more and more kilometers to get firewood and water, or the one who builds her own house with her own hands are also Colombians.

The executive who travels in a few minutes by jet from one end of Colombia to the other, and the shaman, who, tripping on *yajé,* sneaks in the form of a jaguar or snake through the mysteries of human nature are also Colombians.

The *campesino* who plants potatoes in the *páramos* of the provinces of Boyacá and Cauca, or onions near Lake Tota, or fruit near Lake Cocha, and the fisherman of Providencia Island or the diver of San Andrés island using only his own lungs are also Colombians.

The inhabitant of the country and of the big cities, of *páramos* and mangrove swamps, of the deserts of La Guajira, and of palafitte houses in the Ciénaga Grande are also Colombians.

The worker on agro-industrial monocultures in the province of Valle del Cauca and the Indian tilling his vegetable patch in the Amazon jungle are also Colombians.

In a country where biodiversity stares us in the face at every turn, where fate arbitrarily joined together so many universes, so many stories; where more or less arbitrary frontiers, which enclose within their limits such contrasting landscapes and such contradictory human beings, confer to those living within them the common condition of Colombians. Only a few years ago did the Political Constitution of 1991 formally accept that Colombia is a nation of multiple diversities, and that "national identity" is only possible and understandable through the acknowledgment of the other, of his worth, of his differences, of his particularities, of his environment.

Government figures show that Colombia is one of the most violent countries in the world with no formally-declared war. To understand ourselves, we need to go back to the past: the four long centuries of the Conquest and the Colony (from the beginning of the XVI century to the first half of the XIX century) were of permanent submission, imposition and exclusion. We attempted to build our identity on the denial of differences and on disrespect for particularities. We attempted to reduce to invisibility all which did not correspond to a defined model, a tendency prevailing until only recently.

Historians tell us that in the XIX century, apart from the War of Independence, no less than ninety violent occurrences shook the country, consisting of popular or *caudillo* revolts and uprisings, of which nine were nationwide civil wars. During the same period, the country changed political systems, constitution, laws, purpose and name several times.

From this point of view, our century has brought about lesser commotion. Colombia is the South American country that has had fewer military coups (only one, in 1953), and which boasts the steadiest economy and the most stable democracy. Even so, the last three decades have been almost permanently under state of siege. In other words, for two generations the general rule has been a state of exception.

The Chinese say that crisis –and the ideogram that is drawn to express it– represents at the same time danger and opportunity. In Colombia over the past 500 years, crises have not been fleeting moments, but a permanent condition of daily existence.

Life in Colombia is today, and has always meant for its people and its natural environment a tension between the creative possibilities of existence and the unavoidable fate of death.

The enormous biodiversity of the Biogeographic Chocó is –to a large extent– the result of efforts to live and to survive during cataclysms, which have frequently struck this corner of the planet since the very birth of continents in their present state. Some of the most fertile lands in Colombia owe their existence to the proximity of active volcanoes or to the change in the course of rivers.

Today, Colombians deforest at least 600,000 hectares of tropical jungles and *páramos* per year. But at the same time they are able to survive and to generate hope at each step, in the most unbeliev-

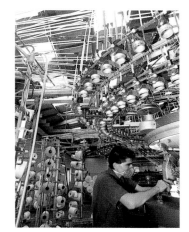

The textile industry was one of the first to be developed in Republican-era Colombia, especially in Antioquia, Boyacá and the province known as "Viejo Caldas". The factory in the photograph is in Ibagué, capital of Tolima, a cotton-producing province in the Magdalena valley, which has also shown great industrial growth.

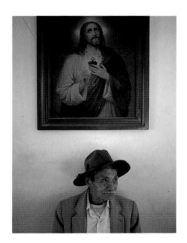

Religiousness is always present in most places during Colombian daily life, through sculptural and scenic images of obvious popular origin as in this scene in Caquetá province.

ably inhospitable conditions in the countryside and the cities. On the same scenery offering the planet's greatest biodiversity –which is nothing more than the outburst of life in all its exuberance– the value of human life can reach its lowest level.

Nevertheless, this country, where the violence of drugtrafficking has been devastating, has given the world the vaccine against malaria, just to mention one example. Sometimes it has not been understood abroad that the Colombia of Botero, García Márquez and Patarroyo is the same Colombia of drugtrafficking, of guerrillas and of paramilitary groups.

Life in Colombia is the daily struggle against annihilating evidences, the everyday effort to contradict them, to abolish them.

Almost everything that is said about Colombia in international news is true. It is not only "bad coverage".

But the other side of reality is never shown. The Yin without the Yang, or vice versa.

The Colombia which is born, grows and reproduces itself –and also dies– every day, the Colombia of Life, with a capital "L", is generally not shown, as if it were not interesting.

We can be sure that the present generations of Colombians are in some way privileged because though we have felt, like other generations in the past, the most destructive and painful expressions of crisis in our own flesh and blood, we have also become aware of our dimension, of our historical responsibility, of our remote roots in all their complexity, and of our duty to the future.

For the first time, a generation of Colombians is massively starting to recognize itself in the other's image, to value themselves in the other, to understand themselves in the other, in their identities and in their differences.

Acts as simple as ways of greeting each other are beginning to be slowly but unmistakably different, warmer and friendlier on scenes where the presence of death had been permanent, where the vulnerability and ephemeral nature of life seemed more immutable. Greeting has become something like a caress, sometimes imperceptible, fugacious, on the back, on the head, a soft squeeze on the forearm, on the shoulder. It is not enough to touch the other in order to show him that we are unarmed, but to touch him softly in order to feel him, for him to feel that we are alive, for him to feel, for him to know that he is alive.

The something which is perceived in the almost intimate ritual of greeting corresponds to a will to live. It is the same will to live that stubbornly restrains the country from going backwards, from stopping.

All over (and in this sense this book could be a sort of imitation of the "yellow pages" of the telephone directory), we find factories of hope in Colombia.

In fact, daily life is full of signs. There is not a month that goes by without a forum on love, on affection, on utopia. In one of the most difficult moments, the students of the Universidad Nacional in Bogotá called for an assembly on tenderness.

When there is an invitation to a poetry festival, twenty or thirty thousand people attend it as if they were going to a football game. That is why today, in Colombia, poetry is also read in stadiums, in

open coliseums, in the open country. In conclusion, life is thus: the conscious or unconscious potential of poetry –the poetry that many times grows like mushrooms from decomposition, from death; but like mushrooms it is able to transform death and despair into fertile land; in our case, poetry is that reality which is diffuse, perceptible, contradictory, true, diverse, confused, full of life (and at the same time violent and destructive) that today is called Colombia.

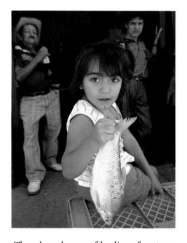

The abundance of bodies of water in Colombia, from lagoons and streams which begin flowing in the páramos to the great jungle rivers and coasts on two oceans all produce a great diversity of fish that is an important source of food throughout the country.

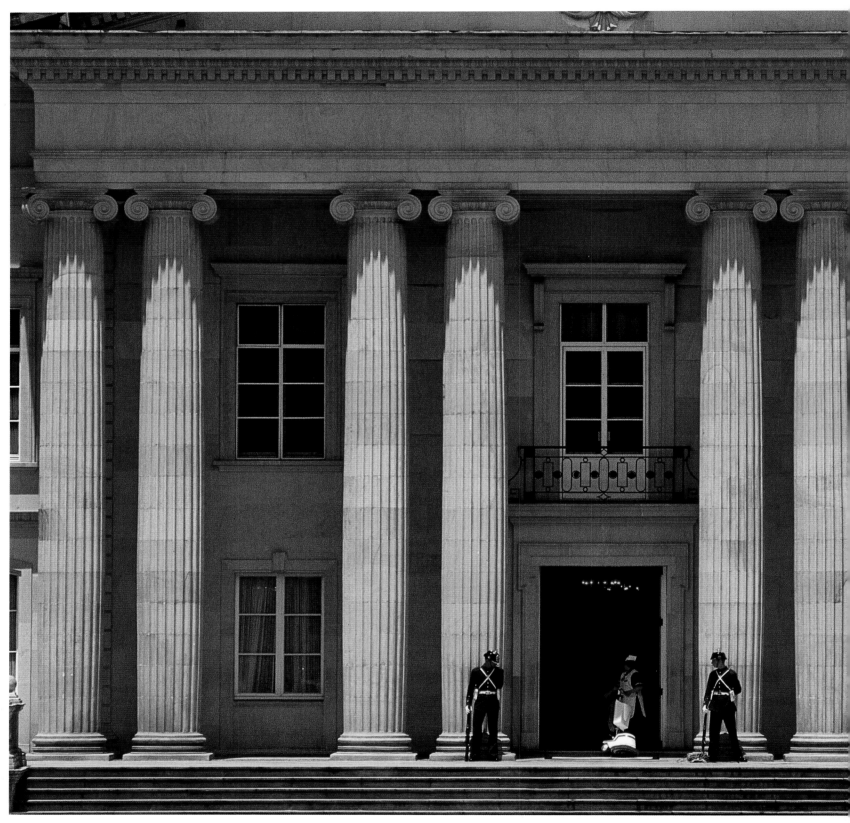

Morning cleaning in Palacio de Nariño, Bogotá

The National Constitution of 1991 reaffirmed the division of power into an Executive Branch, which is presided by the President of the Republic; a Judiciary Branch which is composed of the Supreme Court, the Constitutional Court, the State Council and the Attorney General's Office; and the Legislative Branch made up of the two chambers of Congress: the Senate and the House of Representatives.

President Rafael Reyes ordered the construction of Palacio de Nariño before he was overthrown in 1909. The design was made by Julián Lombana, architect and disciple of English architect Thomas Reed, whose plans were used to start the Capitolio Nacional building in 1847, under the government of General Tomás Cipriano de Mosquera.

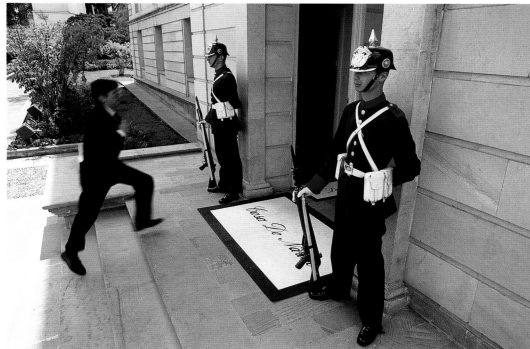

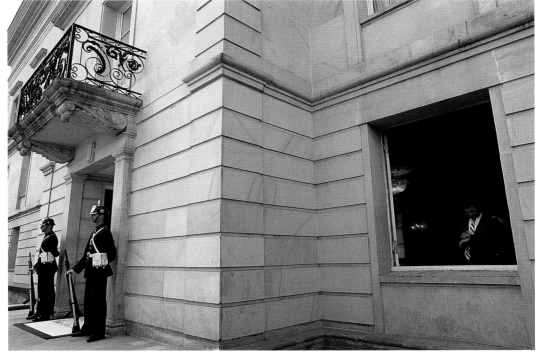

Palacio de Nariño, office of the President of the Republic, Bogotá

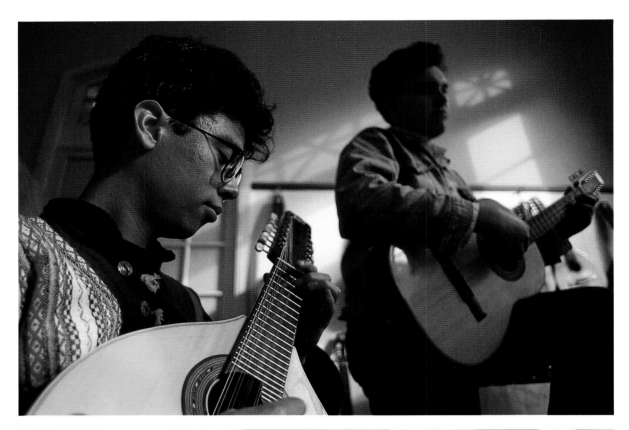

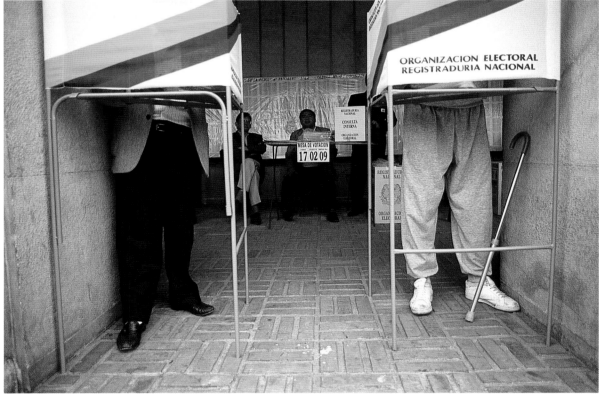

School of Fine Arts, Bogotá
Election day in Palacio Llievano, Bogotá

The arts have their own place in the many cultural centres of Santafé de Bogotá. The city's cultural life offers all kinds of possibilities to those who are able to escape for a moment from their daily, fast-paced activity, and beat traffic jams in order to go to an exhibition or a recital. The duty to vote is not a box-office success at all: the great winner of most elections in Colombia is still abstention.

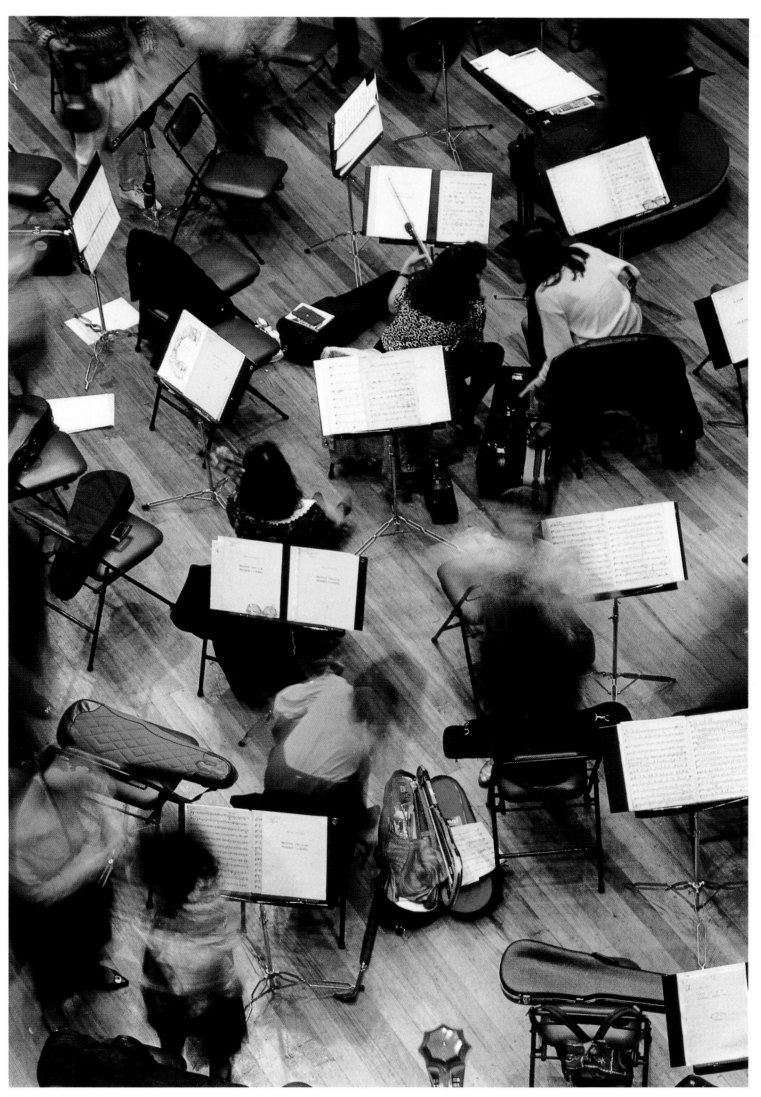

Rehearsal of Bogotá's Philharmonic Orchestra in the auditorium of the National University, Bogotá

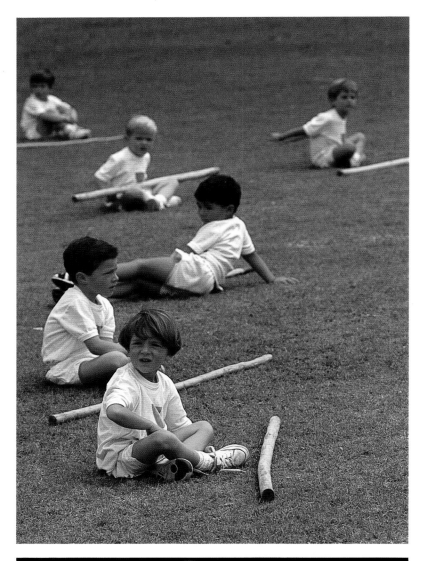

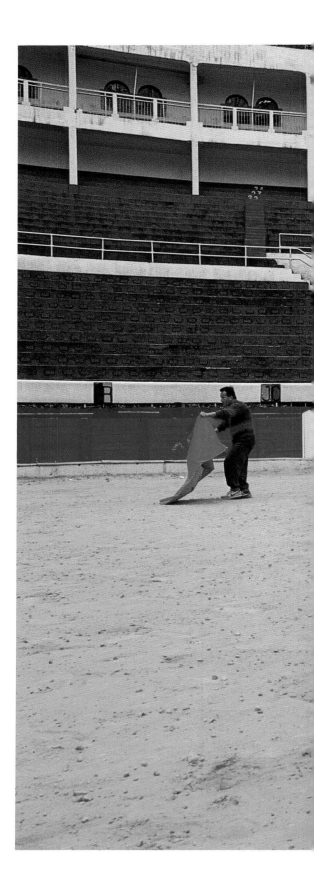

A physical education class at Gimnasio Moderno, Bogotá

Students from Los Andes University, Bogotá

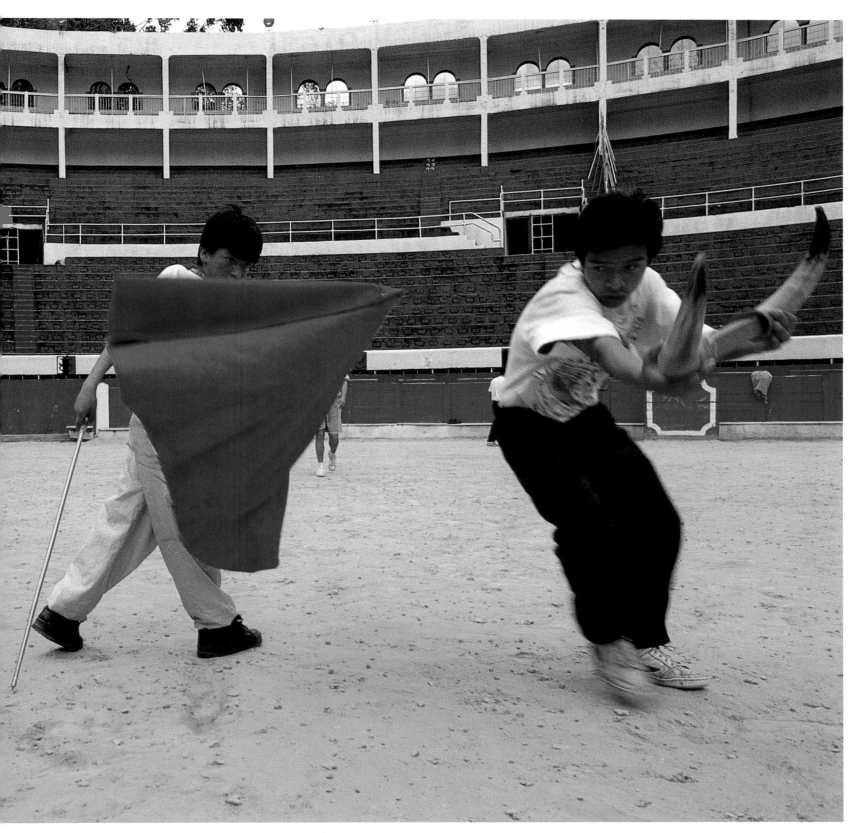

Apprentice bullfighters in Plaza de Santamaría, Bogotá

"Bulls are unpredictable because they are real, and they are real because of an undeniable, essential reason: they are alive", writes Antonio Caballero. Those who enter the "school of life" have a wide range of educational options: from the most orthodox or modern means of regular education to the most daring and unusual survival ventures on the streets of the city.

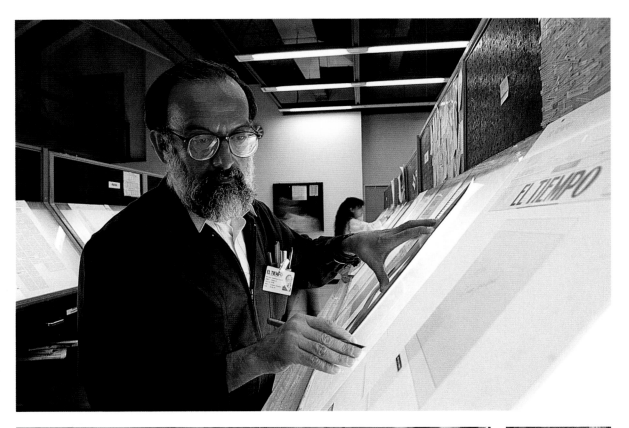

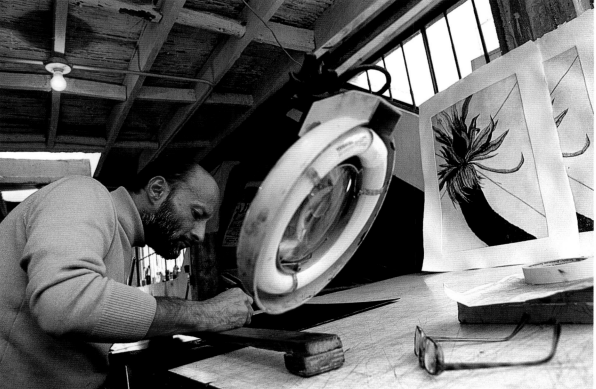

Pasting up El Tiempo *newspaper, Bogotá*
A graphic art workshop in Bogotá

The first newspaper was published in Colombia after an earthquake struck Bogotá, although it's formally considered that national journalism was formally born with the appearance of the Papel Periódico de Santafé de Bogotá *on February 9, 1791. Ever since, the publishing industry became prosperous: today, there are many nation-wide and local newspapers and magazines, and hundreds of thousands of books are printed for Colombian and foreign readers.*

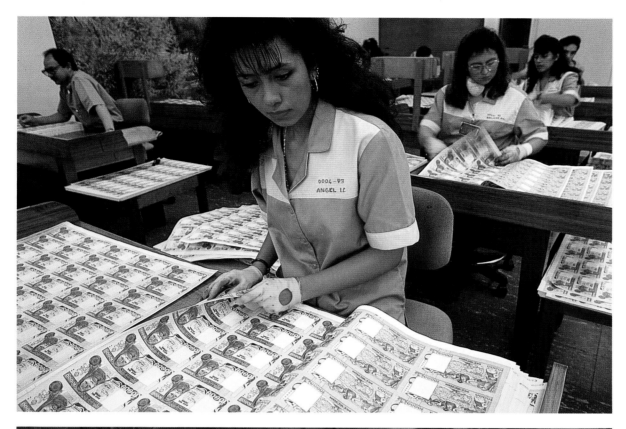

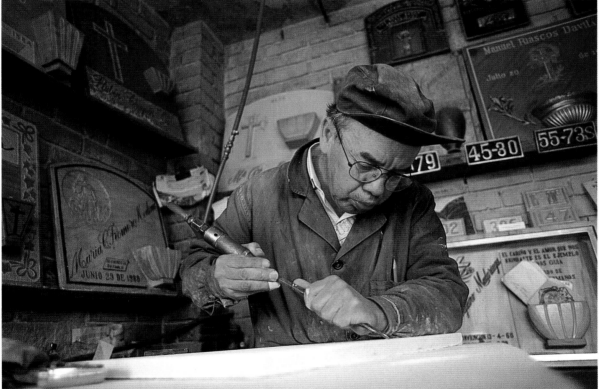

Issue of banknotes in the Banco de la República, Bogotá

Engraver of marble gravestones in the Central Graveyard, Bogotá

Despite the growth of modern industry and commerce, most goods and services in the country are still produced with traditional methods. A large percentage of the Colombian population continues earning its income in domestic and local craftshops, like this gravestone engraver near the Central Graveyard. But for Banco de la República employees, who check recently -printed banknotes, in the photograph above, it is totally forbidden to take work home.

The constant pilgrimages of the faithful and penitent to religious sanctuaries, and the attendance to Holy Week celebrations in different cities of the country, contradict the statement that there are fewer and fewer Catholic people who practice their religion in Colombia.

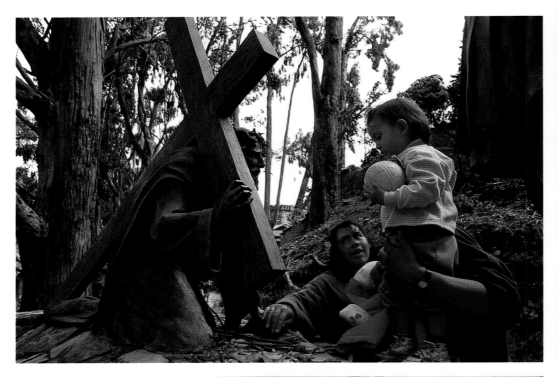

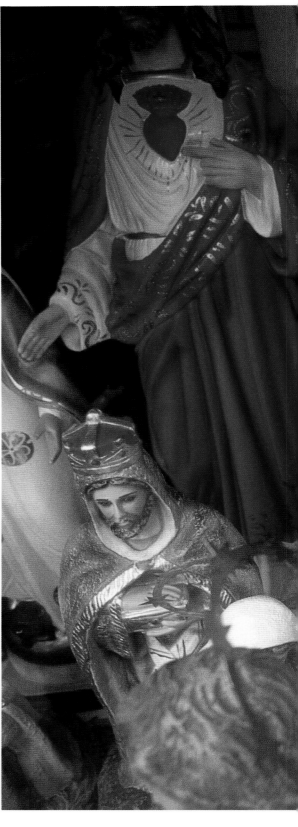

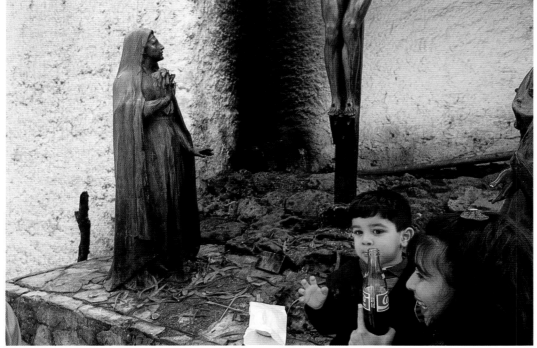

Stations on the Via Crucis in the ascension of Monserrate, Bogotá

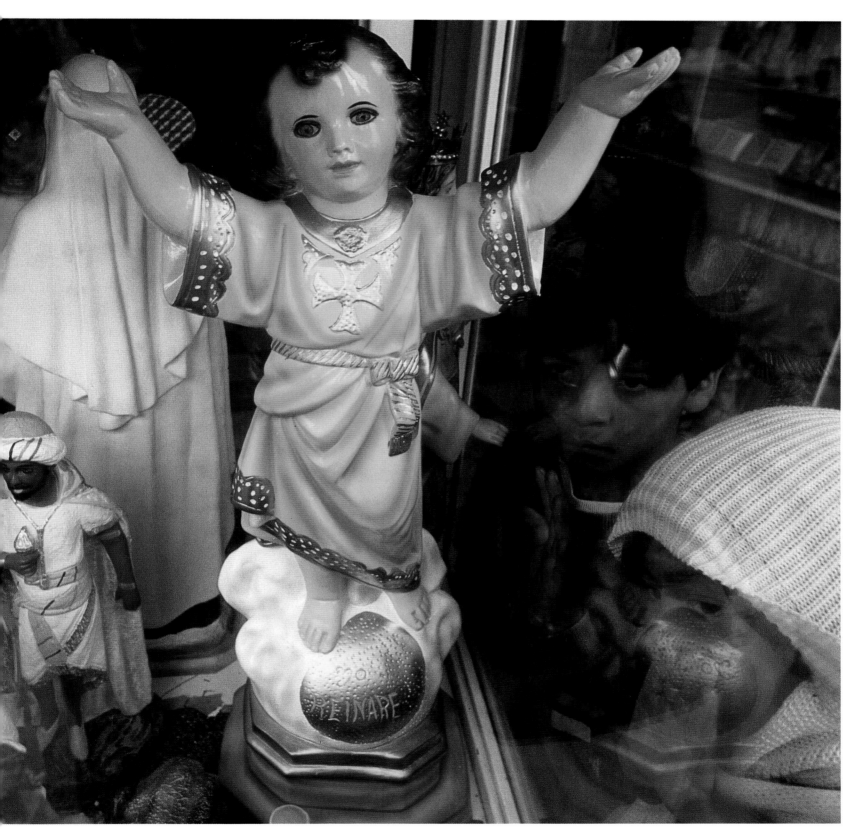

Shop for religious articles in the 20 de Julio neighbourhood, Bogotá

The Catholic faith continues to prevail amongst most of the Colombian population, and it is expressed through a combination of formal liturgy and popular religiousness. Colombians are devoted to different patron saints, whose influence vary from one region to the other: the Chiquinquirá Virgin, the Sacred Heart, the Virgin of Las Lajas, the Infant Christ from Prague... The well-informed say that the Infant Christ of 20 de Julio is one of the most miraculous patron saints.

Scenes of the Agroexpo *Farming and Animal Husbandry exhibition in Bogotá*

Although more than 70 per cent of the population is concentrated in urban areas, the people from the countryside continue to produce food for their 35,000,000 Colombians fellow citizens. Specifically, farming and animal husbandry products from different regions of Colombia arrive in Bogotá: cattle from the Llanos Orientales (where Jesuit missionaries established the first large haciendas in the XVII century), and fruits and vegetables cultivated in small , remote farms.

Vendor in Corabastos *wholesale fresh food market, Bogotá*

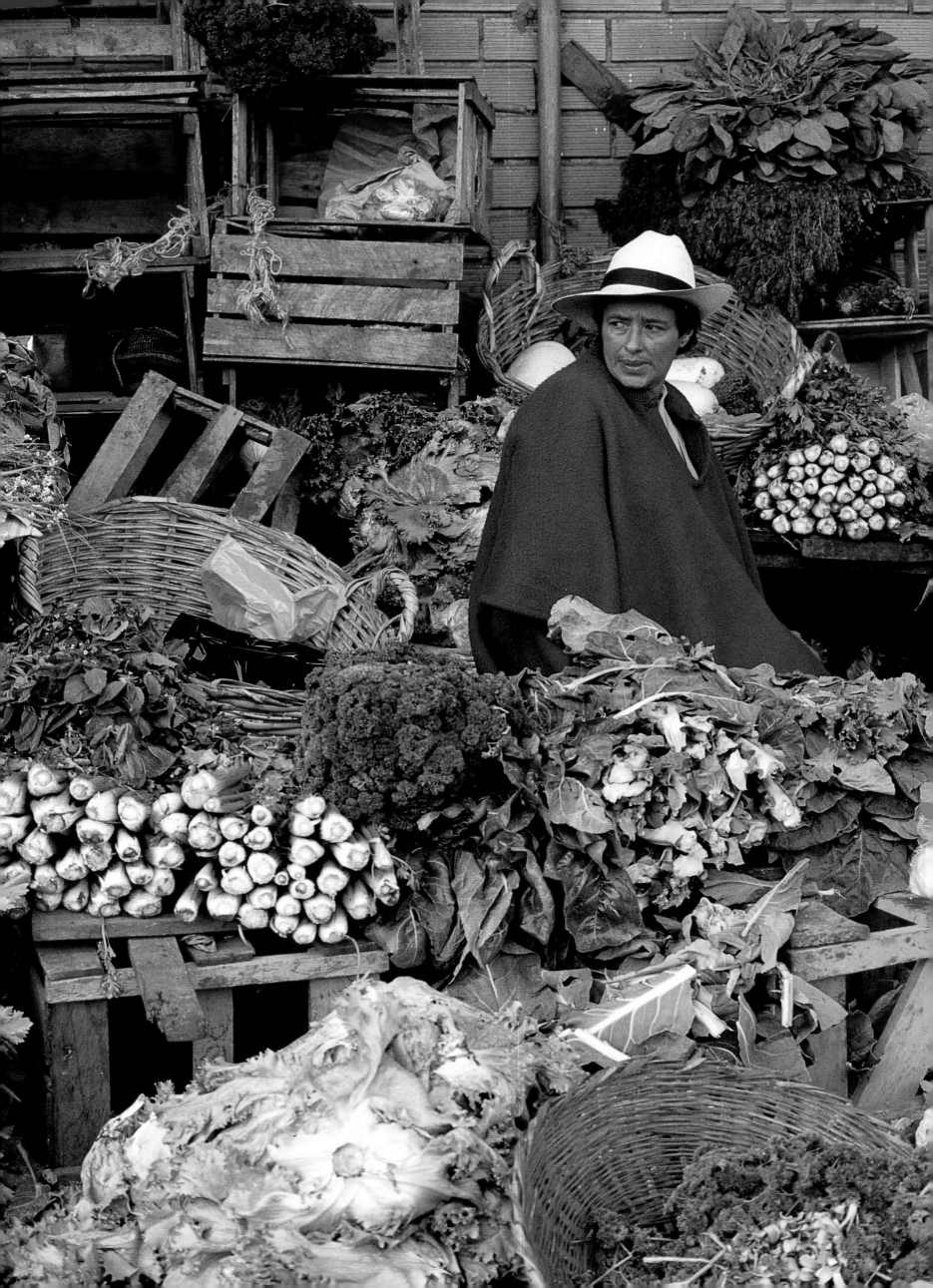

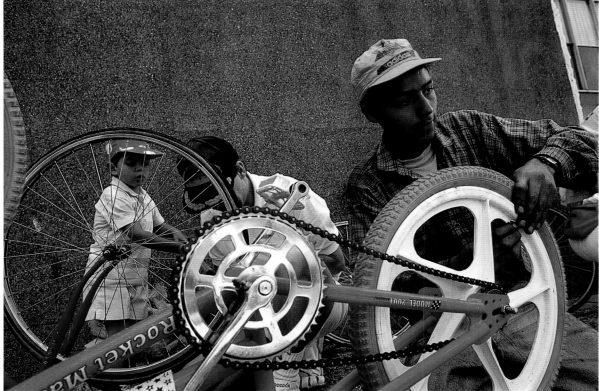

The Zona Rosa in northern Bogotá.
Youth repairing bicycles on cycle-track in Bogotá

During the last 20 years, Bogotá has considerably changed, and even before the current "economic liberalization", the garish influence of the outside world had already transformed a city that was solemn, cold, gray and in many ways monastic. Today, Bogotá's inhabitants, most of them born in other regions of the country and attracted by the city lights, give life (and sometimes death) to a complex and baffling urban organism which covers 35,000 hectares of the Sabana plateau with brick, concrete and pavement.

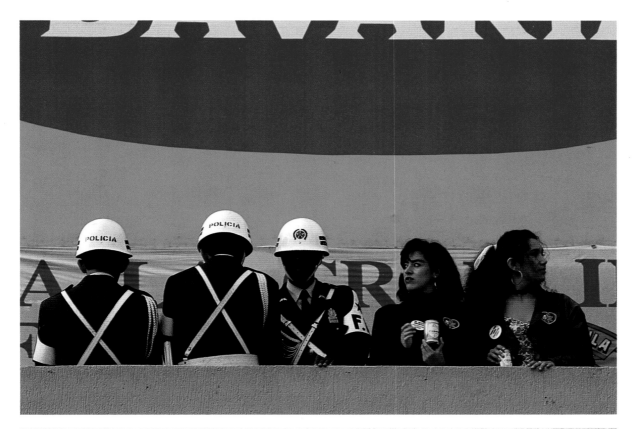

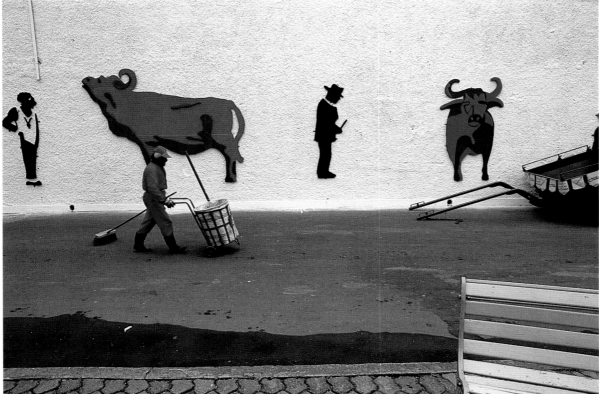

Beer festival and farming and animal husbandry fair in Corferias, *Bogotá*

Unintentionally, these two photographs taken in Corferias *could symbolize two challenges that the different administrations in Bogotá have been unable to meet: how to keep a city with nearly five million inhabitants safe, and clean. At the same time,* Corferias, *the headquarters of continuous national and international fairs, could be the symbol of the "cosmopolitization" of a city which grew from town to metropolis in less than a generation.*

Following page, Cathedral of El Rosario, in the central plaza of Villa de Leiva, Boyacá

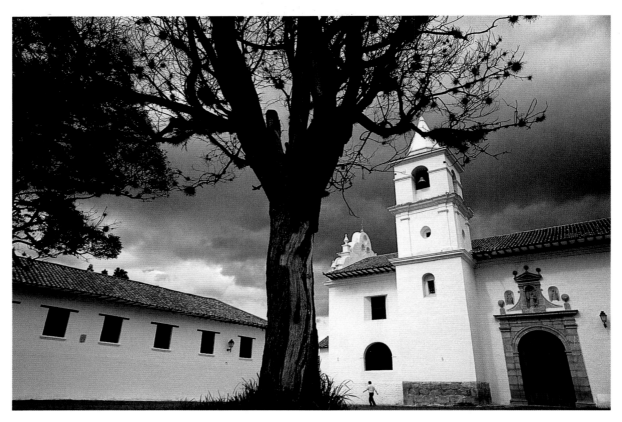

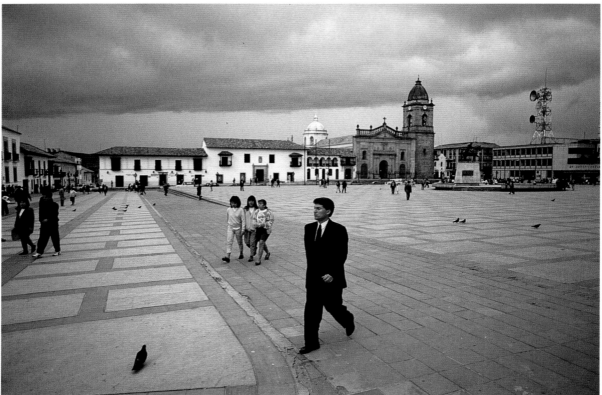

Monastery of the Carmelite Discalced Nuns in Villa de Leiva, Boyacá

Plaza de Bolívar in Tunja, Boyacá

In 1537, after conquering the Zipa territory and the Bogotá plateau (which was called Valle de los Alcázares *by the Spaniards) the conquistadors arrived in the valley of Tunja searching for the treasures of the Quemuenchatocha zaque. Today, the city of Tunja preserves traces of colonial splendour in its civilian, religious and institutional architecture. In 1572, Villa de Leiva was founded as a city for viceregal leisure. The Congress of the United Provinces of Nueva Granada took place here two years after the* Grito de Independencia, *in 1810.*

Campesino family in the village of Tibaná, Boyacá

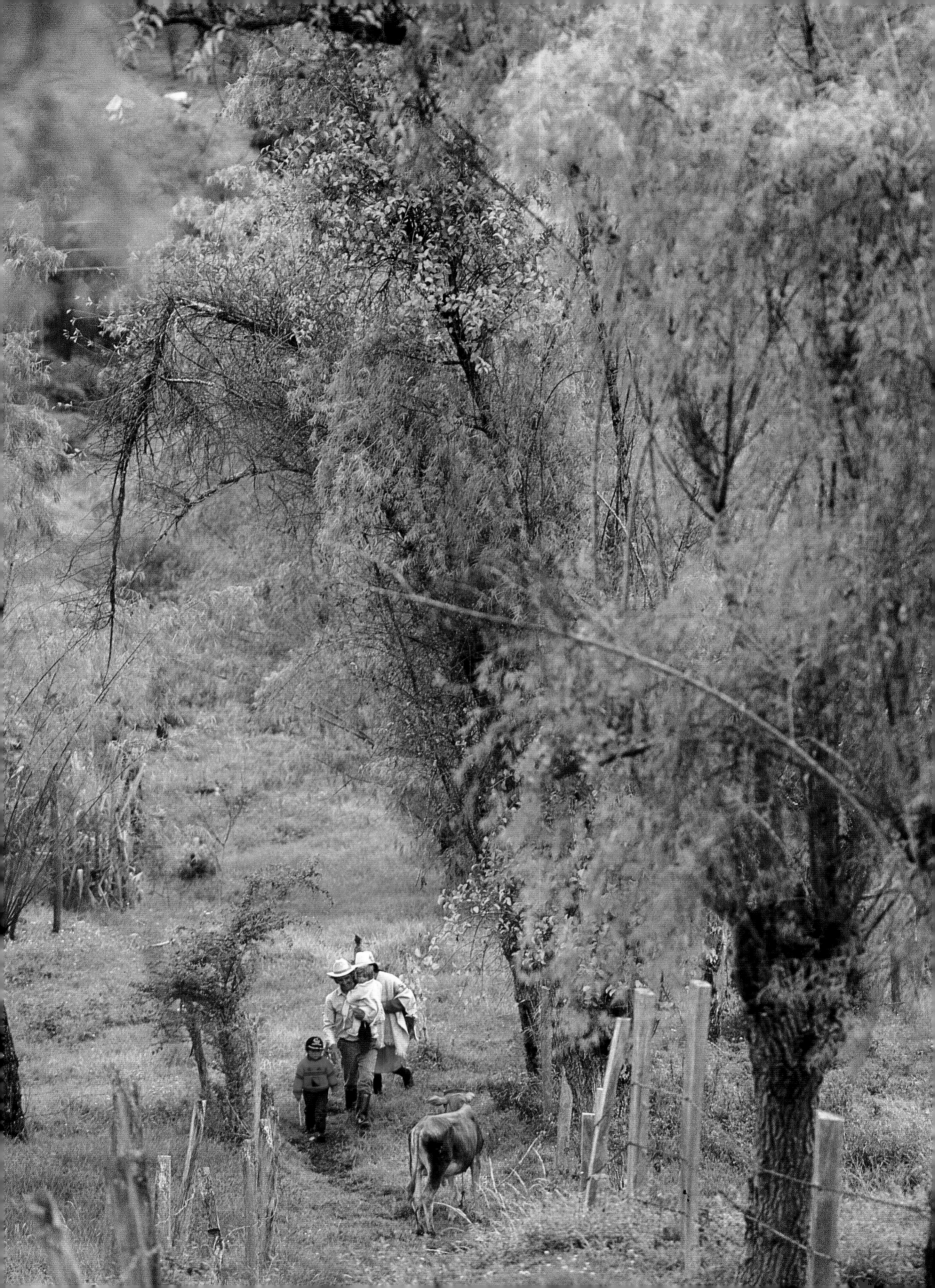

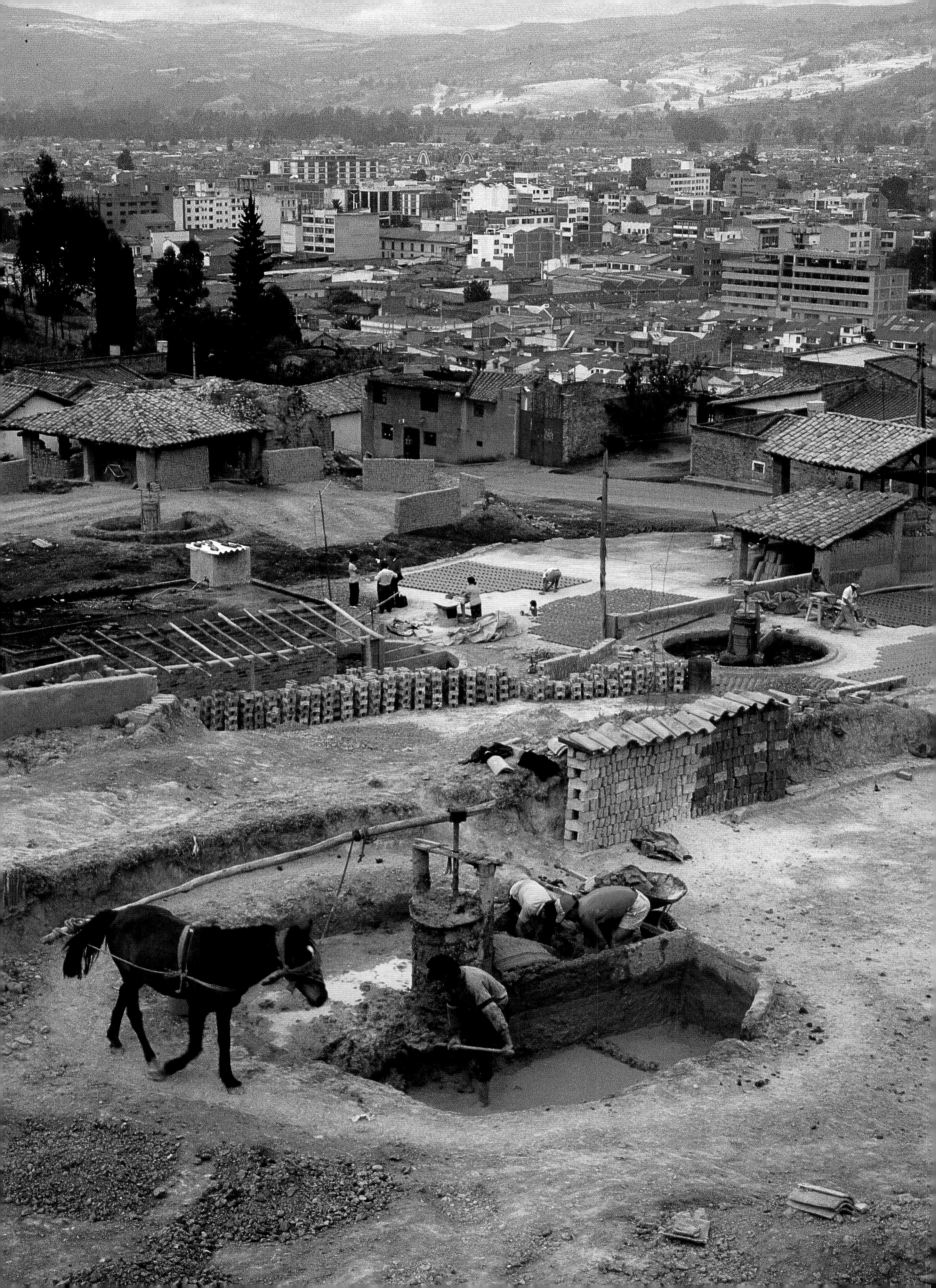

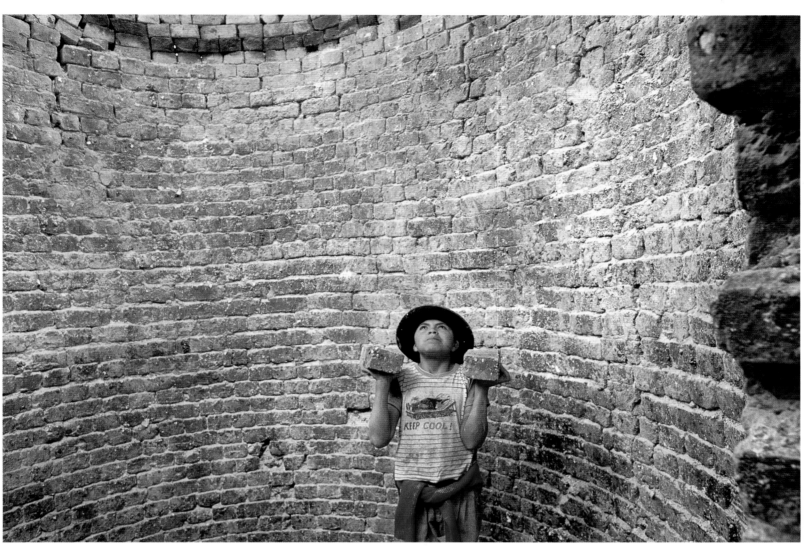

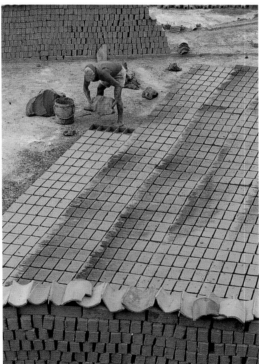

A chircal, *brickkiln, in Sogamoso, Boyacá*

The manufacture of bricks in chircales *like this one are common in various regions of Colombia. In Boyacá, it represents an enormous human and environmental cost that is never compensated by the market price for this beautiful and useful material. Most of the work is done by children and women for piddling wages. Furthermore, the brickkiln is fed with wood from wild forests, which contributes to the deforestation and deterioration of ever-increasing areas.*

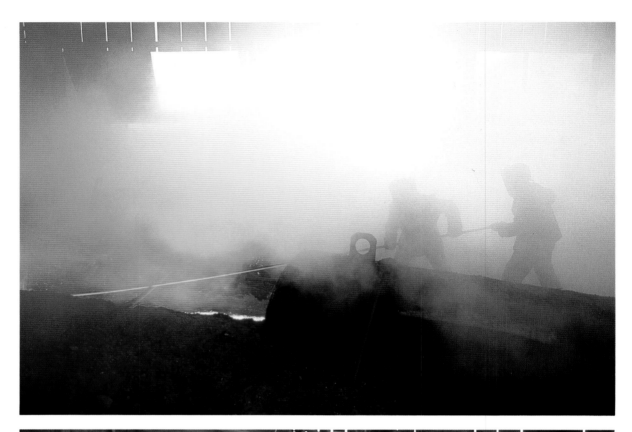

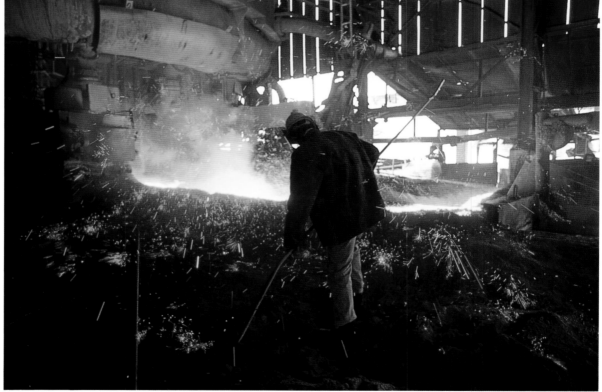

Sections of the Acerías Paz del Río *steelworks in Boyacá*

Colombia entered the Steel Age in 1954 with the foundation of the Belencinto *steelworks, today* Paz del Río. *Huge deposits of iron in the region had been discovered since 1930. Historians say that the early days of the national industry were not easy: workers were directly taken away from farm chores –without previous training– to cope with complex machines and blast furnaces and boilers. Today, after forty years, there is a relatively high-skilled labour force in Colombian industry.*

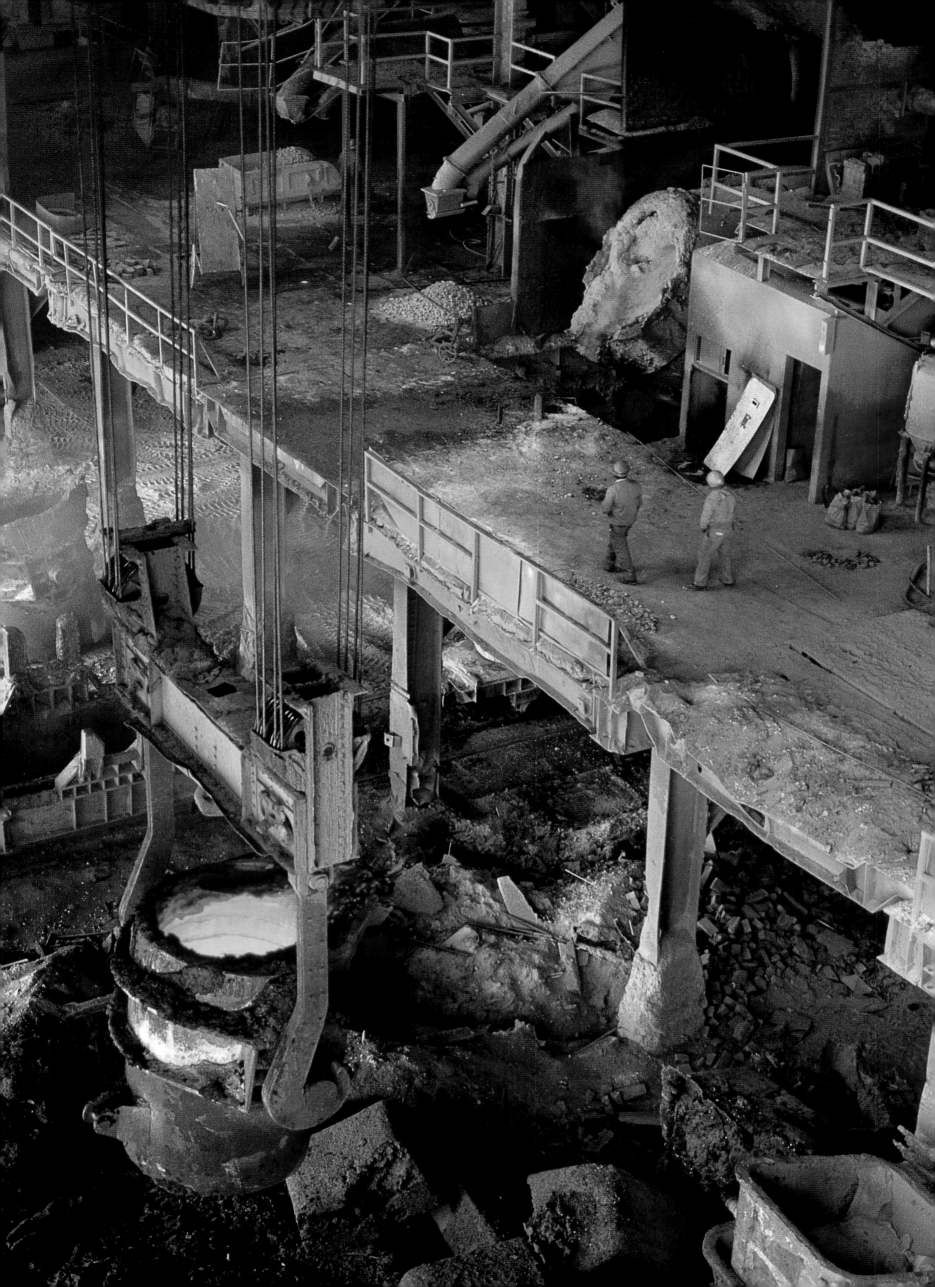

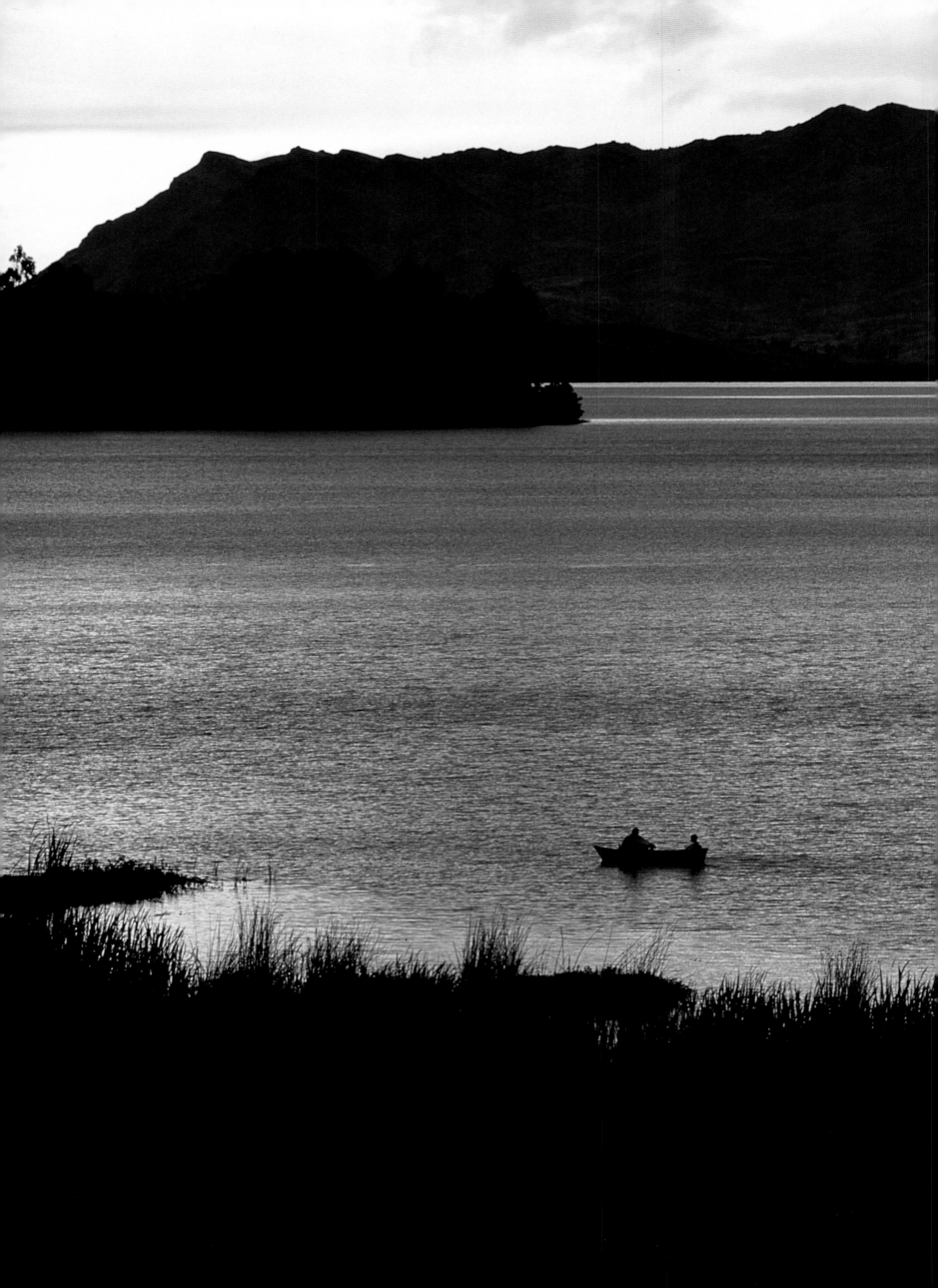

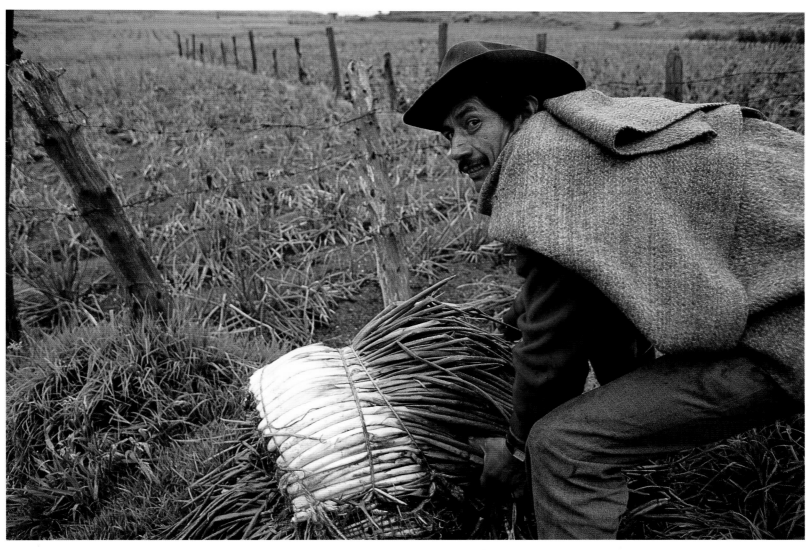

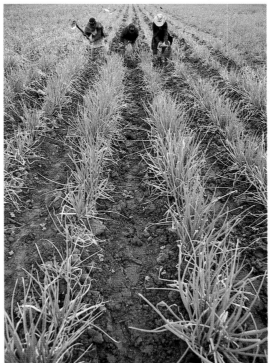

Onion crops on the shores of Lake Tota, Boyacá

Tota, the Indian name of this 56 square-kilometer lake, means "water for farming". However, it is precisely water depletion which is destroying it: the lake "feeds" the populations and farms located in its valley, the Paz del Río steelworks, the tourist accommodations and the hotels in its surroundings. Furthermore, onion crops, abundantly sprayed with agro-chemical products, are increasingly gaining ground over the waters.

Following page, Paz del Río industrial plant in Belencito, Boyacá

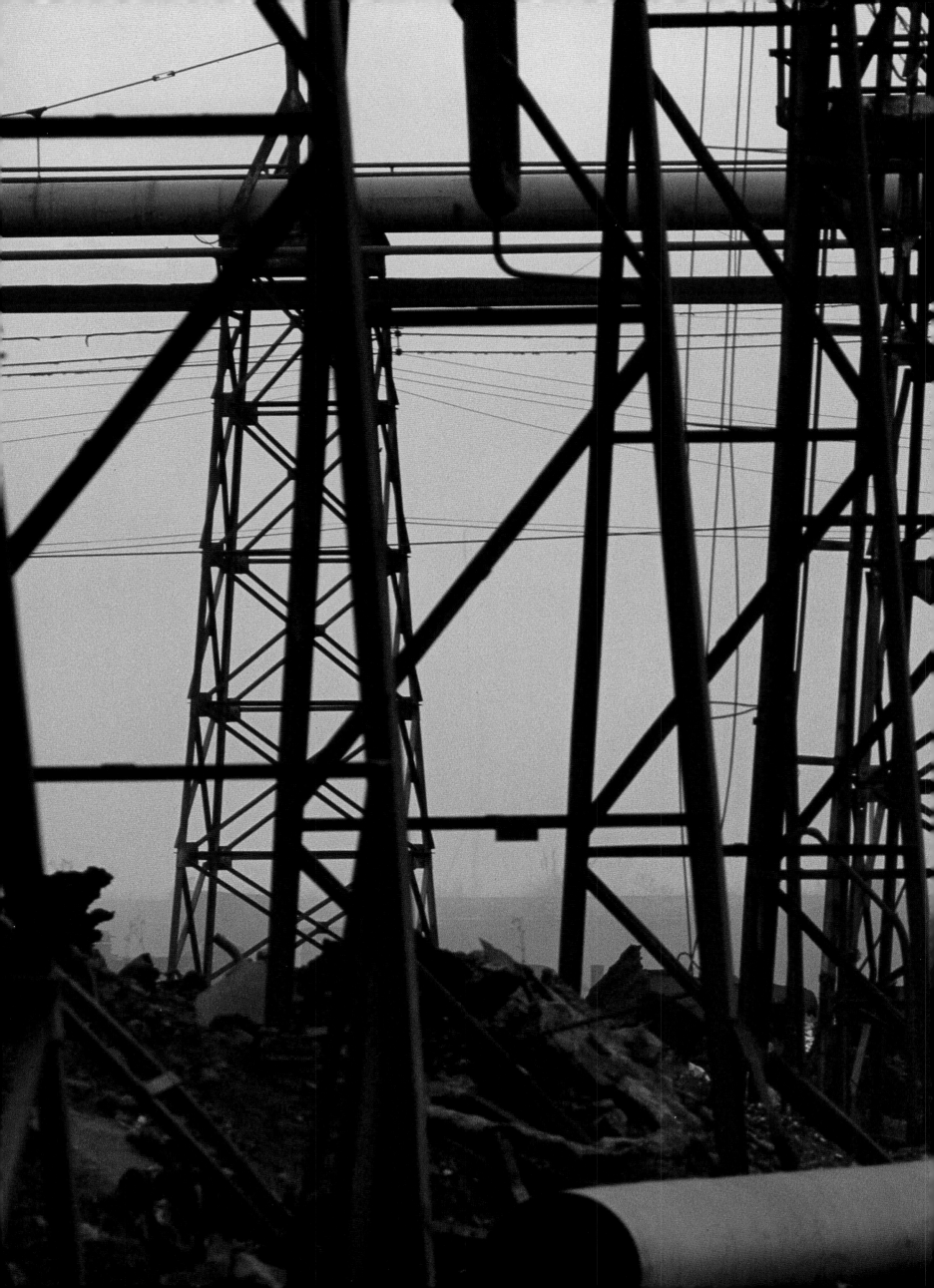

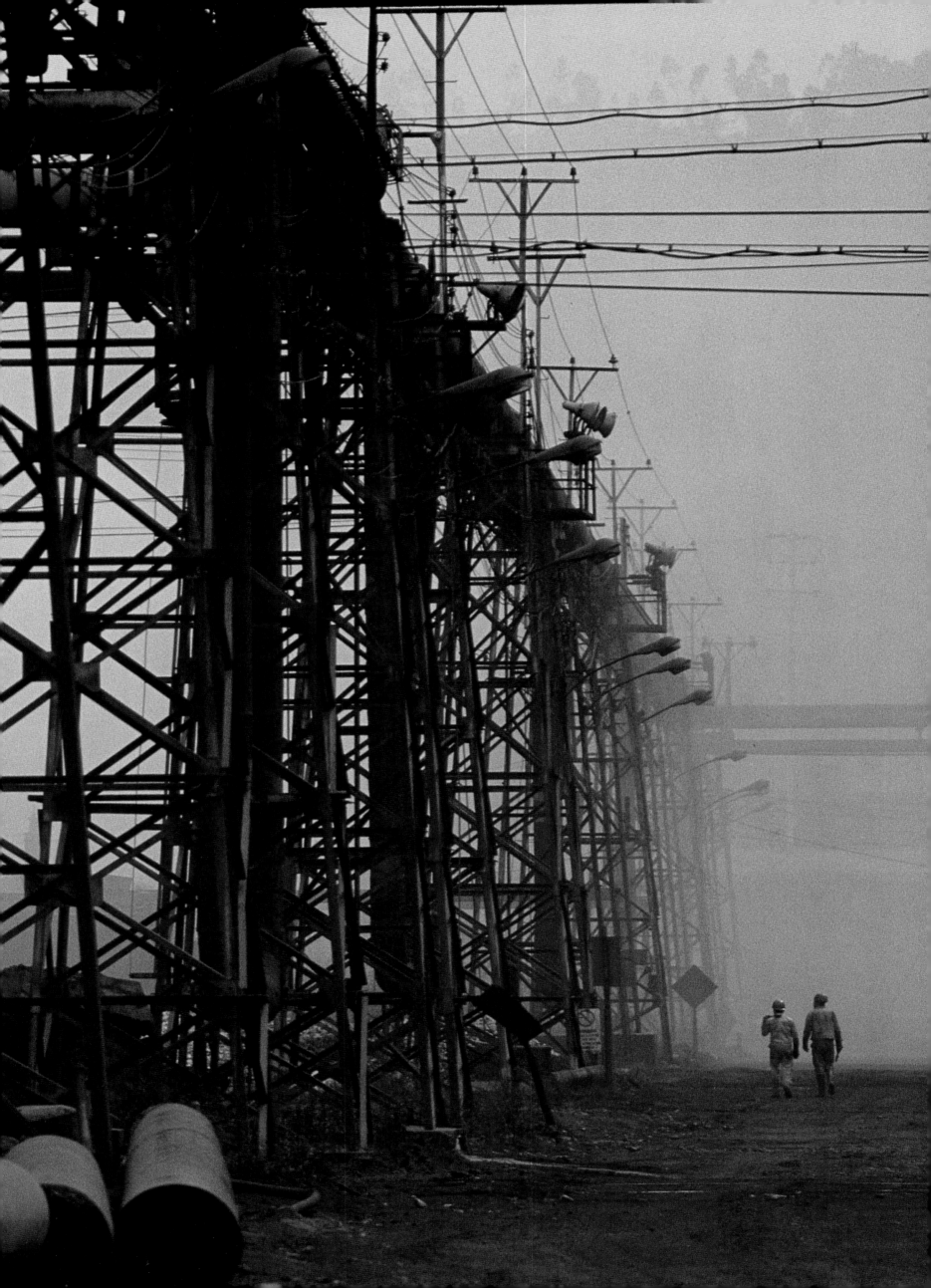

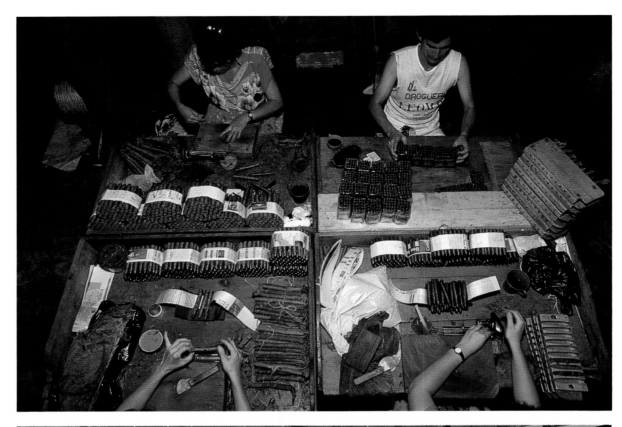

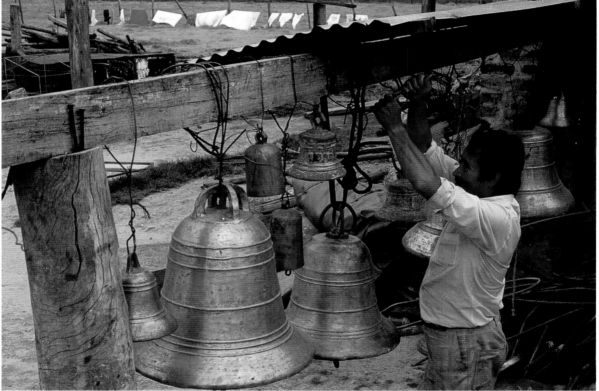

Tobacco factory in the town of Piedecuesta, in the province of Santander
Manufacturing of bells in Sogamoso, Boyacá

One could ask, along with Hemingway, "for whom the bell tolls?", but one could also ask, "for whom do craftsmen weave blankets for?", and "for whom do women roll up tobacco leaves?" It was also in Santander that, during the second half of the last century, craftsmen like these founded the Culebra de Pico de Oro *society in a deadly battle against merchants who were in favour of free imports and free exchange.*

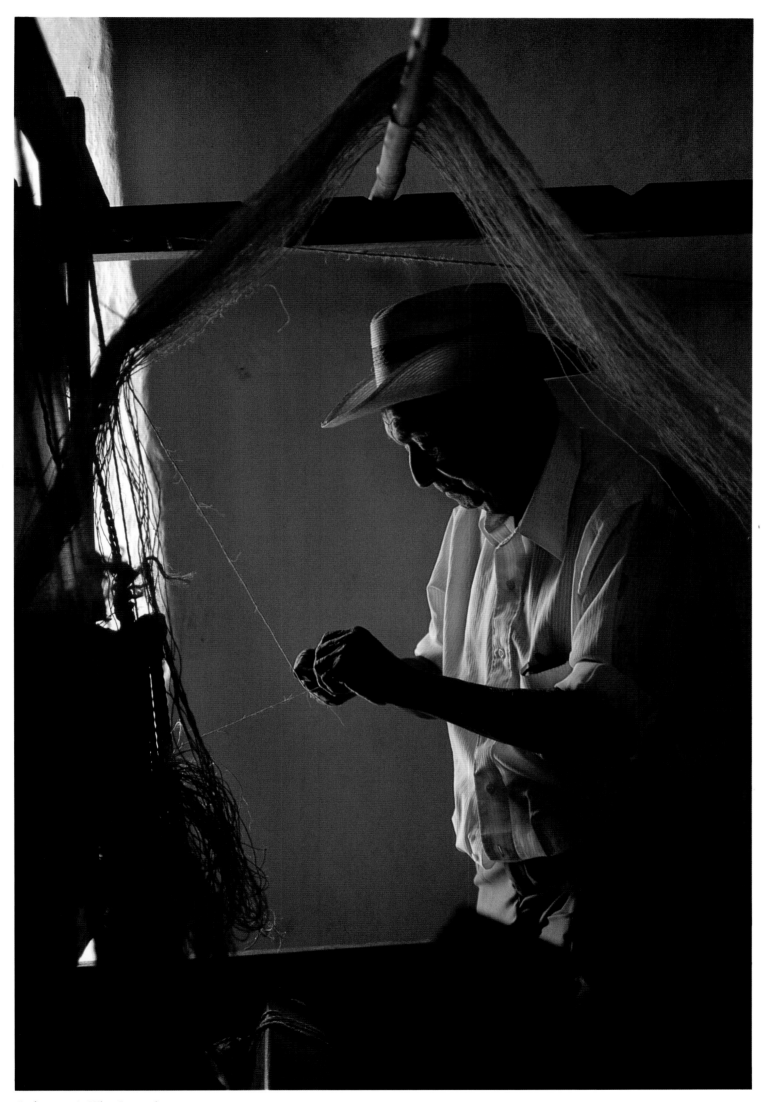

Craft weaver in Vélez, Santander

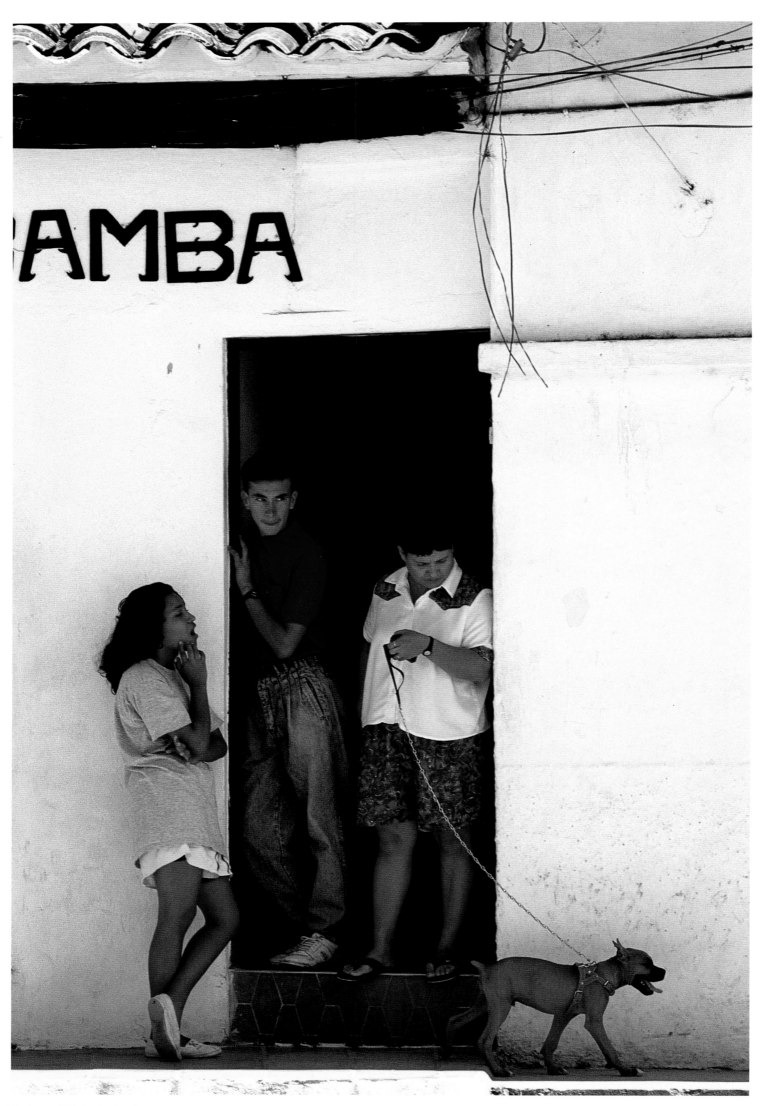

The town of Girón, Santander

Modern Art Museum in Bucaramanga, Santander
Street market in Girón, Santander

San Juan de los Caballeros de Girón is a small colonial town which today has been almost totally absorbed by Bucaramanga's urban and economic growth. This has not stopped it from preserving its slower pace, its physionomy of houses of clay-tiled roofs and white walls, and its fanciful paved streets. However, the capital of Santander has undergone rapid change and modernization, and its population has increased to nearly half a million inhabitants, spread over the narrow plateau of Bucaramanga.

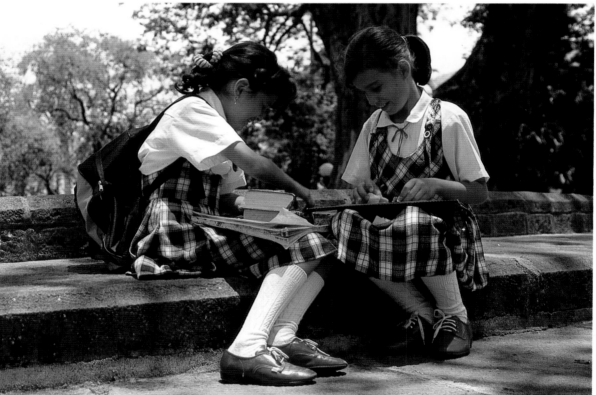

Street in Barichara, Santander
Children doing their homework in the park, San Gil, Santander

The names of the towns of Socorro, San Gil and Barichara are inevitably familiar to children in Colombian history classes. The Revolución de los Comuneros, *the first Latin American popular uprising against the Spanish Crown, began in Socorro, in 1781. Barichara, the birthplace of radical president Aquileo Parra, has been declared a national monument for its magnificent stone architecture. San Gil is famous for El Gallineral, a park with trees covered with gray "old men's beard" moss plants, which, strangely enough, belong to the pineapple family.*

Street in Socorro, Santander

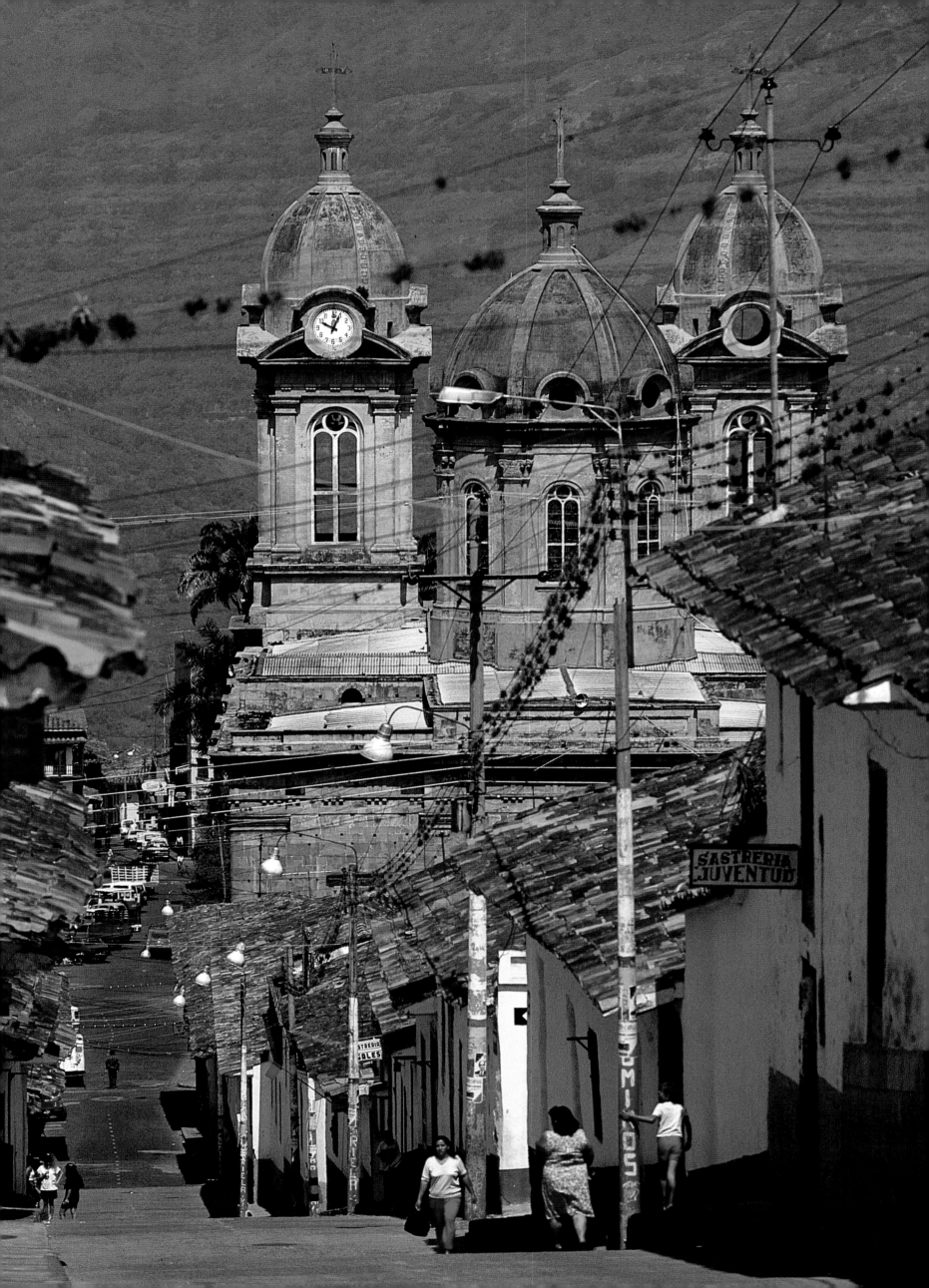

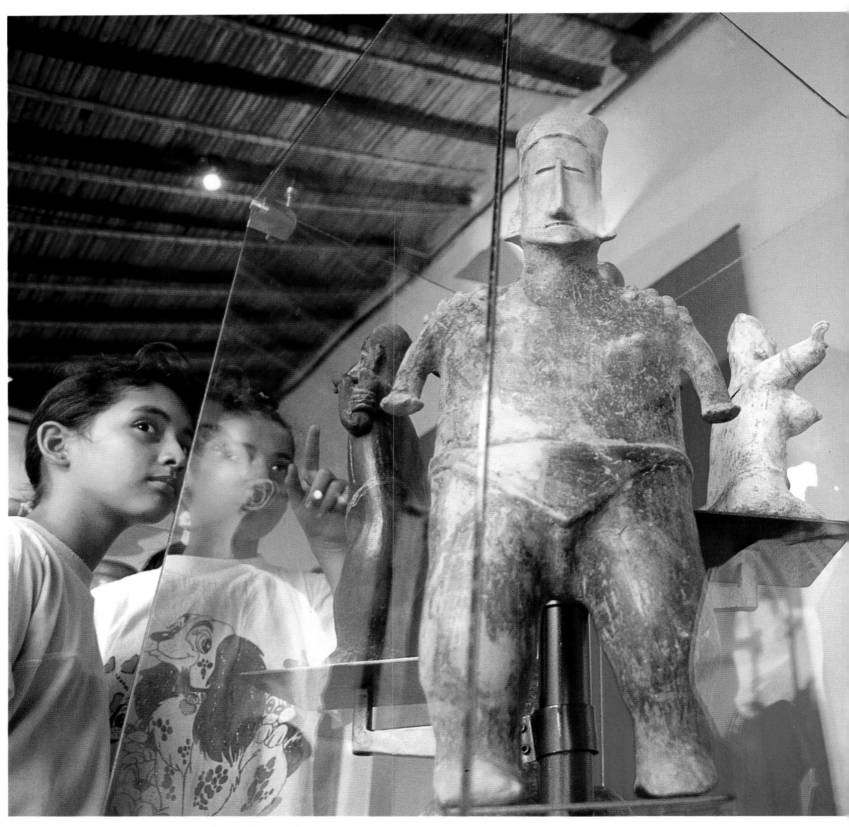

Archeological Museum in Cúcuta, province of Norte de Santander

Cúcuta, the capital of Norte de Santander, is perhaps the only Colombian city founded by a woman, Juana Rangel de Cuéllar (1735). In 1875 it was destroyed by an earthquake. General Francisco de Paula Santander, one of the "Fathers of the Nation", was born in Villa del Rosario de Cúcuta, near Cúcuta.

The classification of Colombia's football team for the 1994 World Football Cup, after obtaining the remarkable triumph over Argentina with a score of five to zero, has given Colombians all over the country a sense of belonging and common purpose.

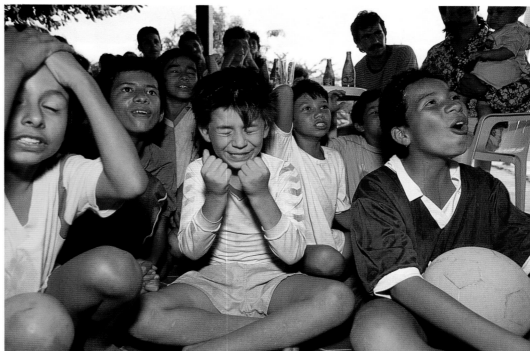

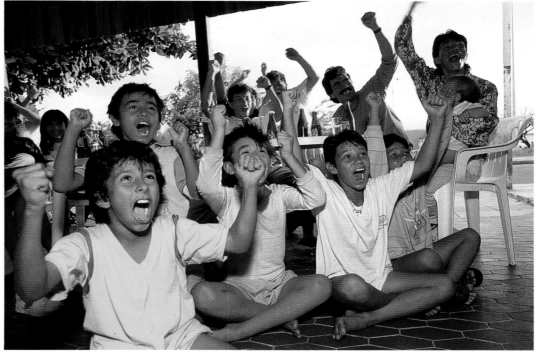

Children watching a television broadcast of a Colombian football team game in Bucaramanga, Santander

Marketplace in Cúcuta, Norte de Santander
Park Photographer in Cúcuta, Norte de Santander

Cúcuta has all the advantages and all the disadvantages of border cities. It is located a few kilometers from Venezuela. Its economy fluctuates constantly because of the volatile bolívar, the Venezuelan currency. When Colombia was still an extremely austere and agricultural country in terms of domestic consumption, the most obvious manifestations of the neighbouring country's oil bonanza reached Cúcuta: illuminated highways, electrical appliances, the latest car models, cemeteries for older ones.

Car cemetery in Cúcuta, Norte de Santander

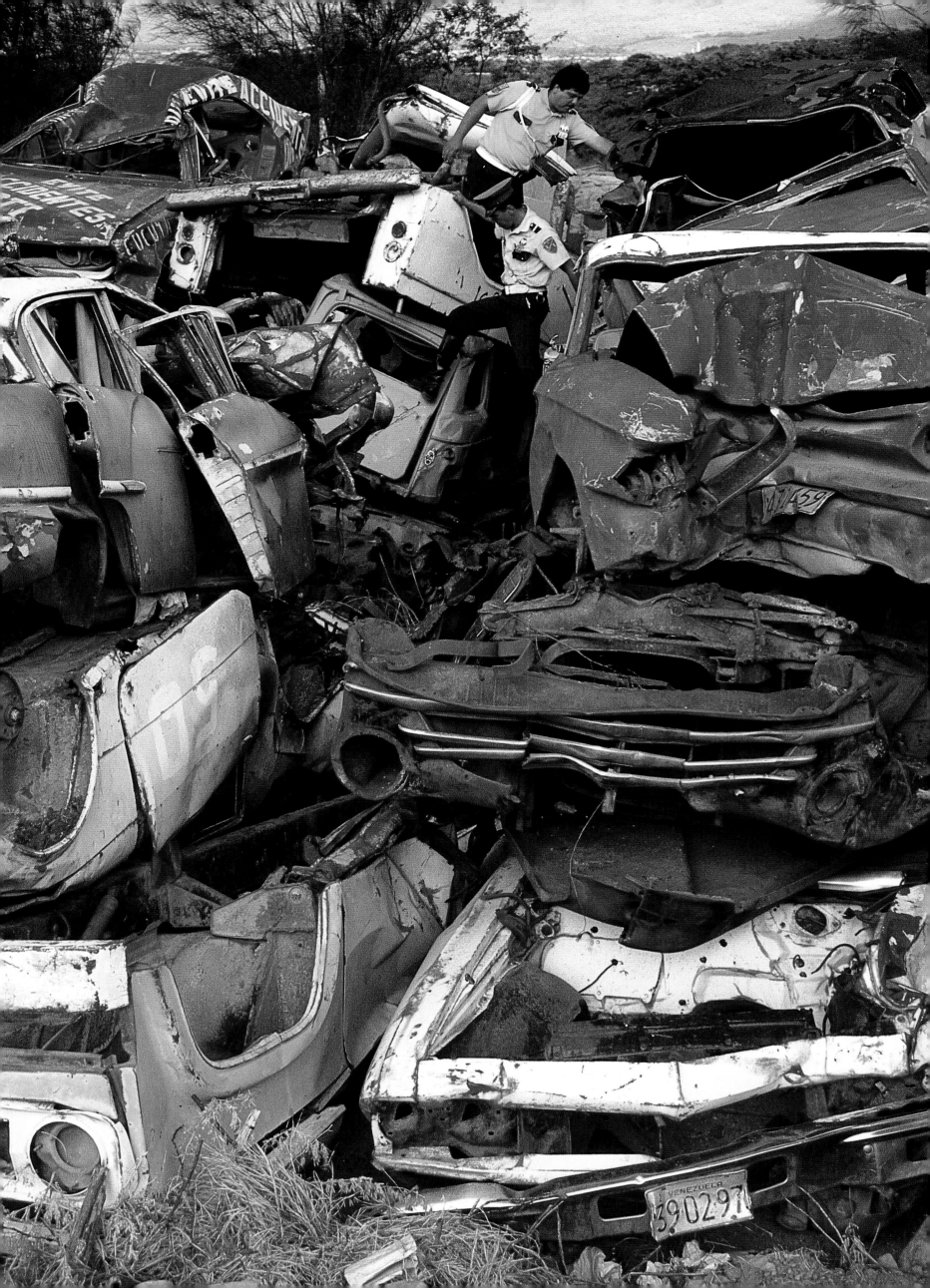

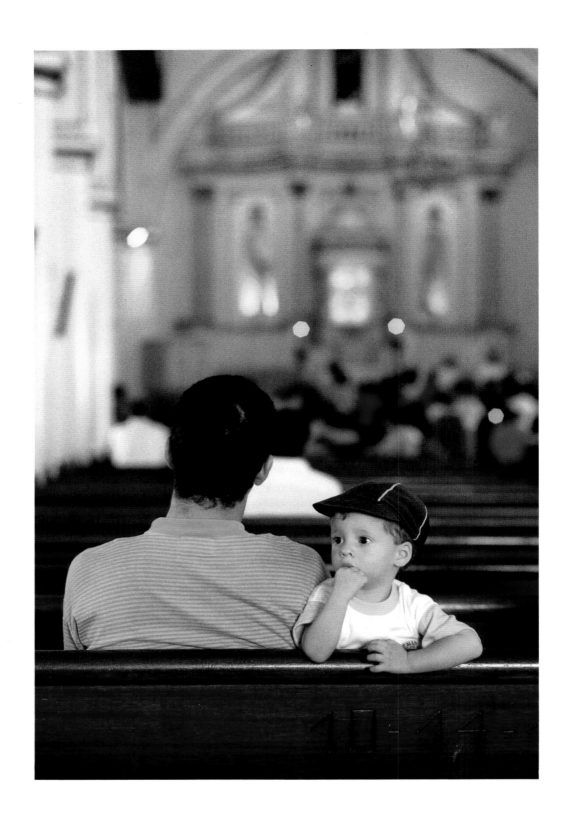

Mass in the cathedral, Bucaramanga, Santander

*"God helps those that help themselves". It is not easy to survive in the difficult –and some-
times totally adverse– conditions that some urban and rural Colombian regions impose
on their inhabitants. Although the secrets of the environment are more or less mastered,
the help of a "Superior Being" is always useful.*

Wayúu Indians in the Park of Uribia, province of La Guajira

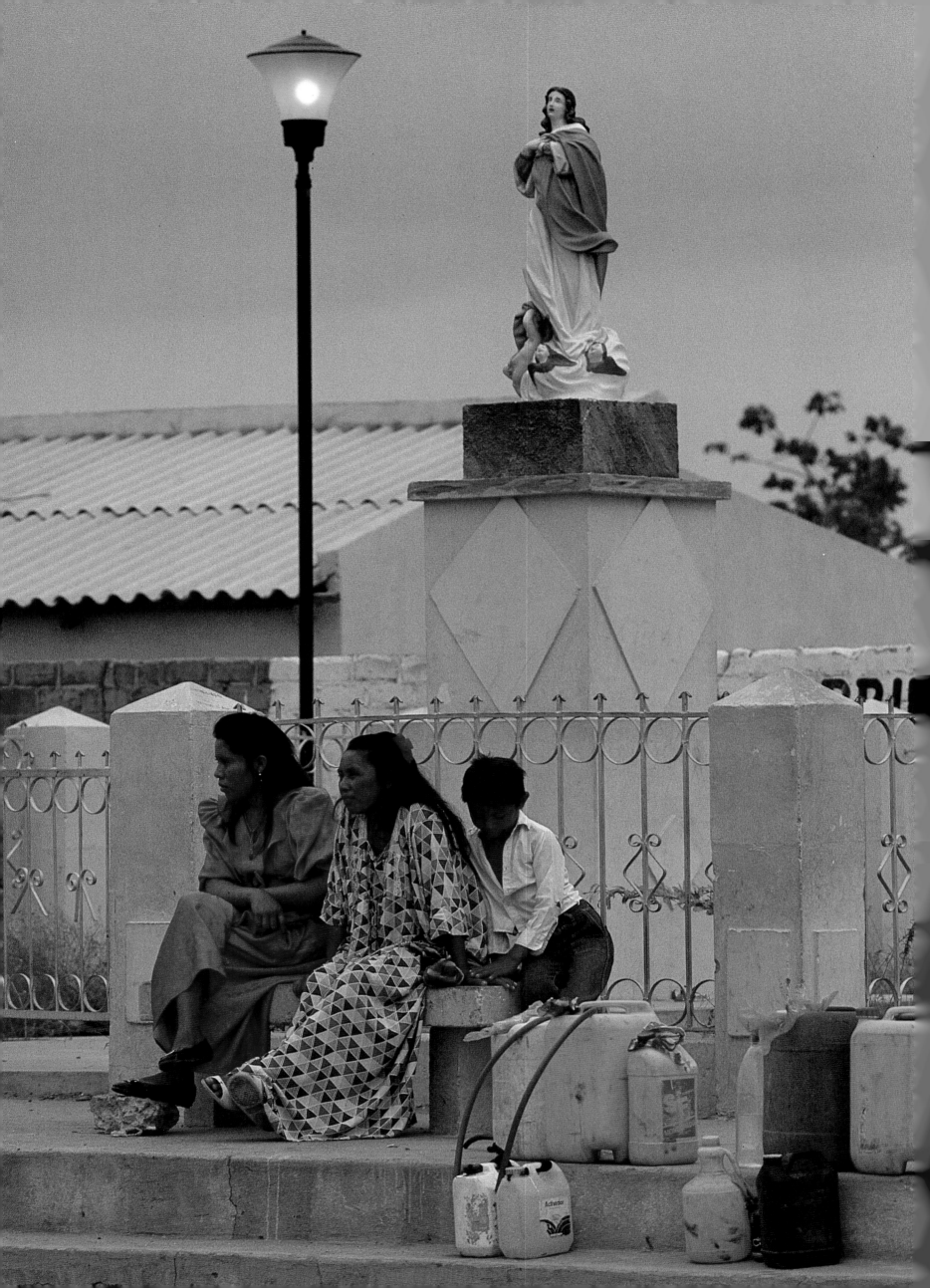

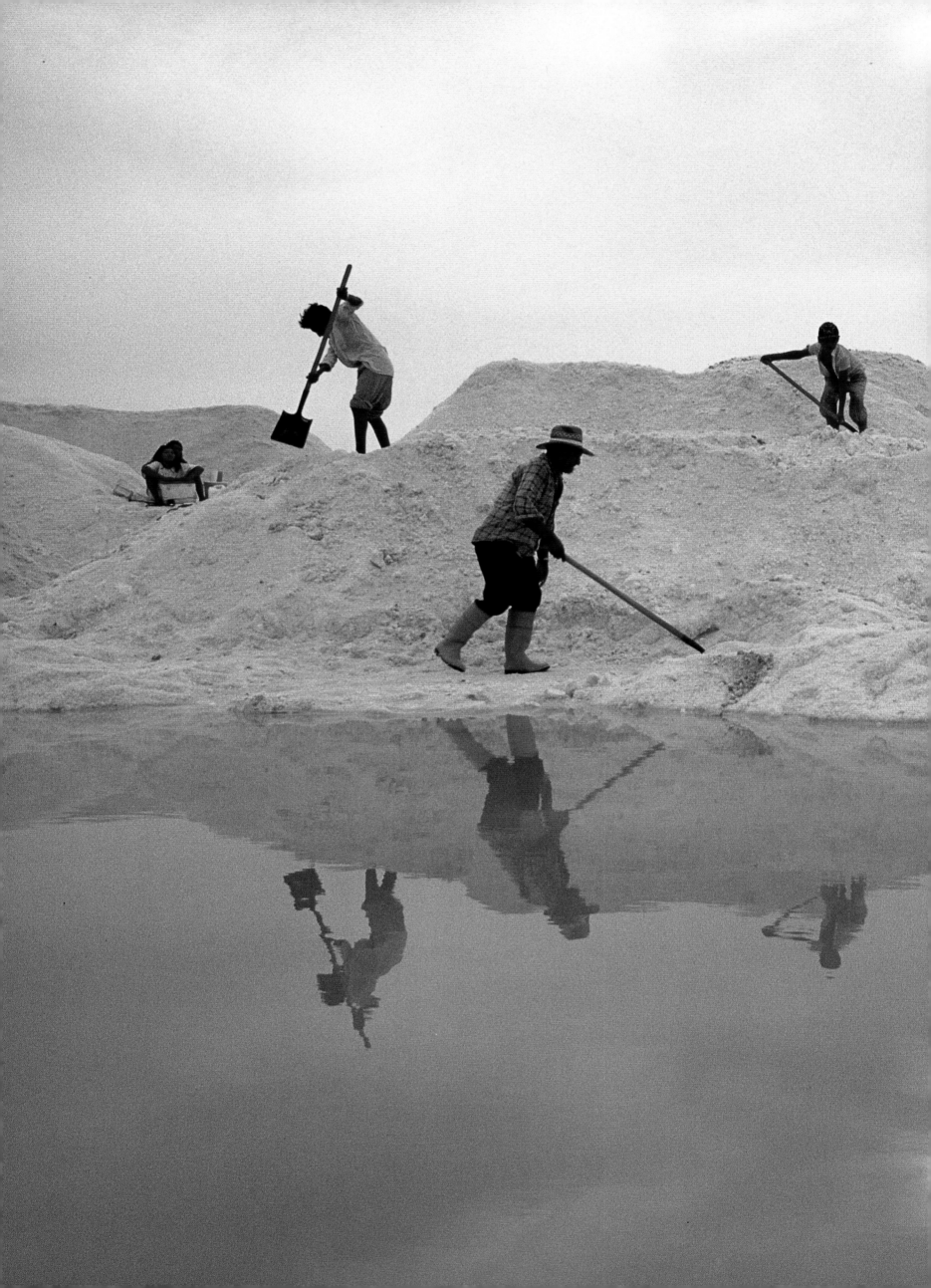

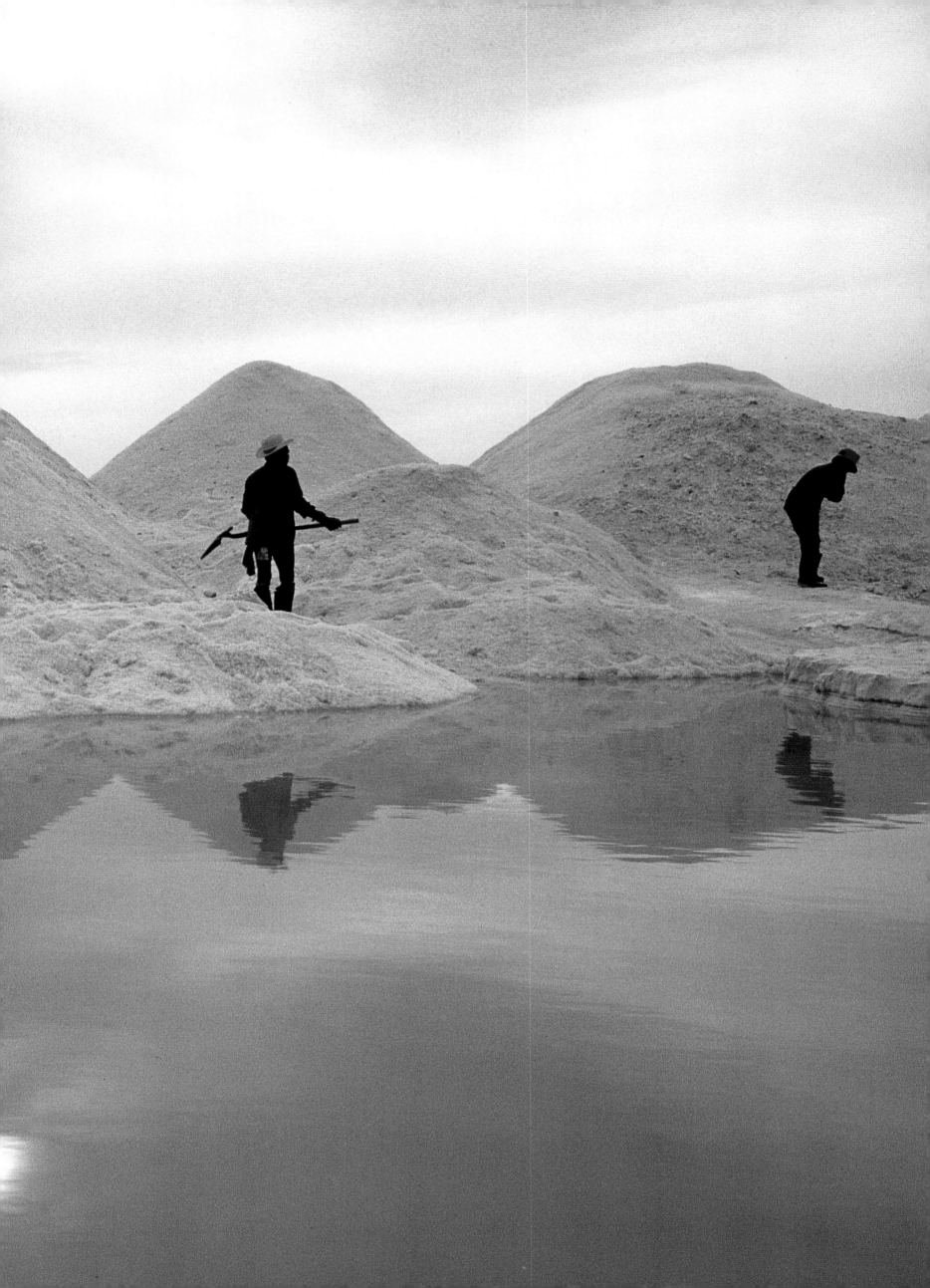

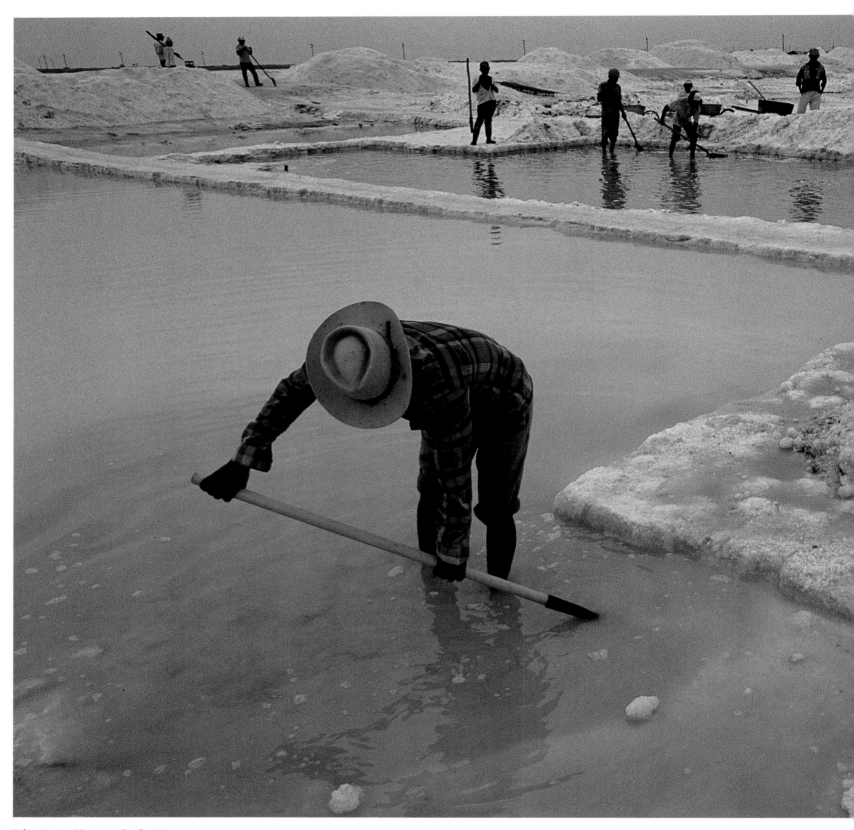

Salt mines in Manaure, La Guajira

Until a few years ago, the economy of the arid peninsula of La Guajira, today rich with natural gas deposits and coal mines, was based on the extraction of sea salt, which continues to be one of the main activities of the Wayúu Indians.

Preceding page, salt mines in Manaure, La Guajira

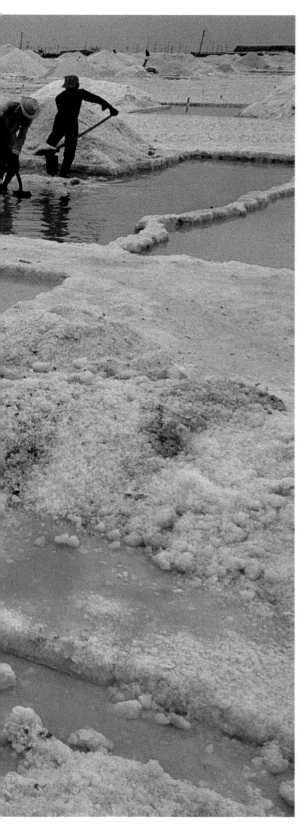

The Wayúu Indians have also been pearl fishermen, goat shepherds and weavers. Some have yielded to the temptation of smuggling, an activity which involves huge quantities of money on the border area, where fresh water continues to be the most expensive and scarce of commodities.

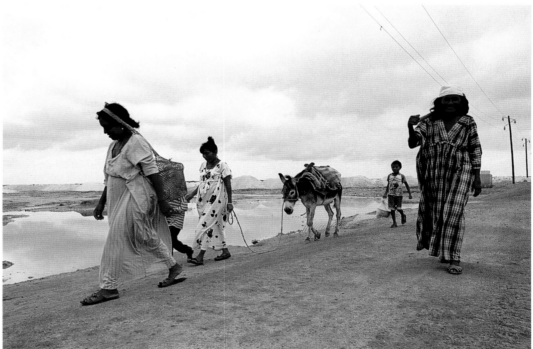

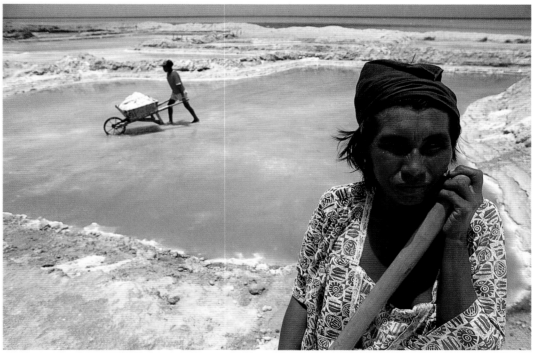

Wayúu Indians, La Guajira

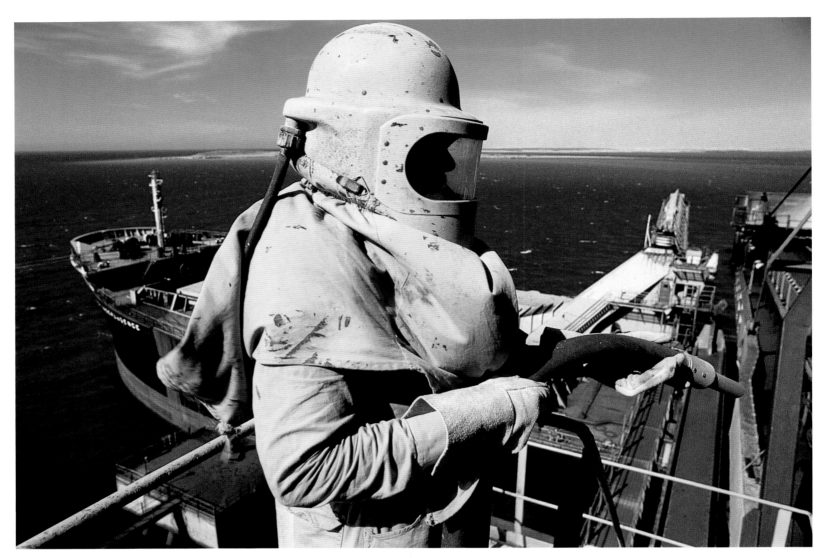

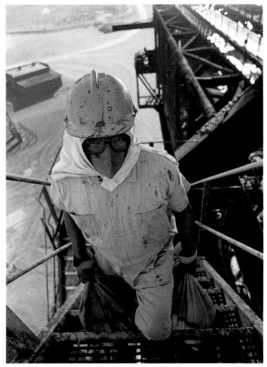

Workers of El Cerrejón and Puerto Bolívar, La Guajira

The biggest open-cast coal mines in the world are in El Cerrejón, on the peninsula of La Guajira. More than 60 per cent of the coal produced in Colombia is extracted here. Exports are shipped out of Puerto Bolívar, in Portete Bay, the infrastructure of which can handle ships of more than 150 thousand tons.

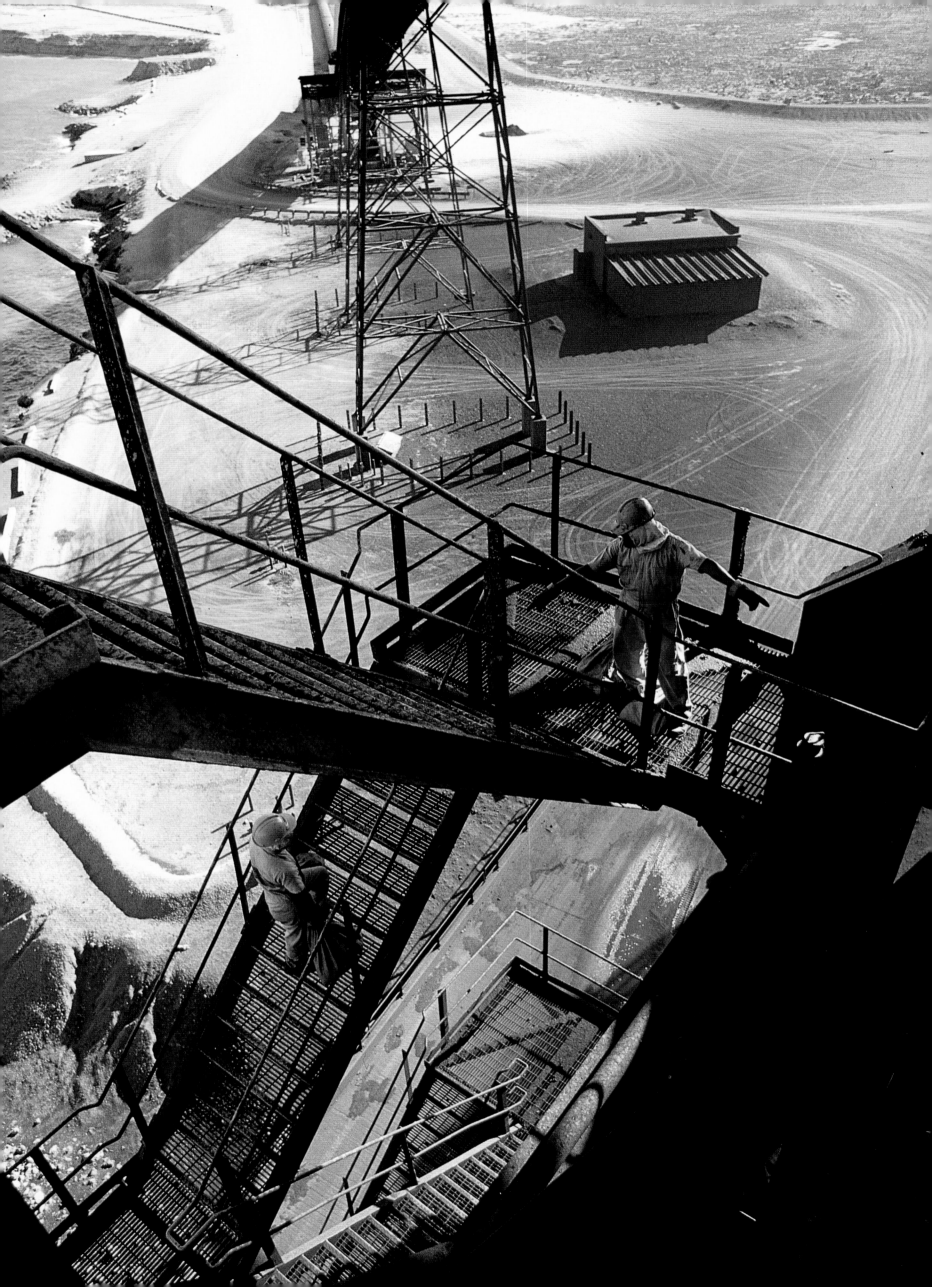

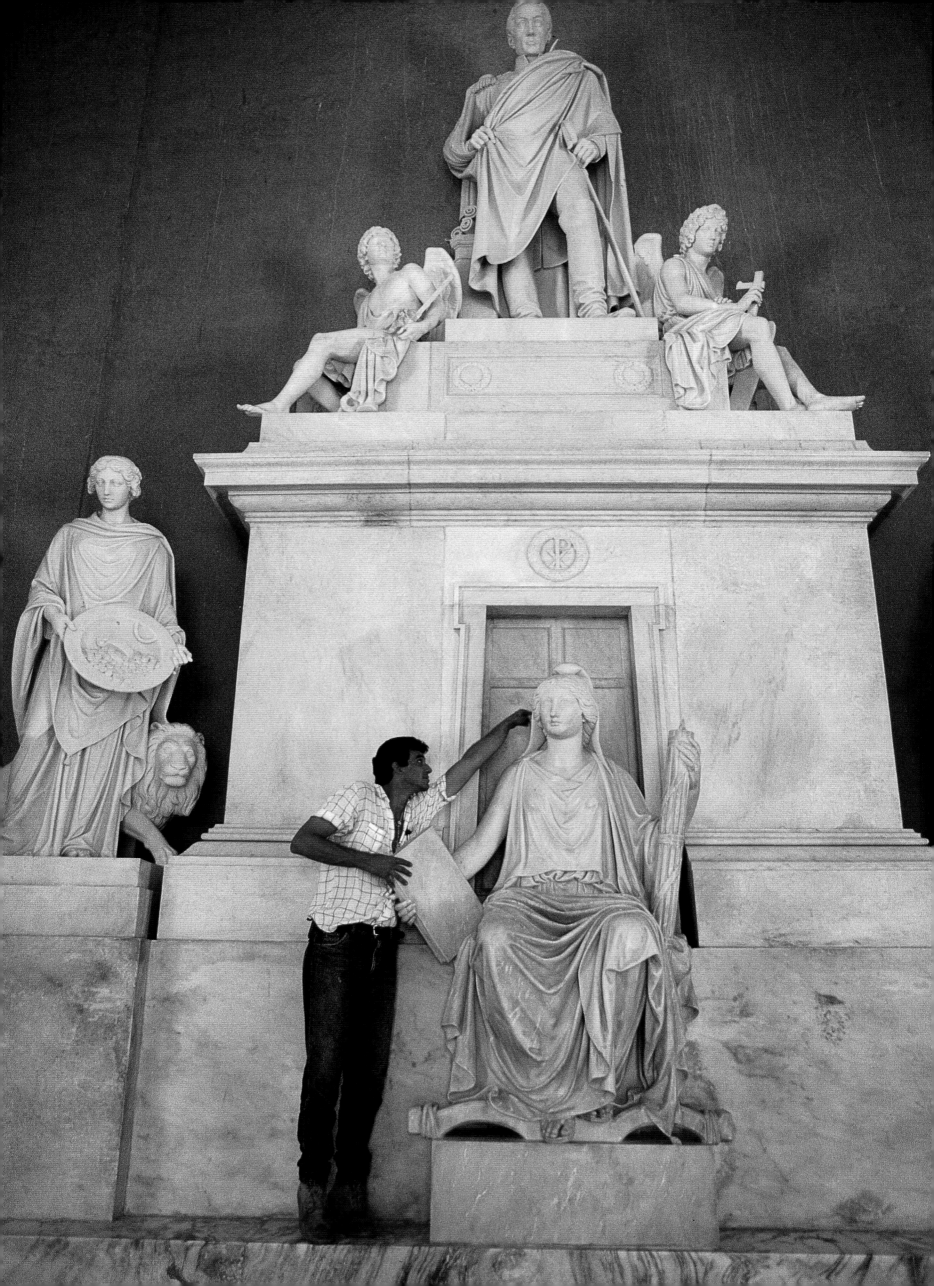

Workers on banana plantations in Ciénaga, Magdalena
Swimmers in Puerto Colombia near Barranquilla, Atlántico

"Florida de San Pedro Alejandrino, three and a half miles from Santa Marta, at the foot of the Sierra Nevada, is a sugarcane plantation with a mill to make panela *(brown sugar loaves)". This is the way García Márquez, in his book* El General en su Laberinto, *described the property of Spaniard Joaquín de Mier, where* Libertador *Simón Bolívar went to die in 1830. For many years, the economy of the Caribbean region near Santa Marta and Ciénaga depended on the banana production, which was in the hands of multinational companies.*

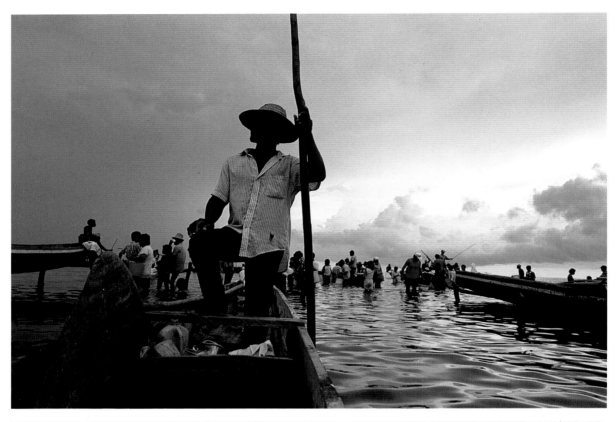

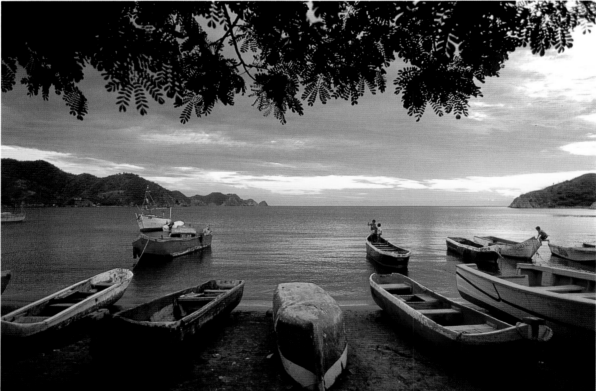

Floating market in Ciénaga Grande, Magdalena

Taganga bay near Santa Marta, Magdalena

Many of the communities which live in the Caribbean region are amphibian, or aquatic to a certain degree. In the Ciénaga Grande de Santa Marta, a 600 square-kilometer "water mirror" at the foot of the Sierra Nevada, there are several palafitte towns, in other words, built on piles over water. Taganga bay, populated by fishermen, is one of many strewing the profile of our Atlantic littoral, which would only be 1,600 kilometers long if it were uninterrupted.

Young fishermen in Taganga, Magdalena

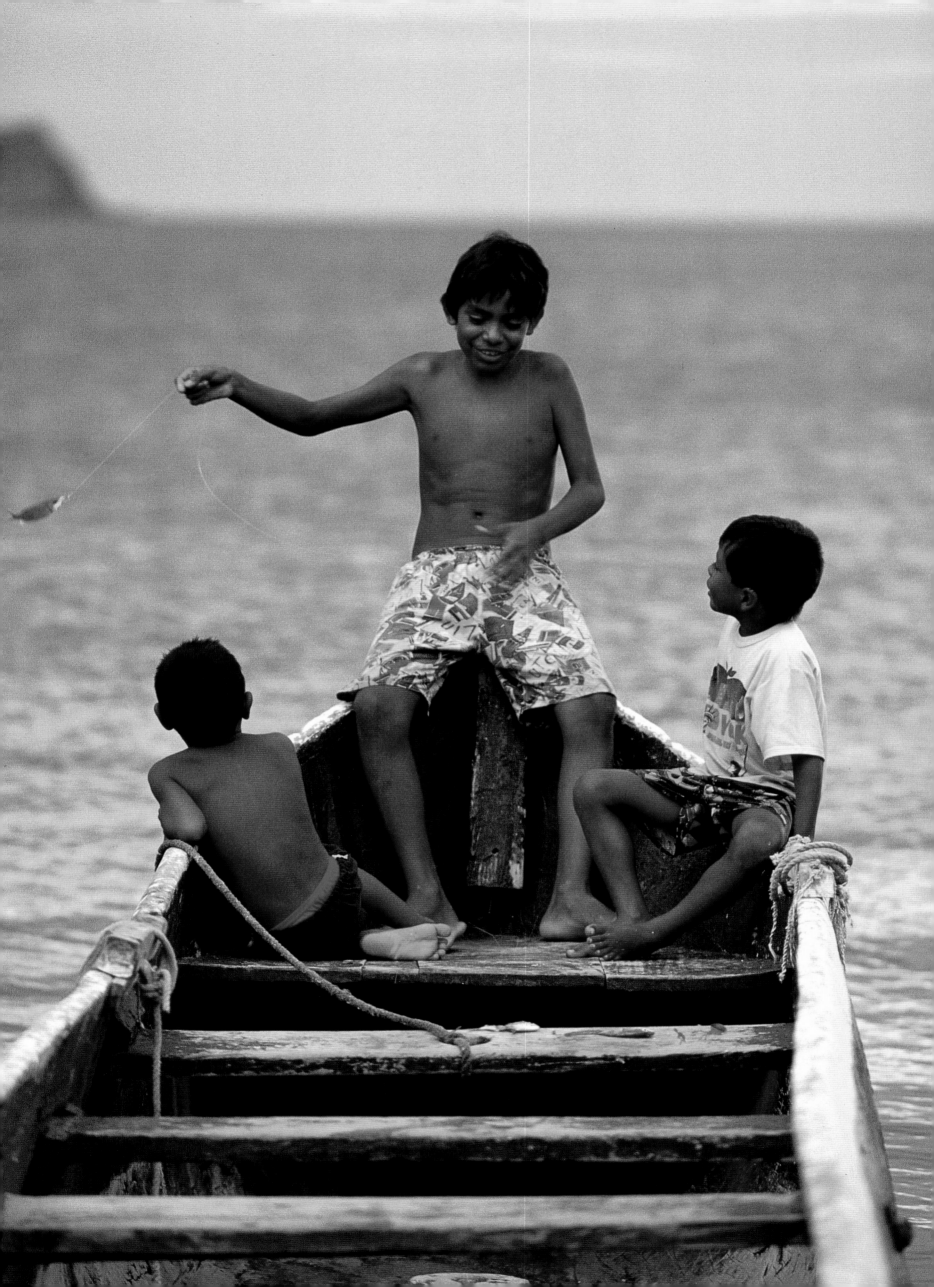

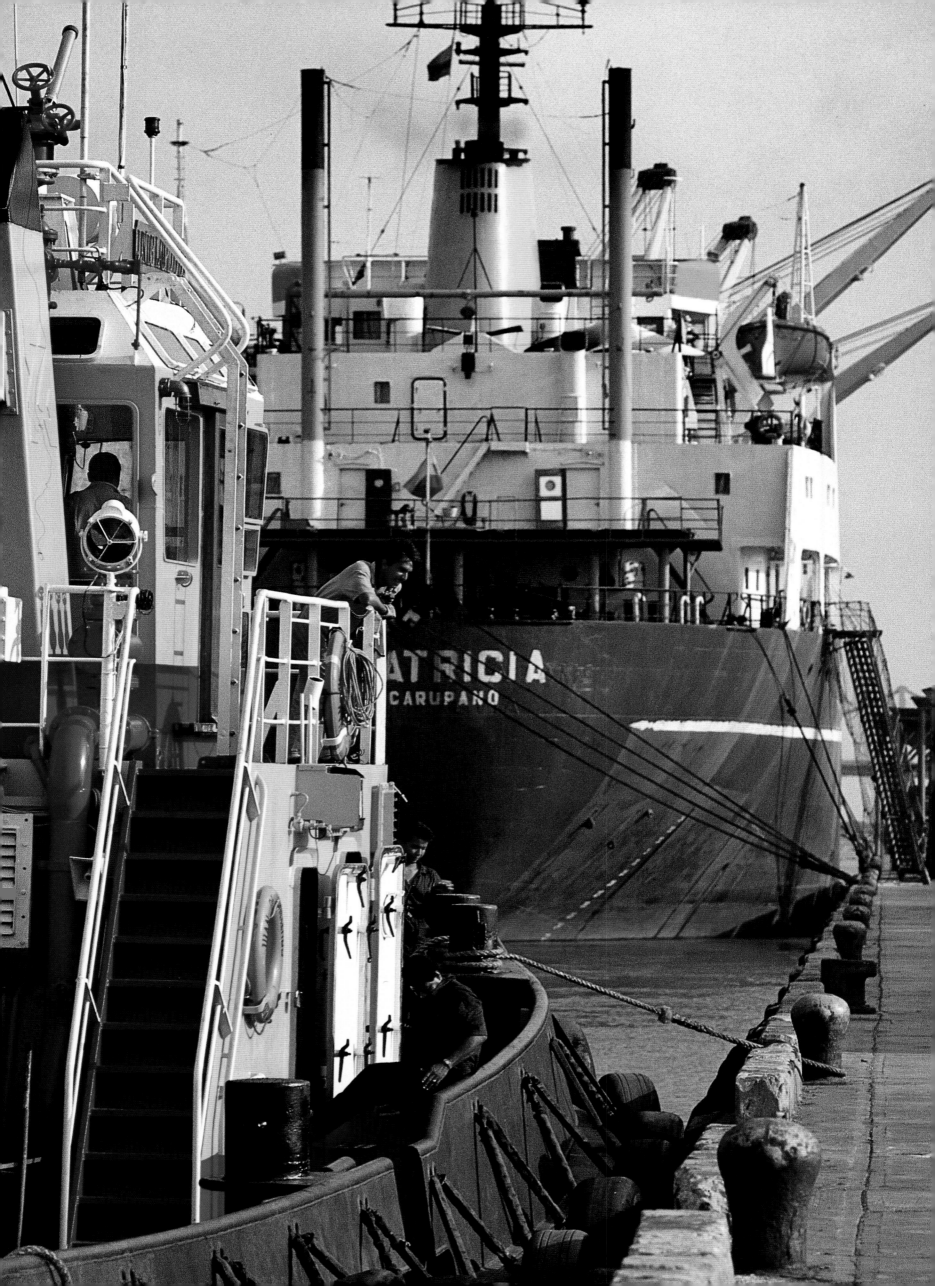

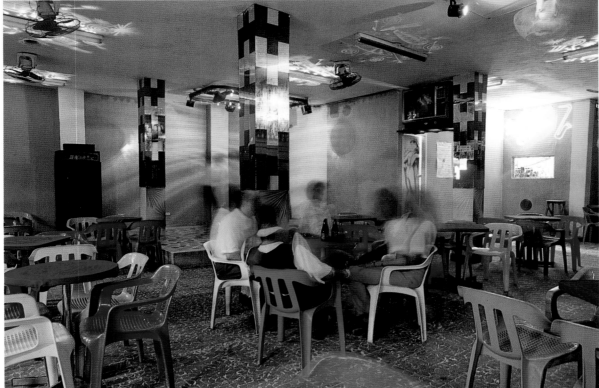

Ipacaraí discotheque in Barranquilla, Atlántico

The construction of Colombia's main maritime and fluvial port transformed Barranquilla into one of the biggest and most important cities of the country, and undoubtedly, the economic and cultural capital of the Atlantic coast with more than one million people. It is located at the mouth of the Magdalena river in Bocas de Ceniza. This industrial city par excellence was at the beginning of the present century a village of small traders and fishermen. Today, it is a cosmopolitan and boisterous city.

Ships moored at the pier in Barranquilla harbour on the Magdalena river, Atlántico

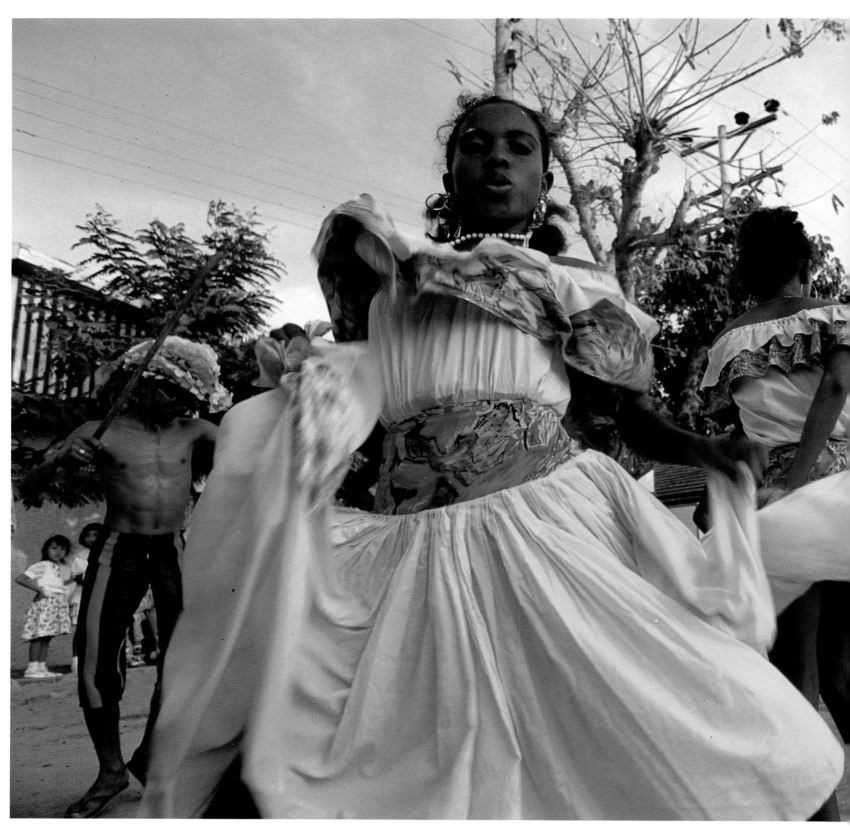

"Dancing in the streets" during Barranquilla Carnival in Santo Tomás, Atlántico

With the risk of classifying Cachacos *(inhabitants of the Andean mountains) as solemn, it can be said that* Costeños *(inhabitants of the coast) are the people who most love dancing in Colombia. To a certain extent, the Carnival of Barranquilla, which is celebrated in February each year, compares with Rio de Janeiro's. There is no doubt about the remote African origin of the carnivals celebrated in Barranquilla and on the Atlantic coast in general. The* congo *and* paloteo *dances by costumed groups under the strict supervision of a "captain" are reminiscences of African tribal war dances.*

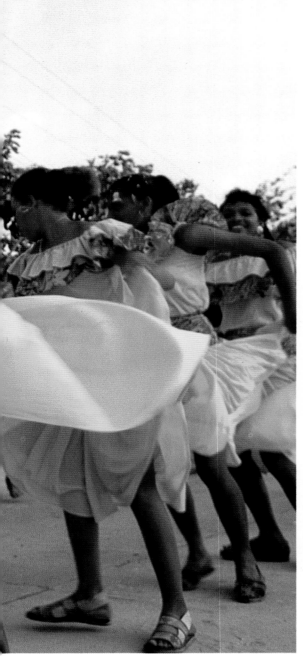

Folklorists affirm that the word cumbia *comes from the Antilles, meaning dance, party, outrageous frolics. They also say that originally it was only music and dance, and not song. On the contrary,* vallenatos *(traditional songs of Valledupar) began as a manner of spreading news sung to the rhythm of a drum and* guacharaca.

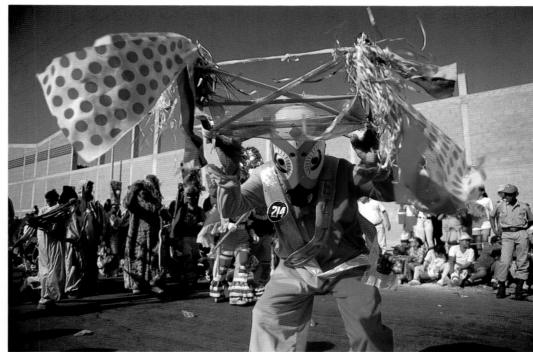

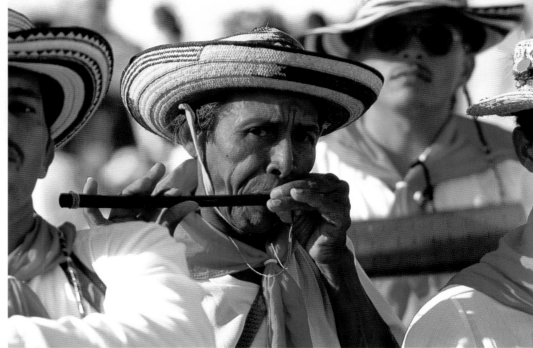

Street scenes of the Carnival of Barranquilla, Atlántico

75

Fountain in the park of Sincelejo, province of Sucre

"Three are company", Santo Tomás near Barranquilla, Atlántico

The Atlantic coast, a territory of 132,000 square kilometers and seven provinces, is "a totally different Colombia". Its inhabitants –the Costeños– *obey to vital rhythms, to different priorities from those of people living in the Andes. They speak, think and dance differently, although their music, cumbias and* vallenatos, *has completely invaded the mountain region. The coast has cities full of history, such as Santa Marta and Cartagena, which coexist with relatively new ones like Barranquilla.*

Coachman and coach near the city walls of Cartagena, province of Bolívar

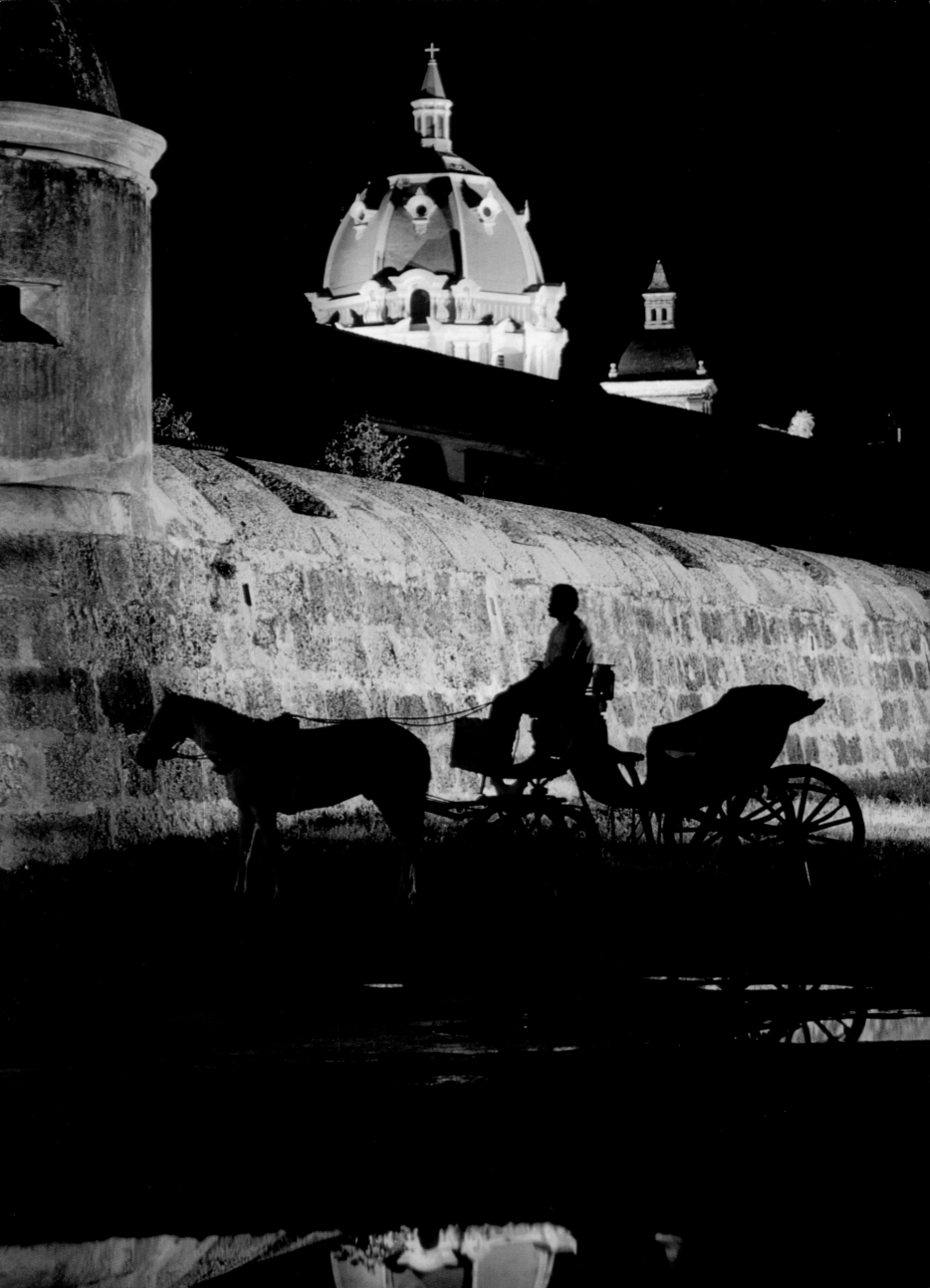

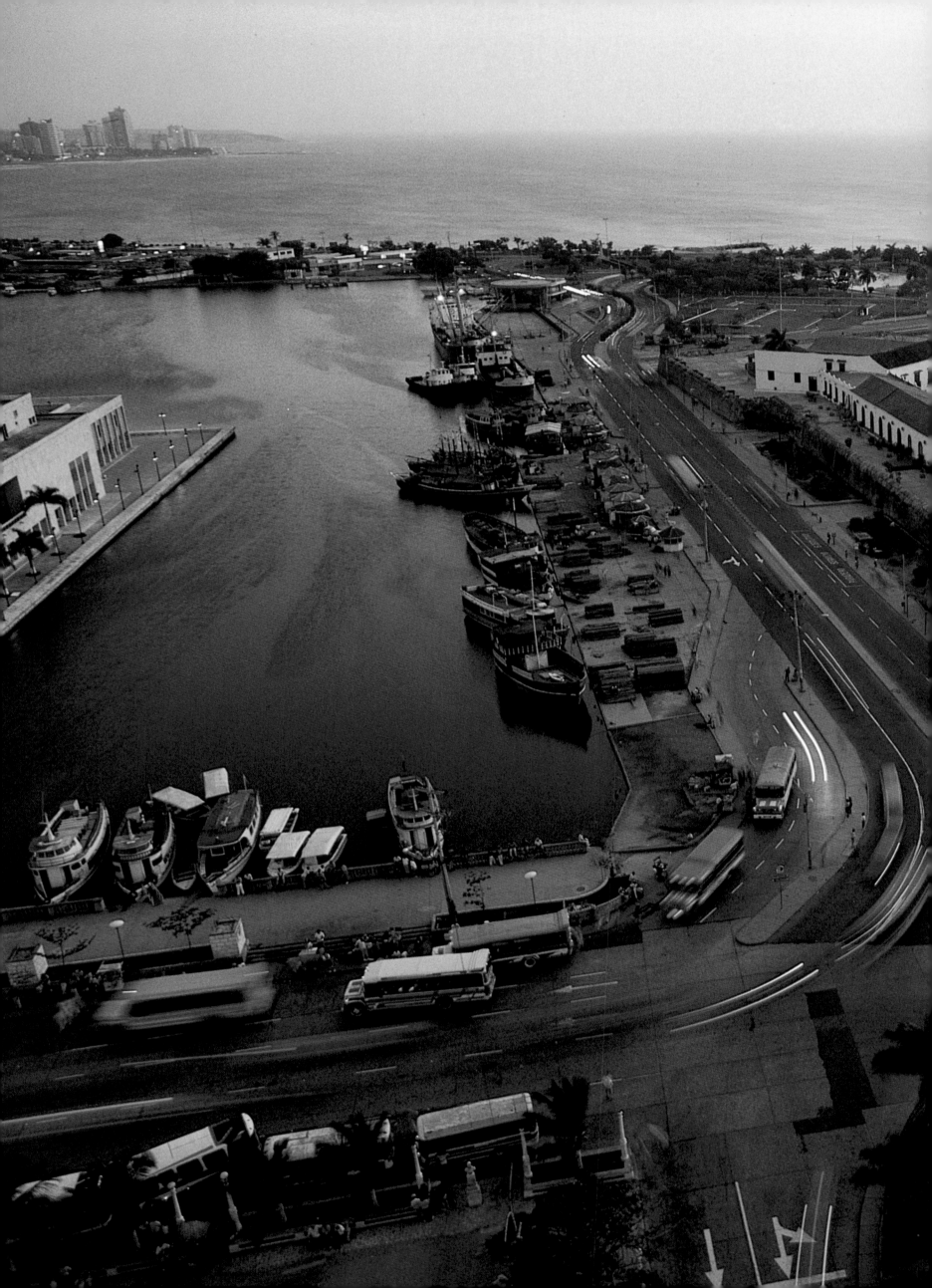

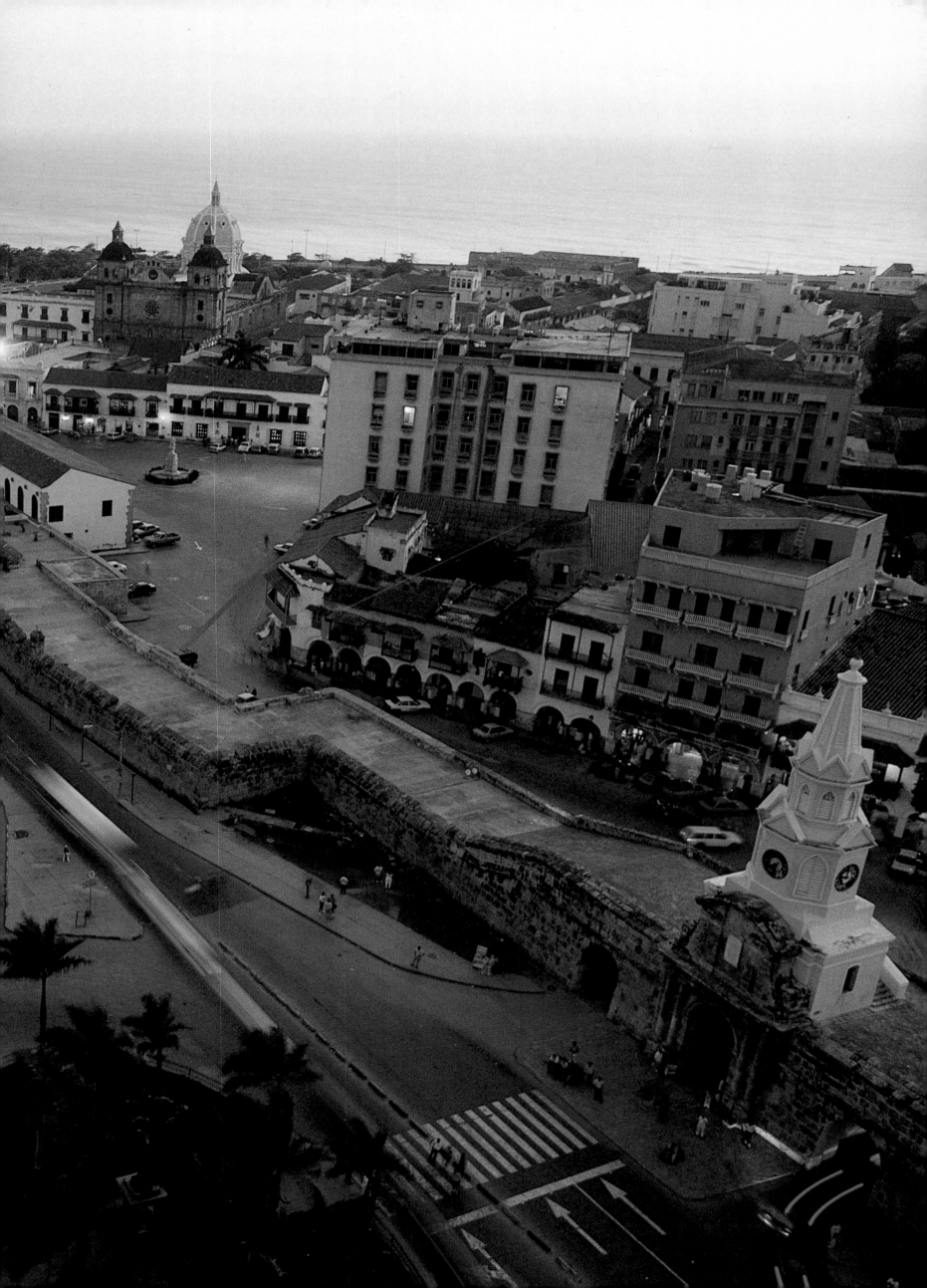

Parque Bolívar in Cartagena, Bolívar
Castle of San Felipe in Cartagena, Bolívar

Foreigners have not always come as tourists to Cartagena, founded in 1533 by conquistador Pedro de Heredia. In the second half of the XVI century, it was frequently attacked and ransacked by English and French pirates and buccaneers, which forced the Spaniards to surround it with mighty walls in the following century. Later on, such fortifications served to defend the "patriots" from the siege they were subjected to by Spanish "pacifier" Pablo Morillo.

Preceding page, Puerta del Reloj and fortified enclosure in Cartagena, Bolívar

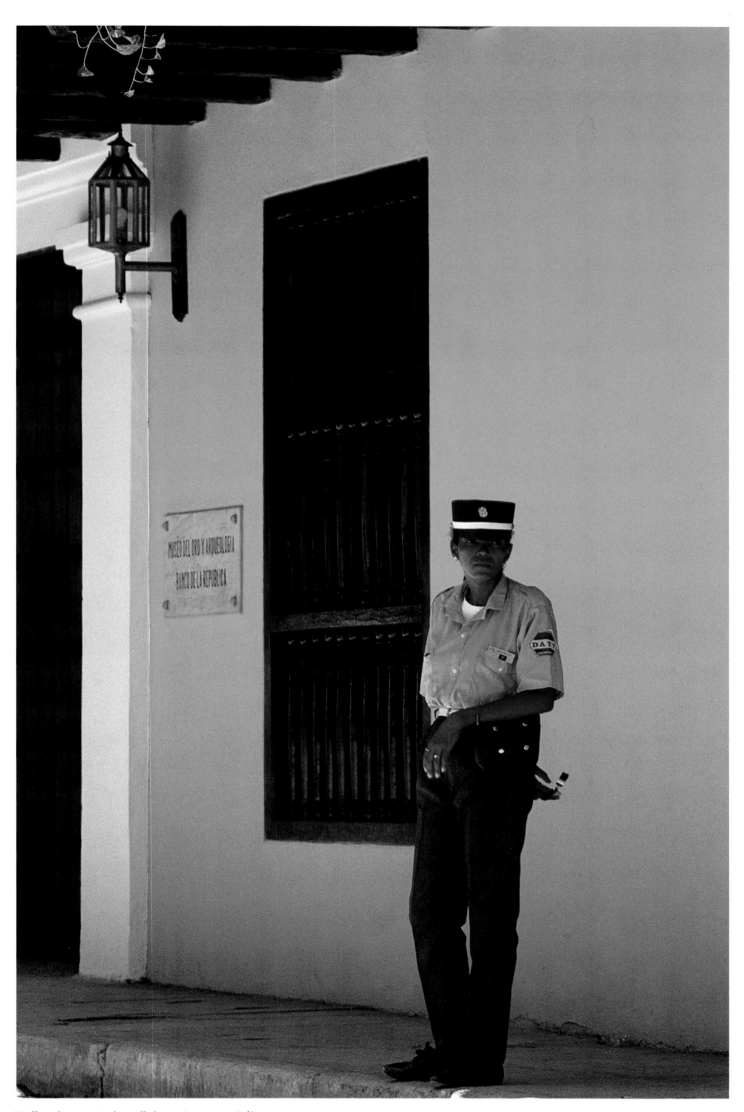

Traffic policeman in the walled city, Cartagena, Bolívar

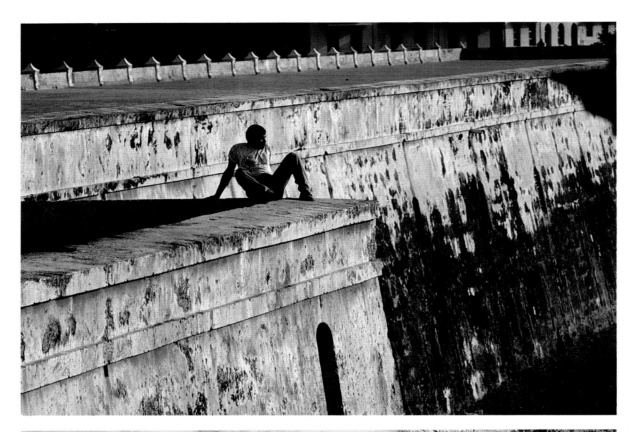

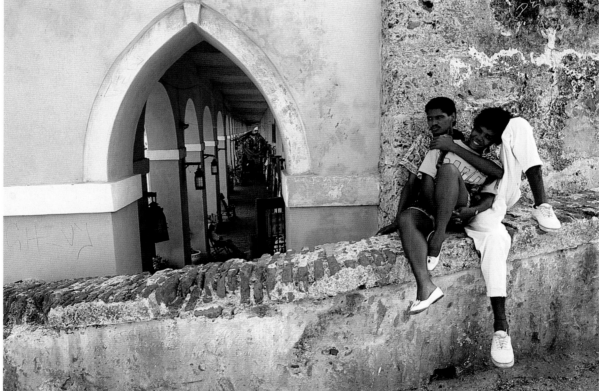

Resting on the city walls in front of the arches, in Cartagena, Bolívar

"One or two days after the attack against San Lázaro (San Felipe), the admiral requested that sixteen cannons be mounted on one of the Spanish warships we had captured, to be manned by detachments of our own vessels in order to bombard the city. In this manner, it was towed to the inner harbour during the night, and moored half a mile from the city walls. It began firing at the enemy at dawn and continued doing so for six hours, against at least thirty cannons, which finally obliged our men to set the ship on fire and to abandon it as best they could in lifeboats".
(Chronicle on Vernon's Attack of Cartagena, *Tobias Smollet*).

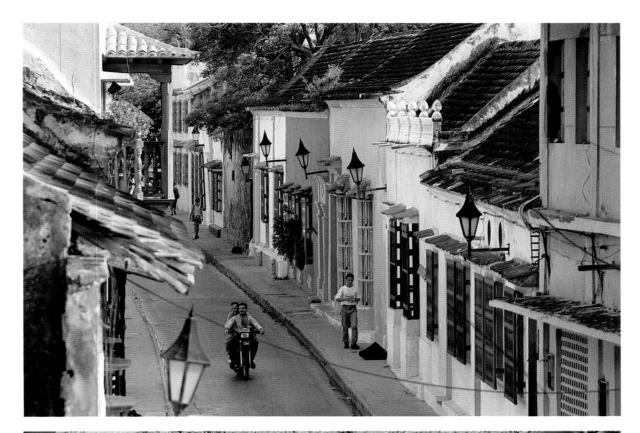

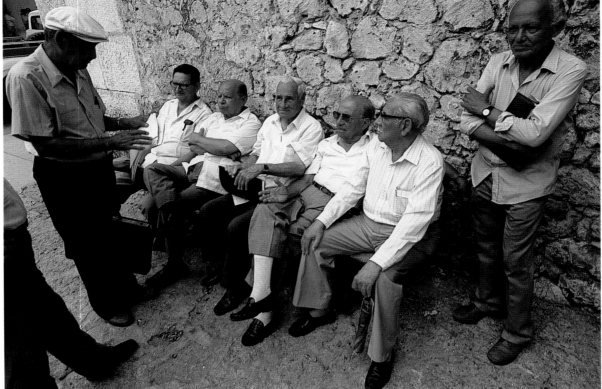

After Sunday mass, Cartagena, Bolívar

"Noble hide-away of my grandparents: nothing / like remembering, crossing narrow streets, / the times of the cross and the sword / of the dark oil lamp and straw matches... / Well, it is over, walled city / your age of romantic stories... The caravels / have vanished forever from your bay... / oil no longer comes in earthens! / you were heroic in colonial times, / when your children, proud eagles, / were not a flock of swallows. / But today full of aged disarray, / you ably inspire that warm fondness / held for one's old shoes". (A mi Ciudad Nativa, *Luis Carlos López*)

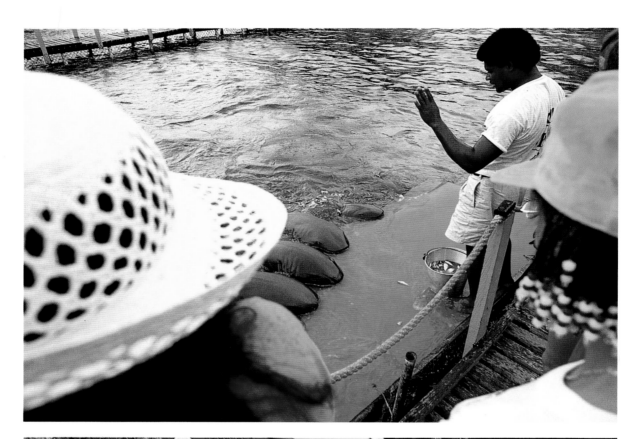

Feeding sharks in the aquarium , Rosario Islands

Engine trouble, near Monteria, province of Córdoba

It is possible to travel along the Atlantic coast as if through a textbook: the Rosario Islands, near Barú and Cartagena, are an archipelago of coralline formations surrounded by translucent waters and mangrove trees. The Sierra Nevada, the highest coastal mountain range on earth and the Ciénaga Grande, the most extensive "water mirror" in America are close to Santa Marta. Barranquilla is reached by going over the Pumarejo bridge, the largest in Colombia, after passing by Salamanca Island, a sanctuary of migratory and native birds. Macondo is also nearby, through a road which crosses the banana plantations.

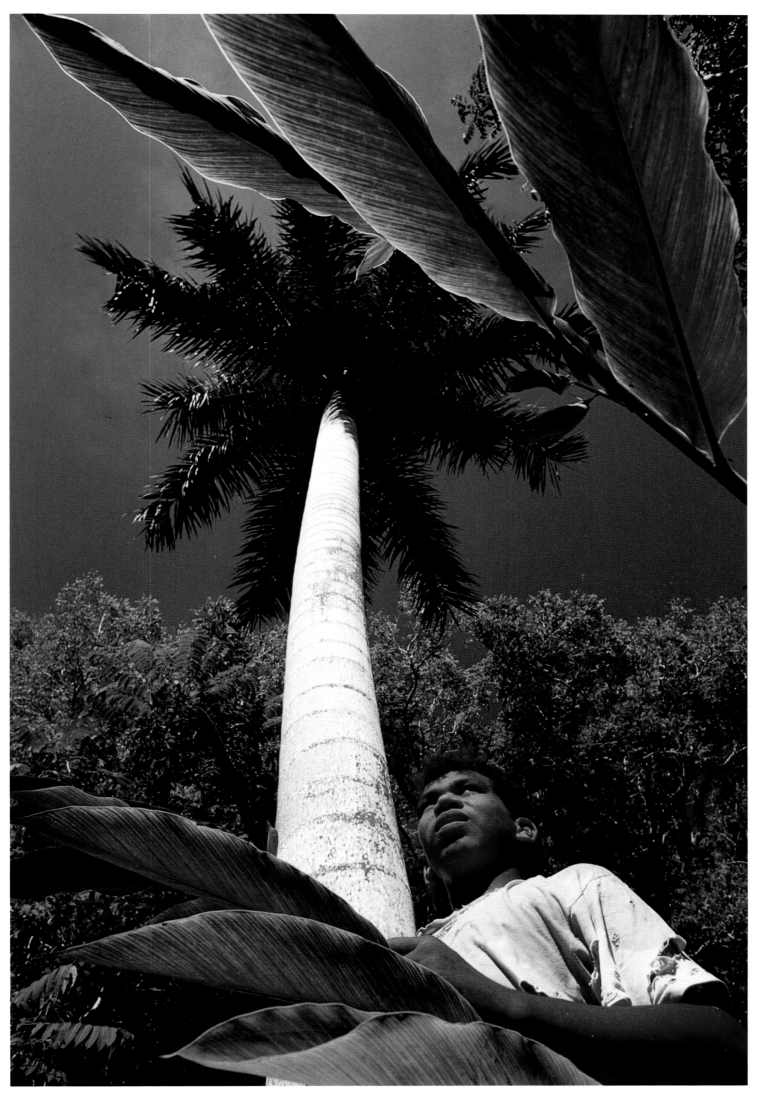

Guillermo Piñeres Botanical Garden in Turbaco, near Cartagena, Bolívar

Following page, Stillwater Bay on Providencia Island

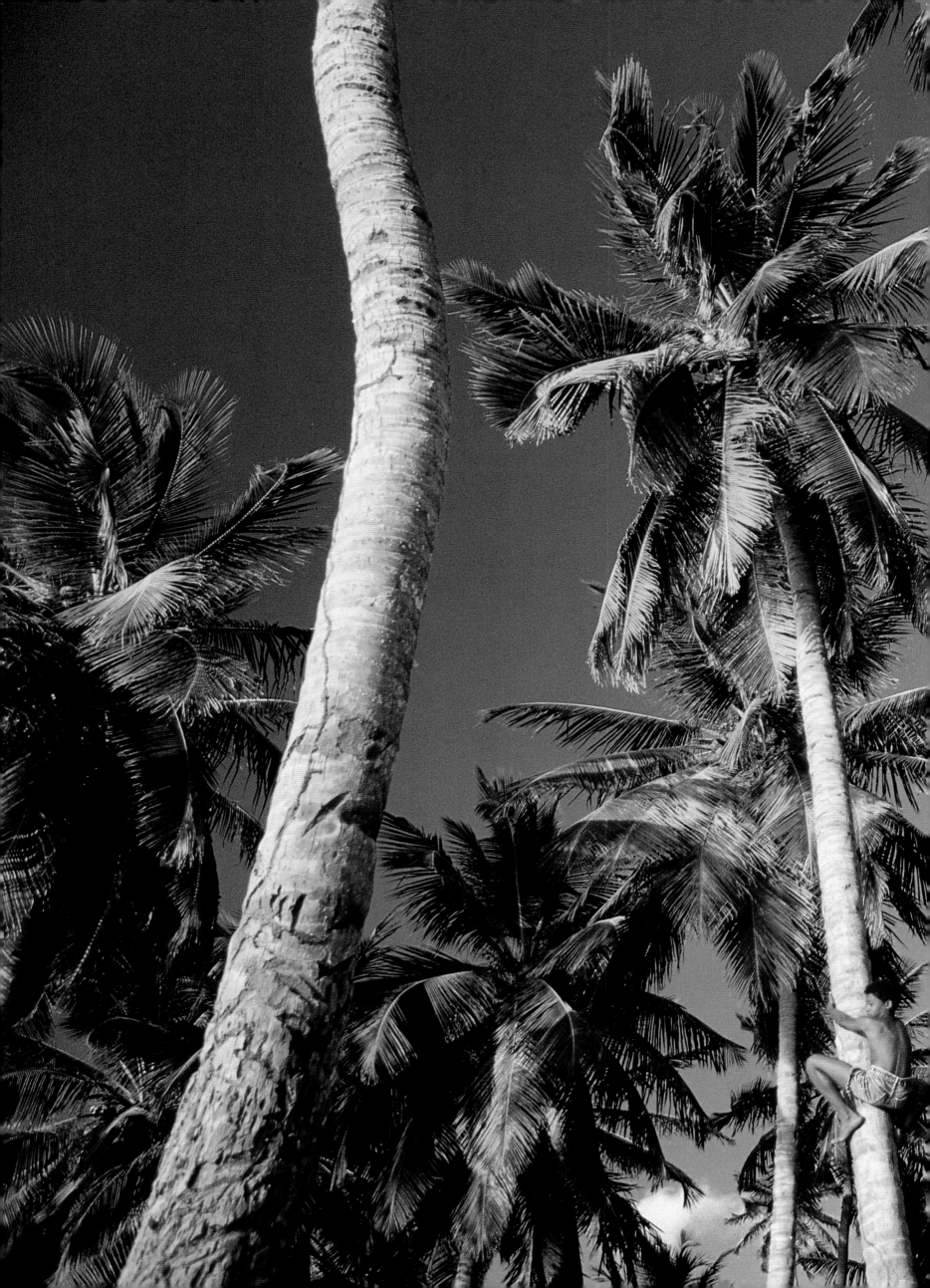

The San Andrés and Providencia archipelago is the only part of Colombian territory where English is the native language. This is because the islands were first colonized by English immigrants, Cromwell partisans who fled from the rule of Charles the First.

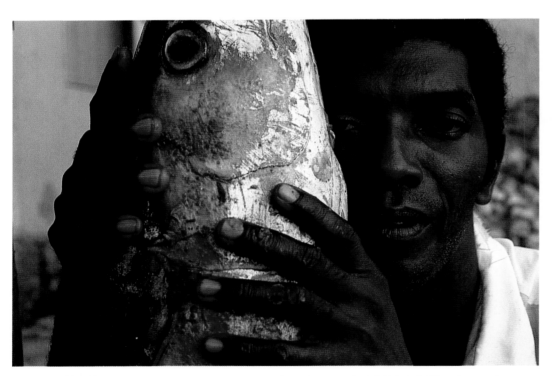

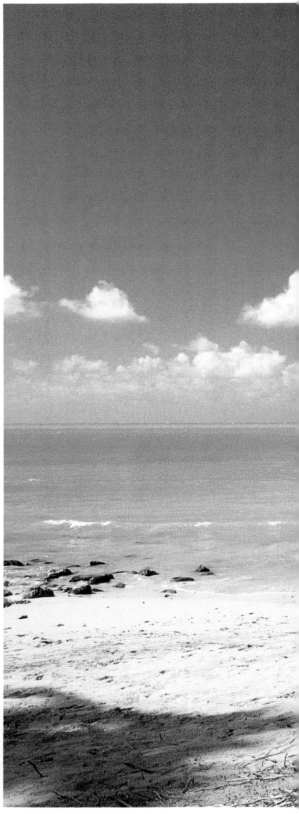

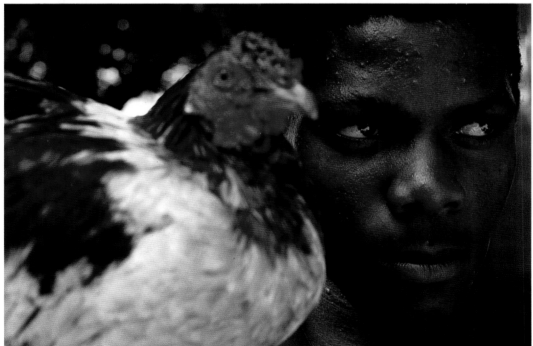

Fisherman from Fisherman's Bay, San Andrés Island
Fighting cock breeder, Providencia Island

Beaches on Providencia Island

The "development pattern" of San Andrés and Providencia is very different: in the first case, the main criterion was that of "industrial" tourism with many casinos, commercial establishments and gaudy high-rise hotels; in the second case, the rule was what today is known as "ecotourism": the visitor dwells in cabins built with materials and techniques used by the native population, and the purpose is to preserve nature.

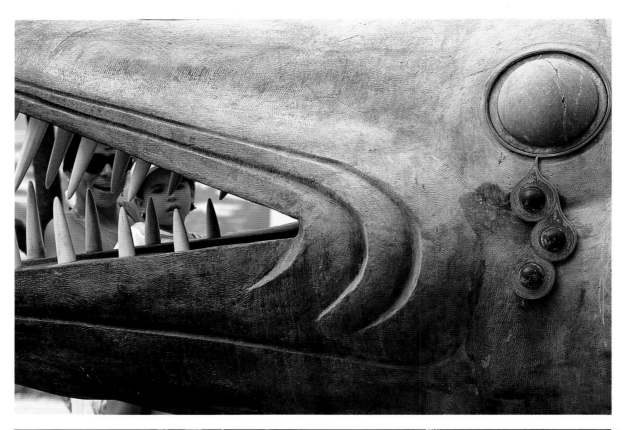

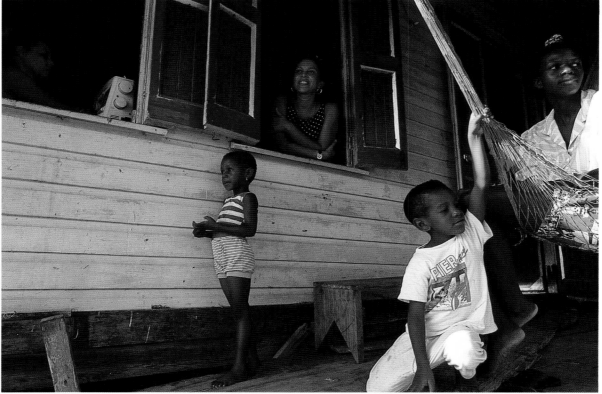

Sculpture of a barracuda on San Andrés Island

Family relaxing in front of a house on Providencia Island

The 1991 National Constitution not only converted the San Andrés and Providencia archipelago into a province, but established the possibility of "limiting circulation and residence rights, creating population density control, regulating the use of soil, and subjecting property transferral to special conditions, all of this in order to protect the cultural identity of the native communities and to preserve the environment and natural resources". (Art. 310, NC)

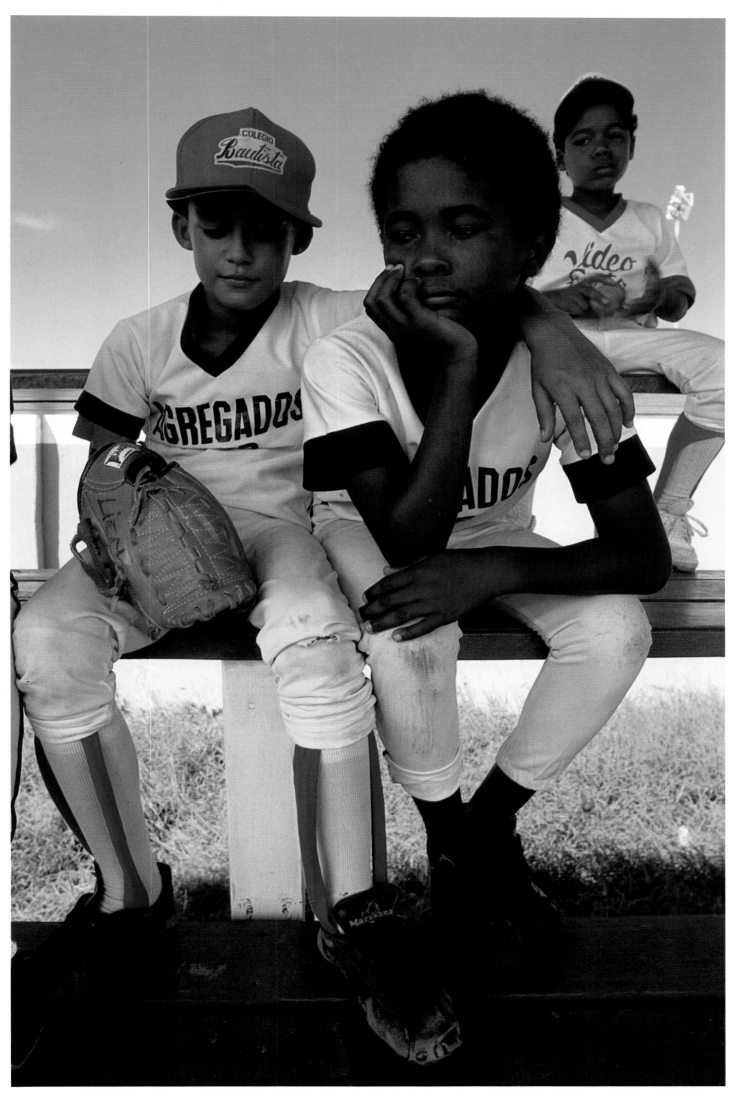

Young baseball players on San Andrés Island

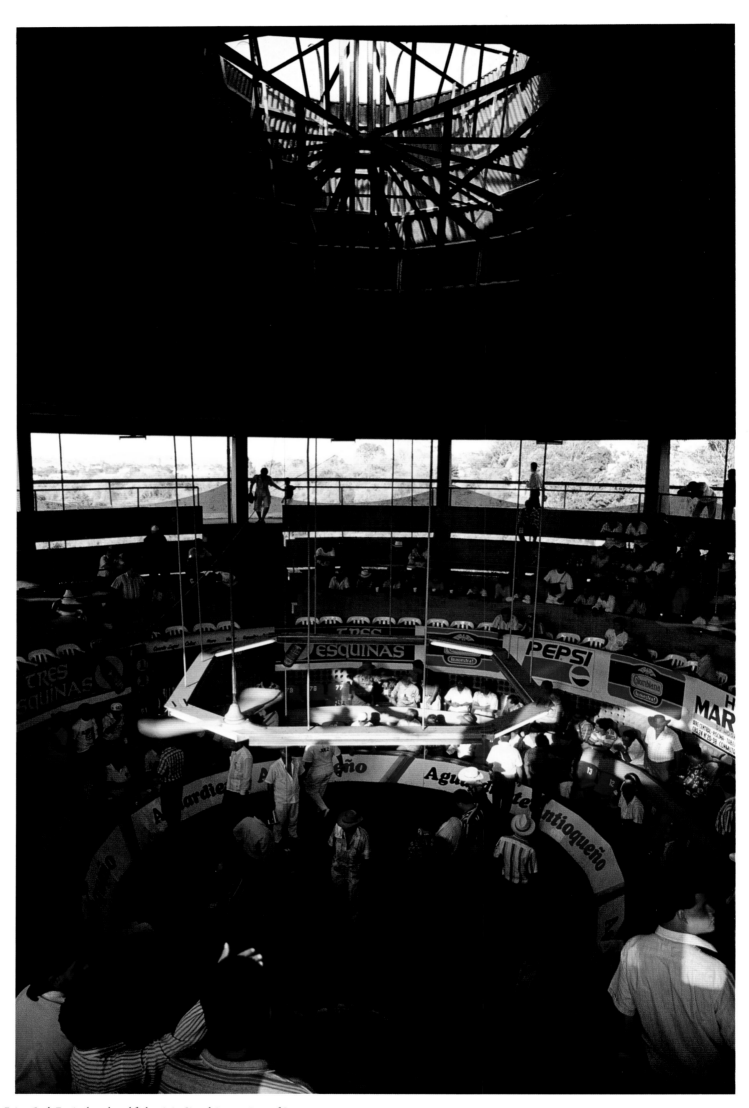

Prize Cock Festival and cockfight pit in Sincelejo, province of Sucre

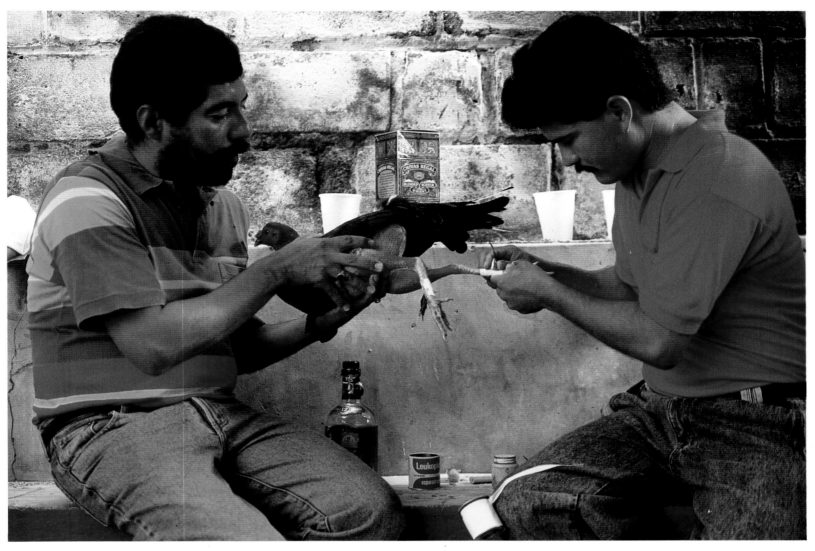

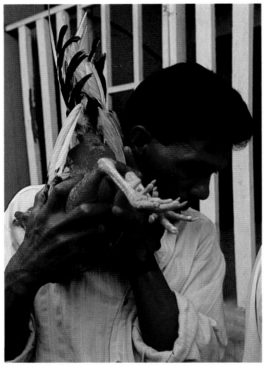

Fitting tortoise-shell spurs on a fighting-cock in Sincelejo, Sucre

Entering a cockfight pit in Sincelejo, Sucre

Cockfights are part of popular culture in many regions of Colombia. Preparation or capoteo of a prize cock can last up to two months, and generally starts when the animal is eight months-old. The cock's feathers are trimmed and its crest removed in order to make it less vulnerable to the opponent's attack. A fight may last up to half an hour, but it might finish before if one contender kills the other, or gouges its eyes out, or mortally pierces its lungs -a blow known as pulmonear. *The amount of one sole bet can exceed the value of a fighting cock many times over, and betting is vouched by the breeder's word, his word of honour.*

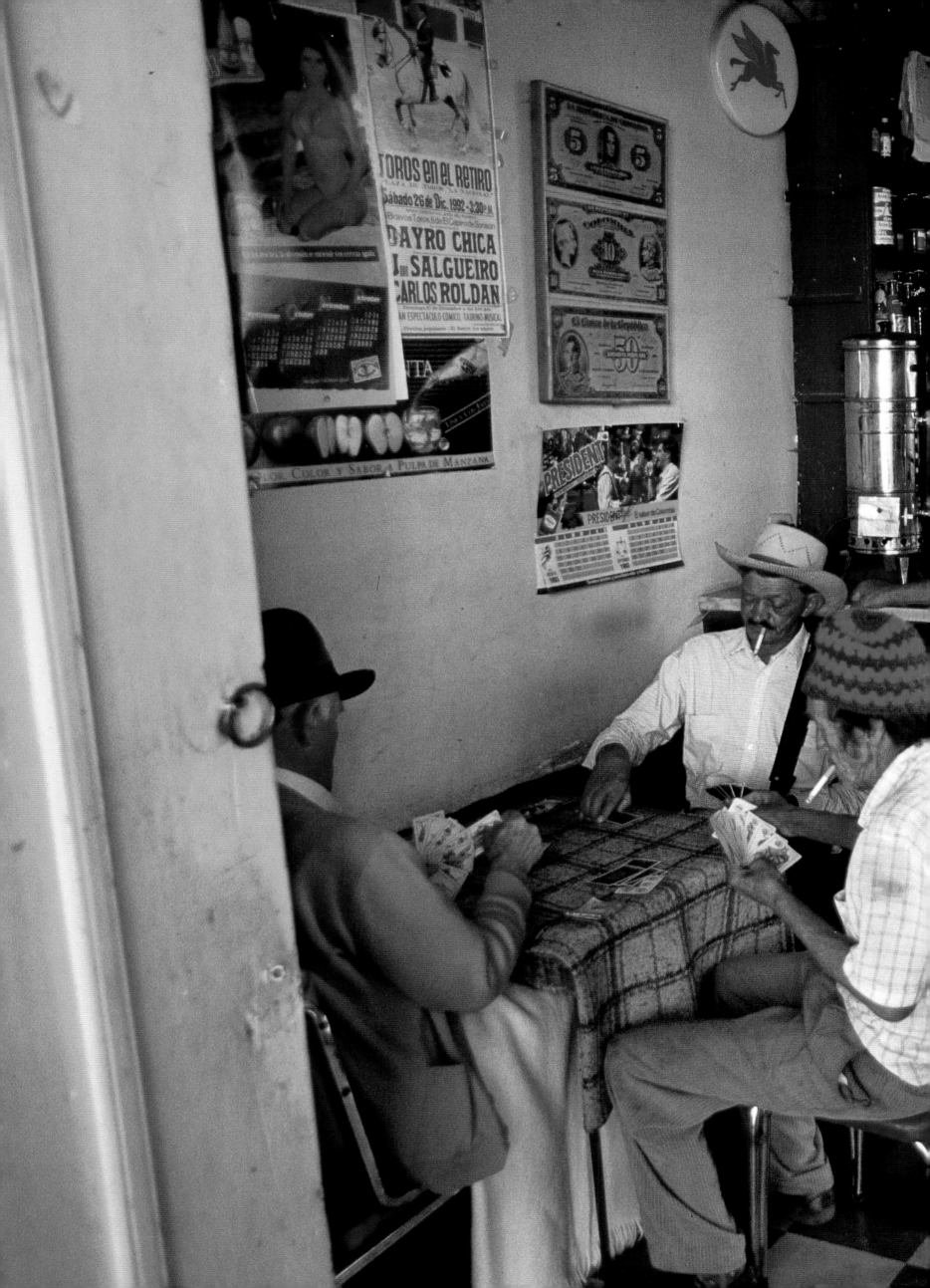

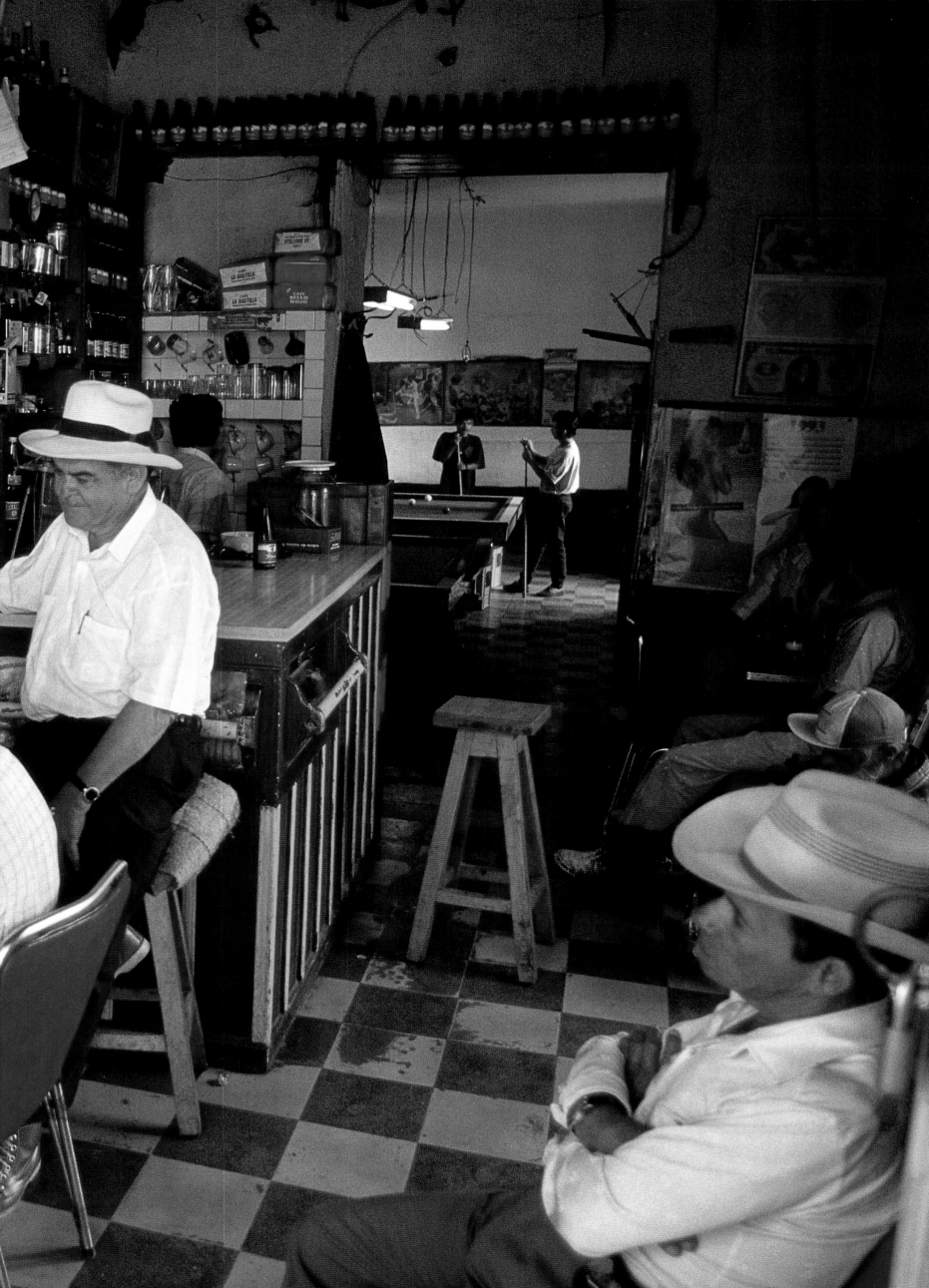

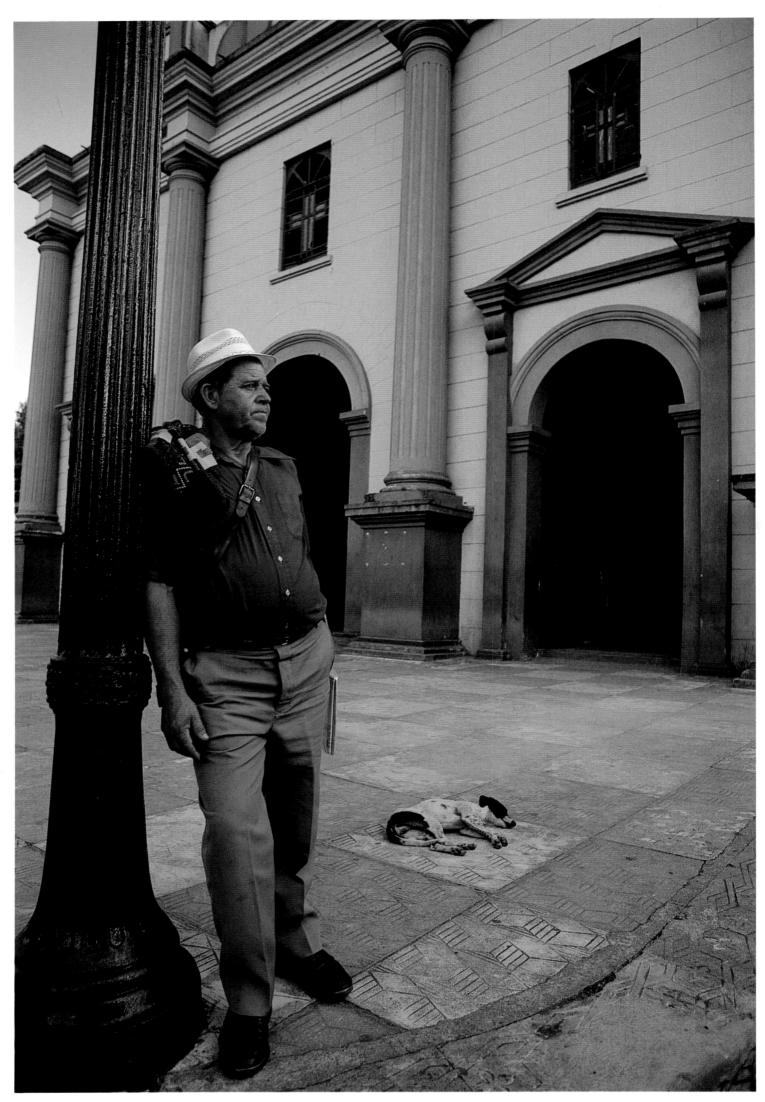

In front of the church, El Retiro, Antioquia

Preceding page, card-playing in a store in El Retiro, Antioquia

Typical window of traditional Antioqueño *architecture in Santa Fe de Antioquia*

With respect to los paisas *(inhabitants of Antioquia), President Belisario Betancur, who is paisa by antonomasia, wrote that they often accomplish their goals just to be able to tell stories. The* paisas *are industrious, crafty, early-rising, daring, hard-working and lucky at gambling... Wherever it passed,* Antioqueño *colonization has left in its wake ruthless deforestation of native forests substituted by "lucrative" crops, and a popular, intensely colourful architecture of great intricacy.*

Coffee merchant in El Retiro, Antioquia

Cattleman in Bolombolo, Antioquia

Historians explain that in the XIX century, the relationship between landowners and land in Antioquia was different than in the rest of the country: there was no class domination like the one imposed by white men on Indians, mestizos, the underprivileged and Negroes in other regions. And, partly due to a tradition of gold-mining peformed by free and independent mazamorreros instead of by slaves, from the beginning, criteria for land exploitation and agricultural produce marketing proved economically viable.

Graveyard in Medellín, Antioquia

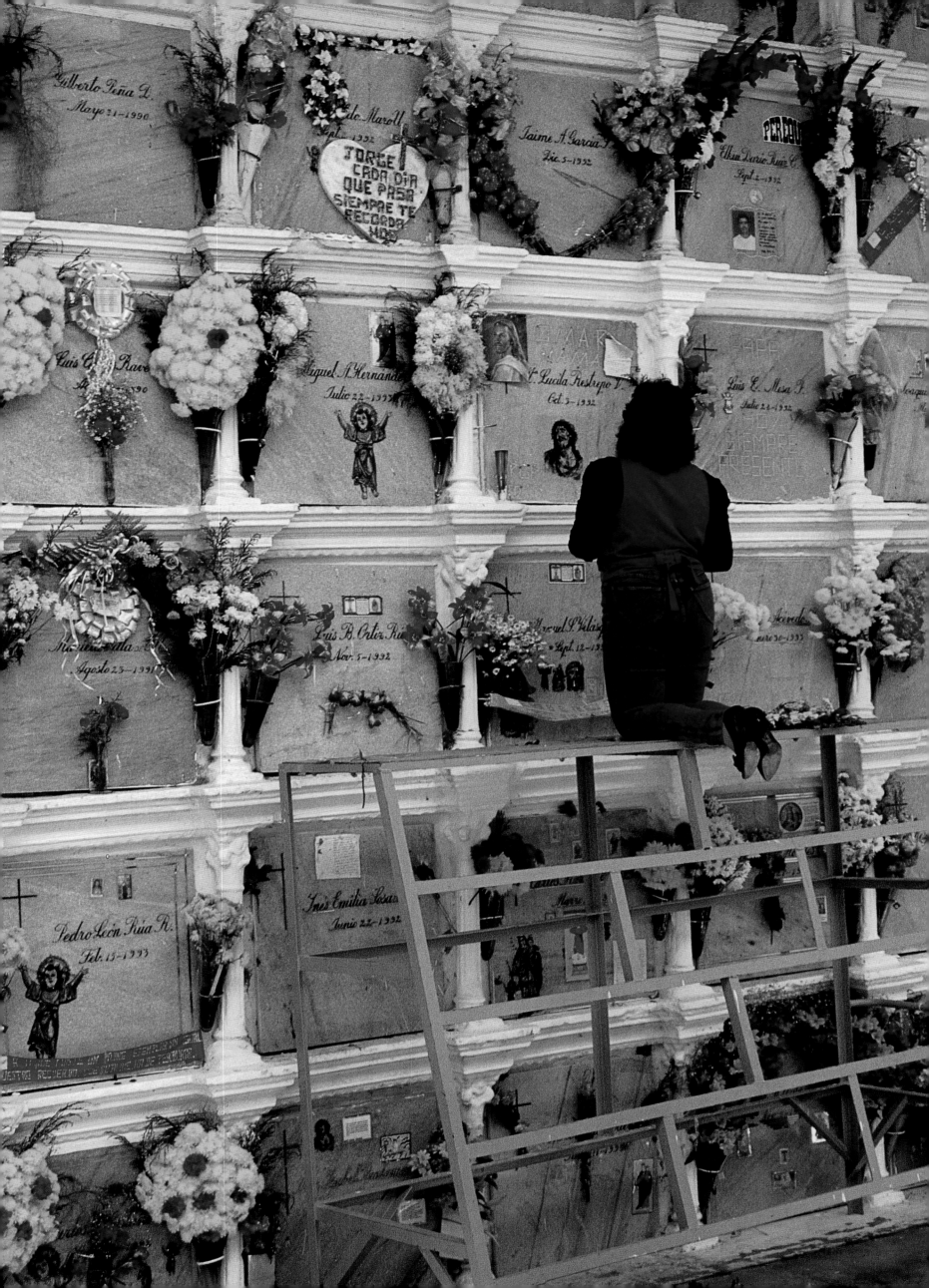

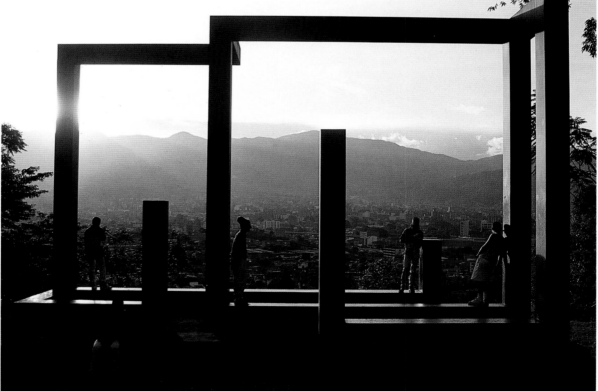

Alpujarra Administrative Center in Medellín, Antioquia

Sculpture by Carlos Rojas on Cerro Nutibara, in Medellín, Antioquia

The many creative possibilities engendered by crises are significantly evident in Medellín, a city greatly affected by terrorist violence over recent years. Seldom does hope flourish as vividly as here among entrepreneurs and the youth of popular communities. For those who have just heard of this city through the headlines of international agencies, it is not always easy to understand that in Medellín many utopias are becoming a reality.

Preceding page, Rionegro airport terminal, Medellín, Antioquia

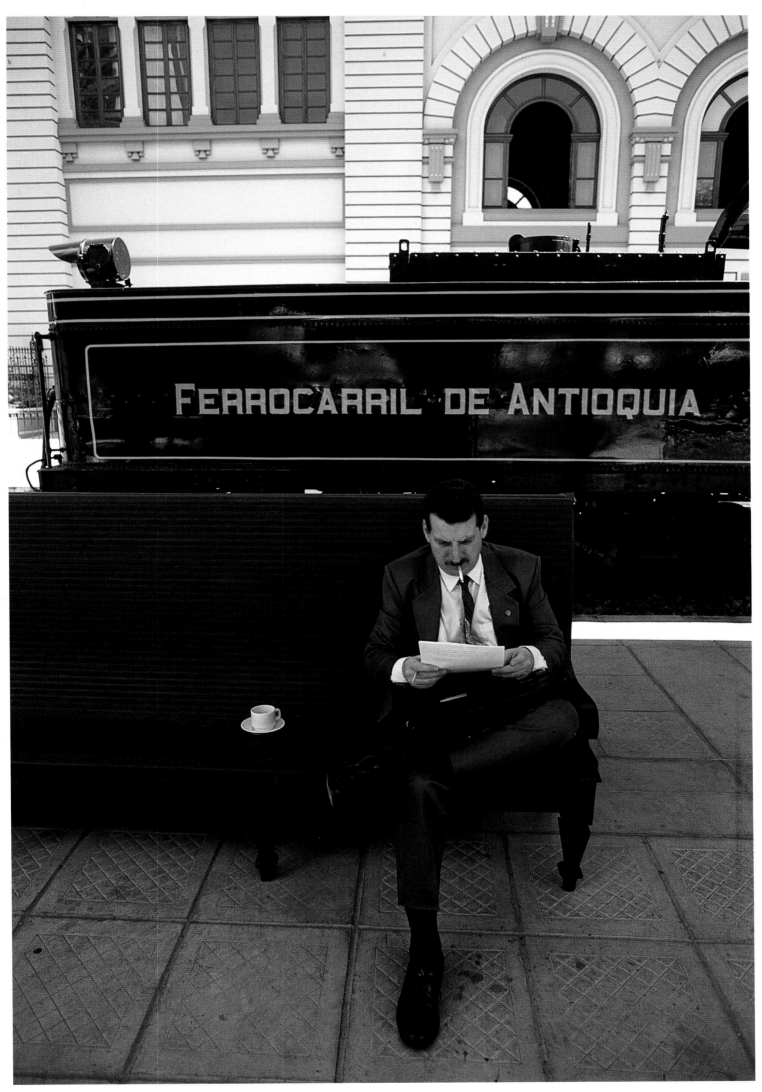

The old Medellín railway station, presently the siege of the Railroad Foundation of Antioquia.

Botero Salon in the Museum of Antioquia, Medellín, Antioquia

While newspapers flooded the world with news about the Medellín Cartel, Fernando Botero, born in Antioquia and internationally known as the most important Colombian painter in recent years, "colonized" the most famous art galleries in the world with his enormous sculptures. Botero's Fat Lady, *in Parque Berrío, is practically taken for granted by city pedestrians. Not in vain do critics extol the "warmth" and "charm" of the work of this painter and sculptor who taught a country plagued by violent death the true meaning of immortality.*

Botero's Fat Lady *sculpture in Medellín, Antioquia*

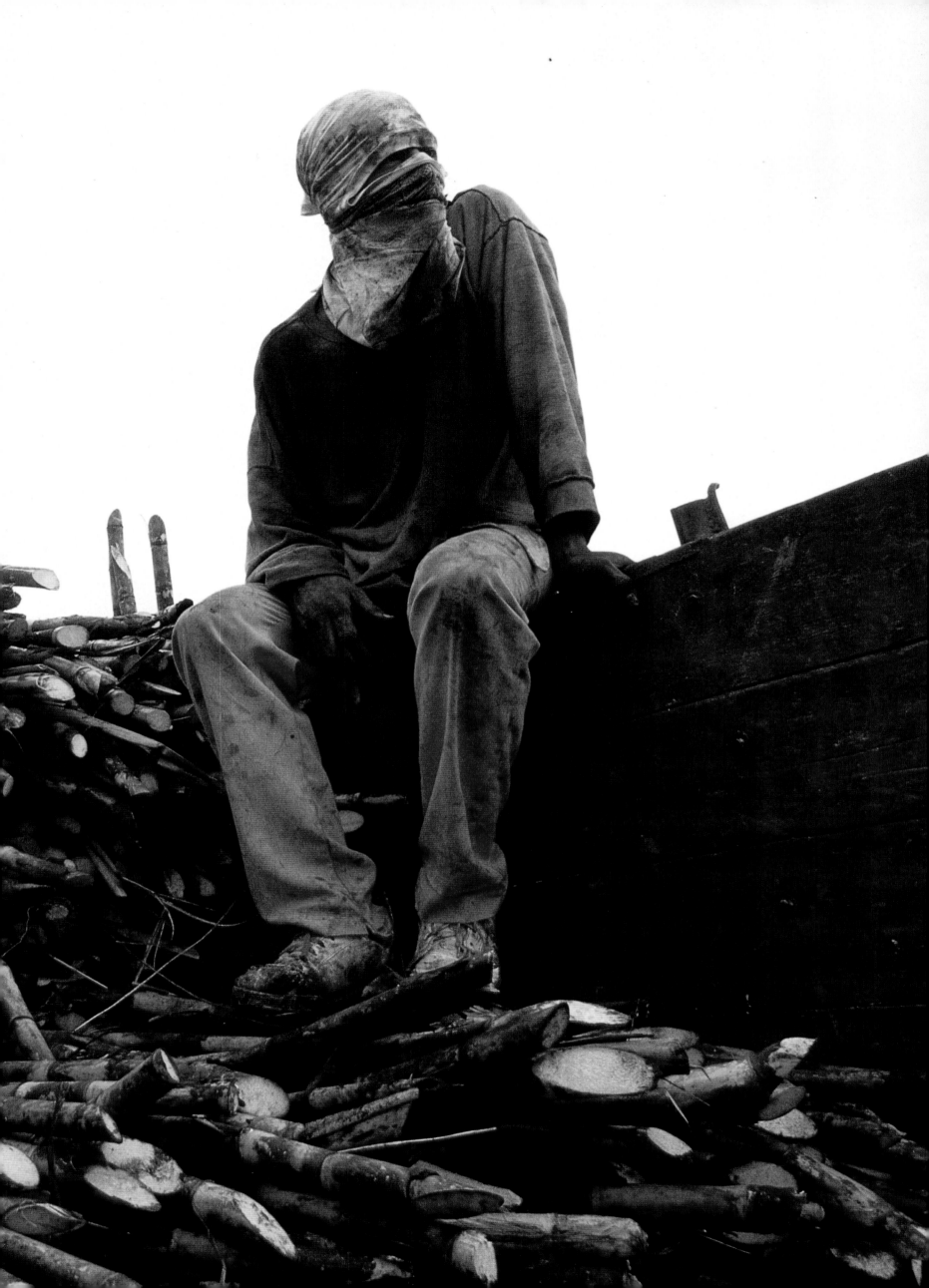

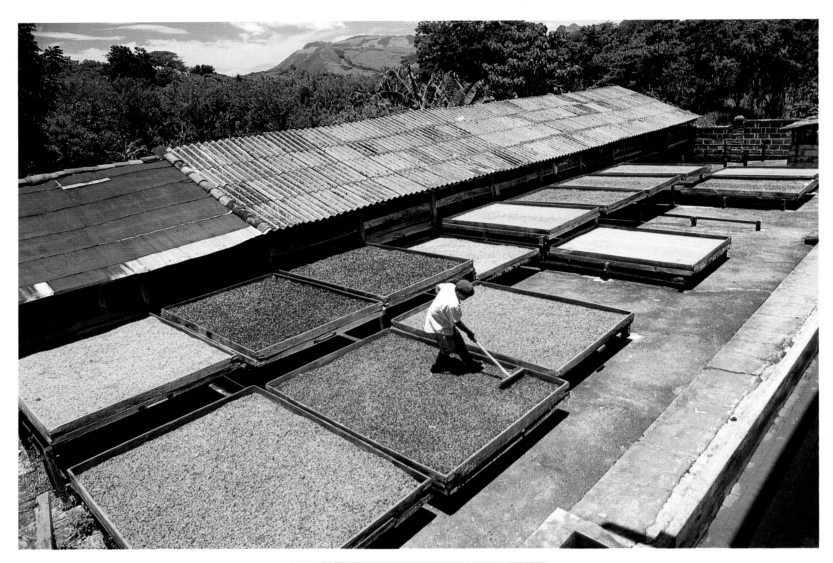

Coffee-drying in a coffee hacienda, *Caldas*
Lyophilization vats in Chinchiná, Caldas

Coffee was brought to Colombia in the XVIII century by the Jesuits, who started planting it on their haciendas *in the Llanos. Interestingly, its initial prosperity occurred in the first half of the XIX century as a consequence of the early development of the coffee economy in the Venezuelan Andes: towards 1830, the first Colombian coffee region was in the Cúcuta area. Later on, the nucleus of the coffee economy moved to the Andean slopes. In 1860, coffee only represented four per cent of Colombian exports.*

Preceding page, sugarcane harvest in Chinchiná, Caldas

Coffee gatherer in Bolombolo, Antioquia

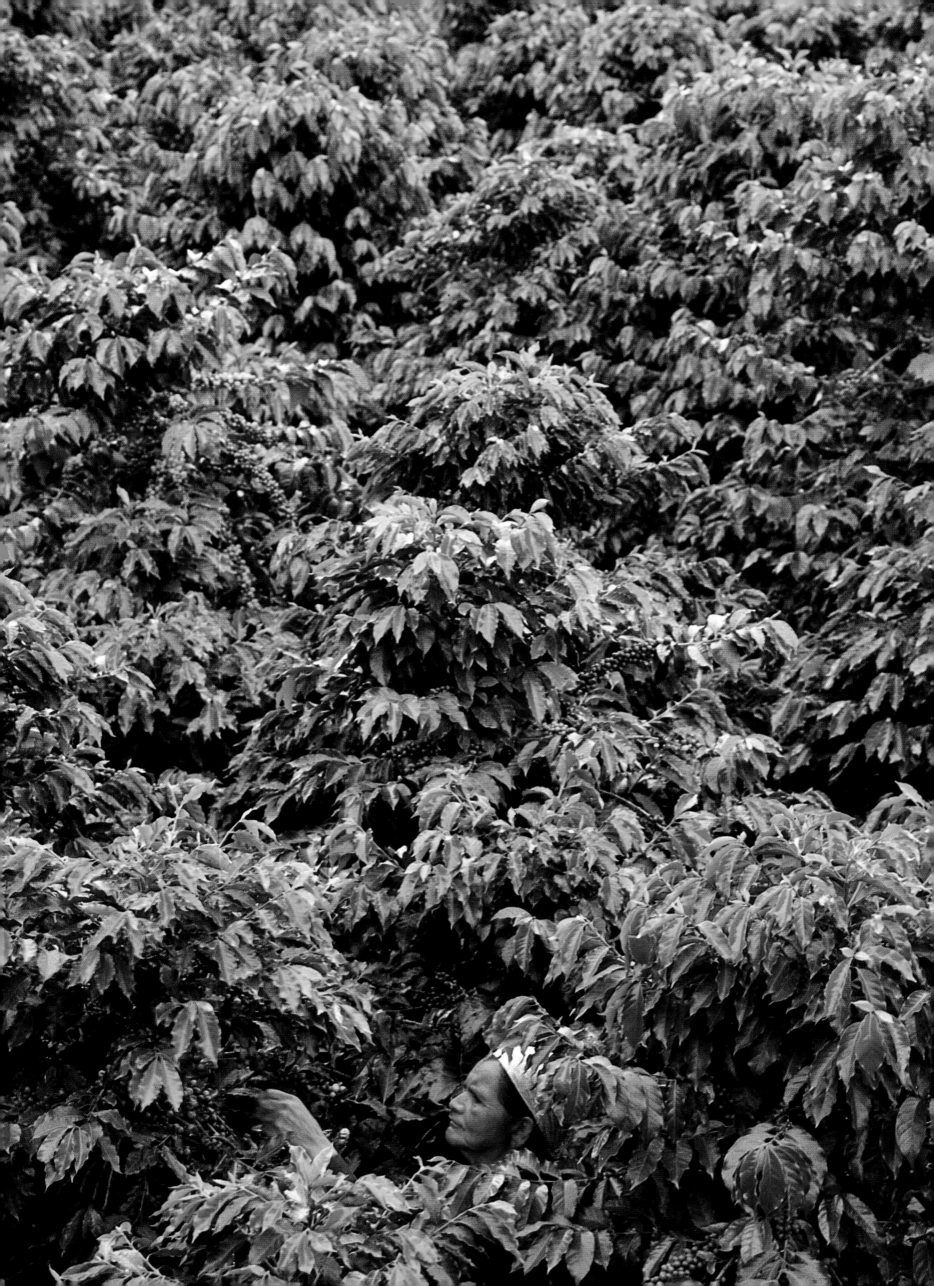

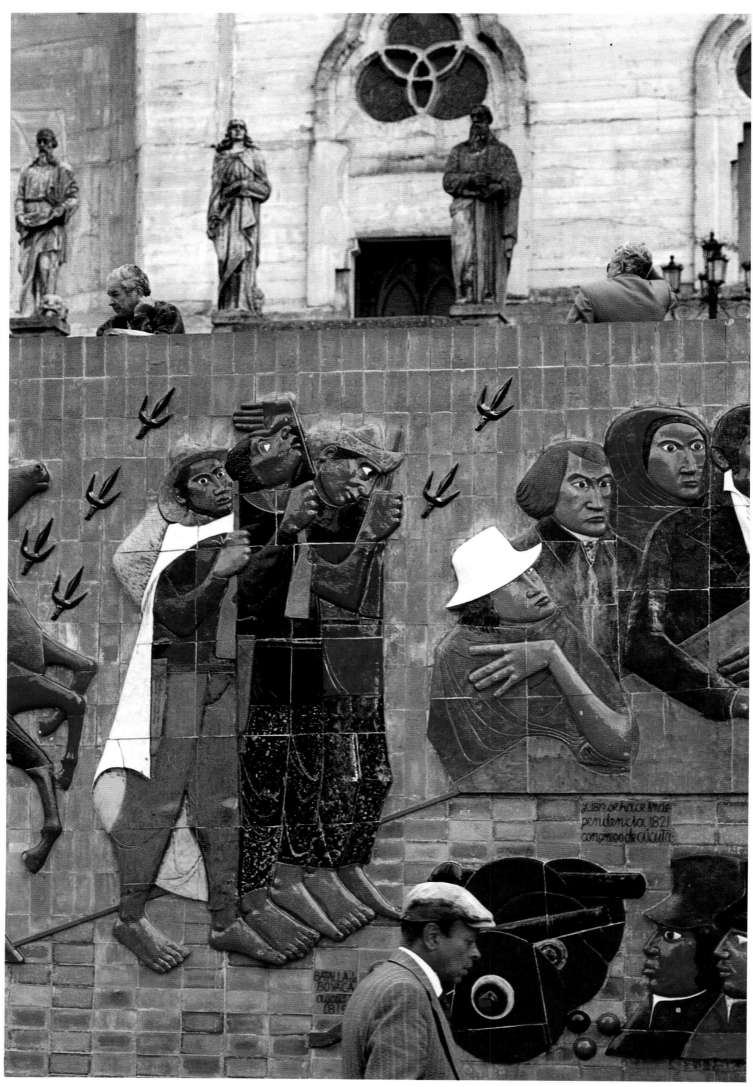

Plaza Bolívar in Manizales, Caldas

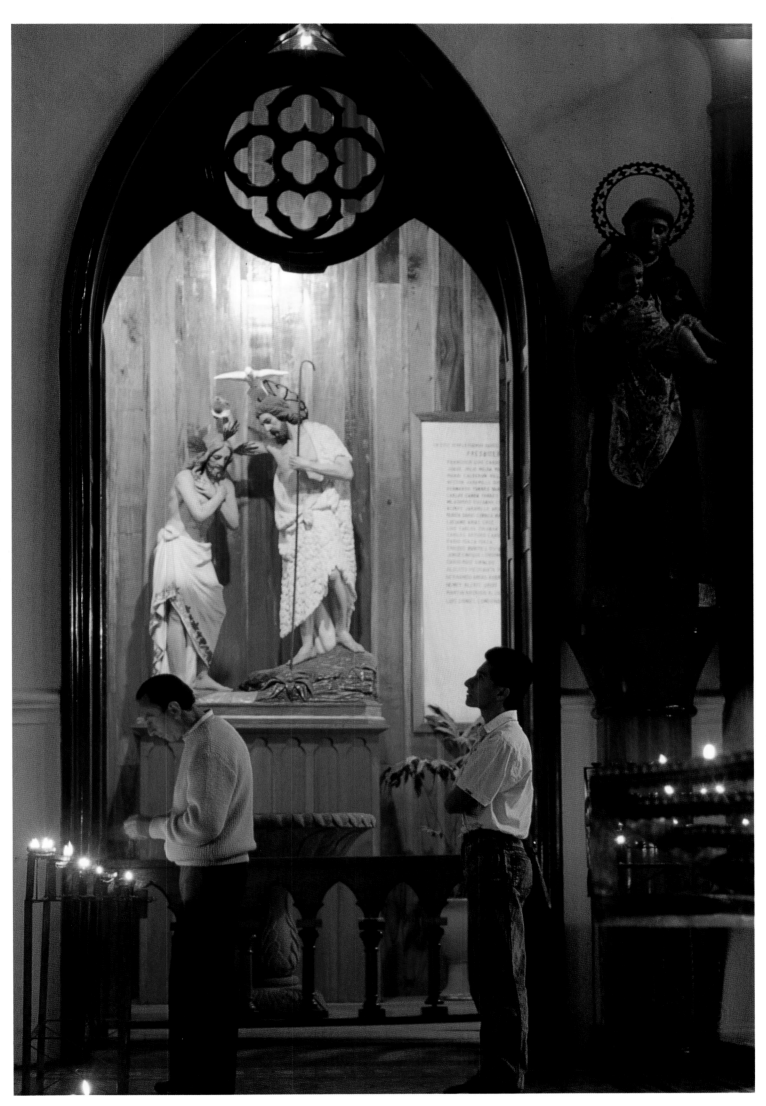

Church of the Virgin Mary in Manizales, Caldas

Off to school in Manizales, Caldas

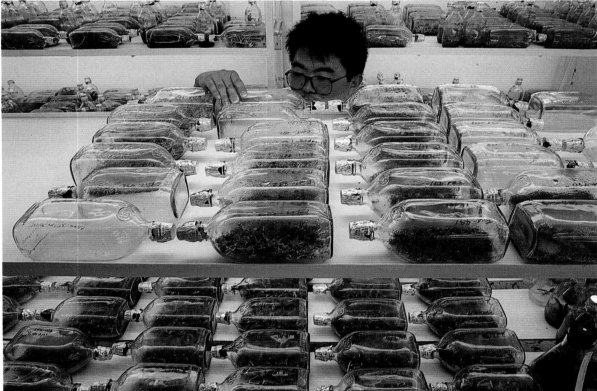

Natural History Museum of Caldas University, Manizales
Reproduction of orchids in a laboratory near Pereira, province of Risaralda

Colombian coffee is a prized commodity on world markets, but the country has made great efforts in order to diversify its exports and to depend less on the bean's fluctuating prices. Biodiversity, reflected in the enormous variety of ecosystems, in animal and vegetal species, and in overall genetic resources, opens unsuspected perspectives for Colombia in the field of biotechnology, which is considered the science of the XXI century. In addition to the avant-garde developments of this new branch of human knowledge, Colombia possesses enormous biotechnological wealth in the traditional medicine of its rural communities.

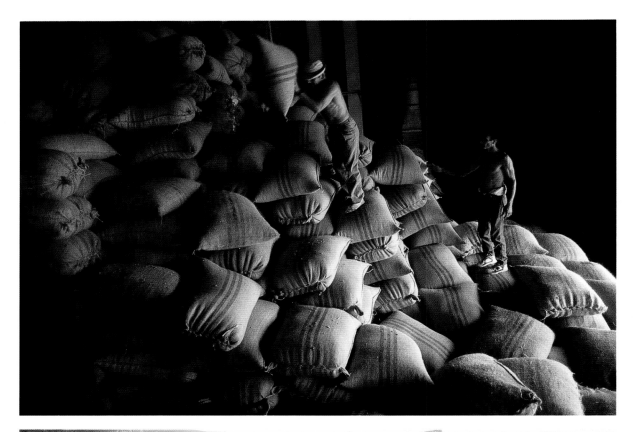

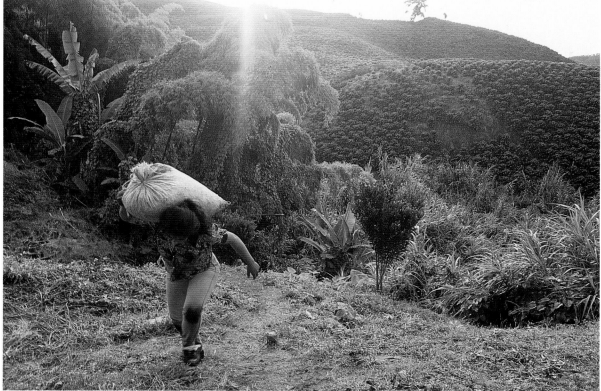

Coffee bags for export in Pereira, Risaralda
Coffee harvest in Armenia, province of Quindio

The traditional technique of planting coffee crops under banana or shade-giving trees –although it may appear less profitable– offers a series of environmental advantages compared to "clean" or "open-sky" single crops. The latter require intensive chemical treatment, which produces rapid soil deterioration. Furthermore, on some international markets, much better prices can be obtained when demonstrated that the coffee has been grown with organic technologies imitating the interactions of natural ecosystems.

Banana market in Armenia, Quindio

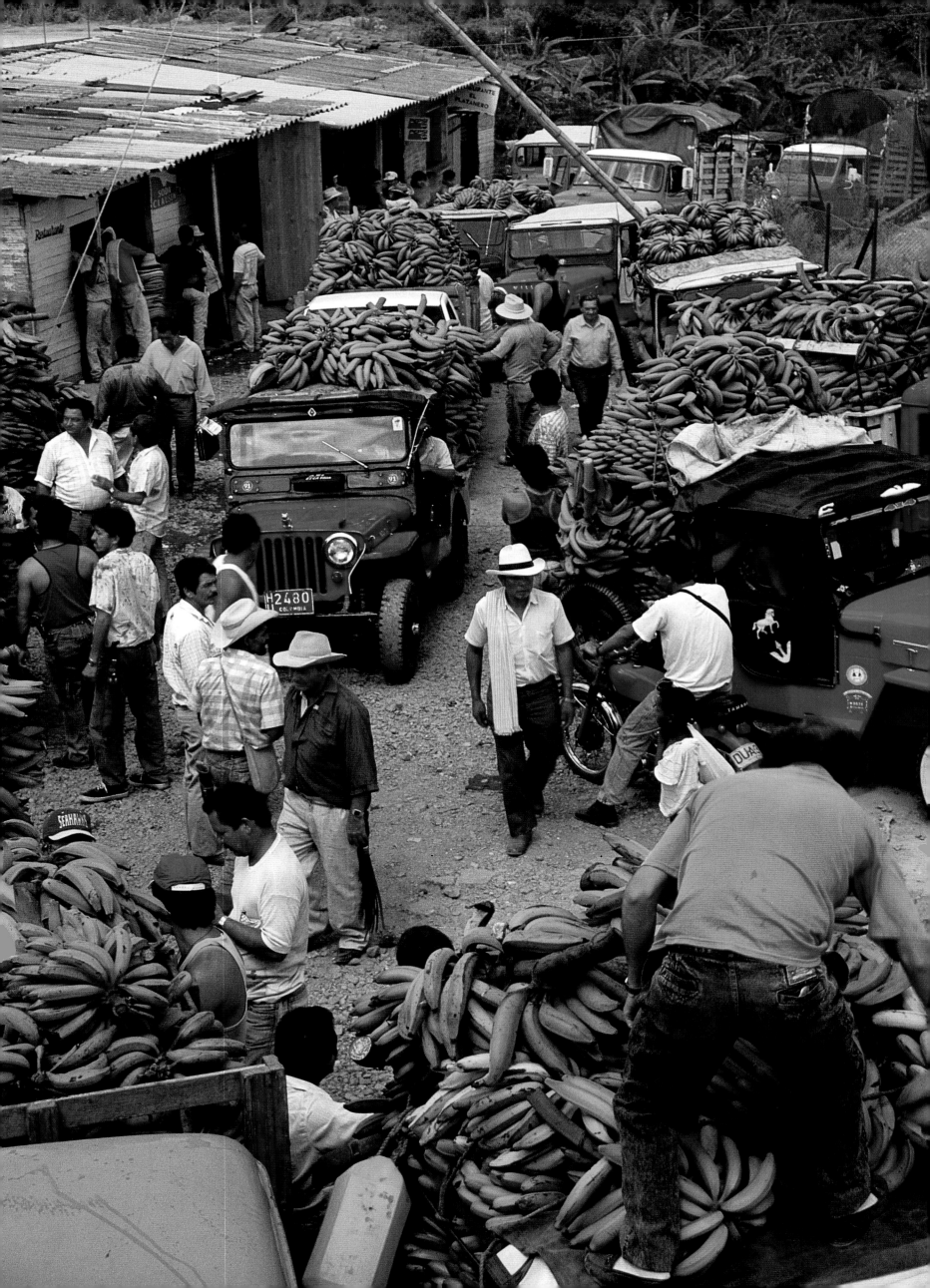

The Magdalena river passes through 1,540 kilometers of land from its source in Páramo de las Papas to its mouth in Bocas de Ceniza. Although pollution and sedimentation (produced by land erosion in the Andean cordillera, which in turn is caused by deforestation and overgrazing) have limited its navigability and reduced fishing, the river continues to be the main source of livelihood for thousands of families.

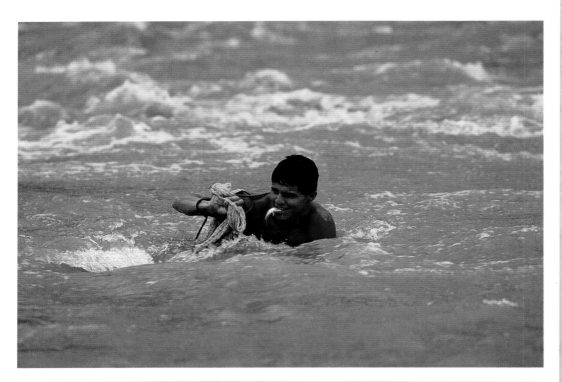

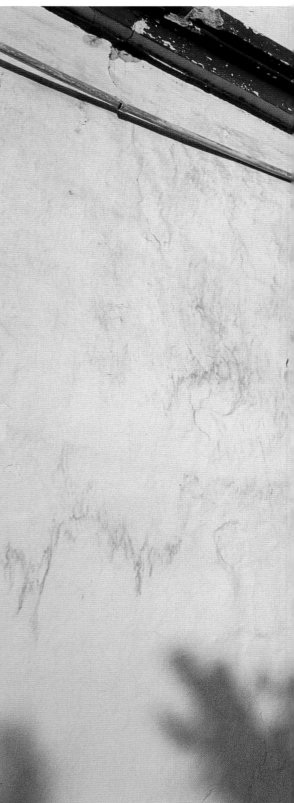

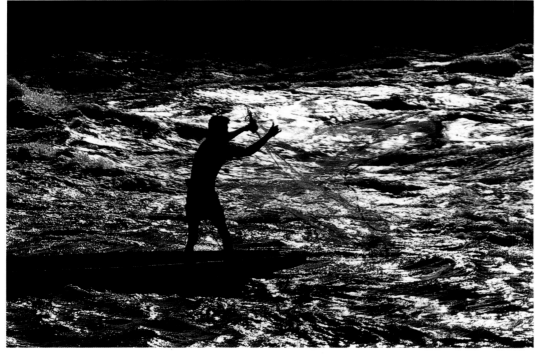

Fishing on the Magdalena river at swelling season, in Honda, Tolima

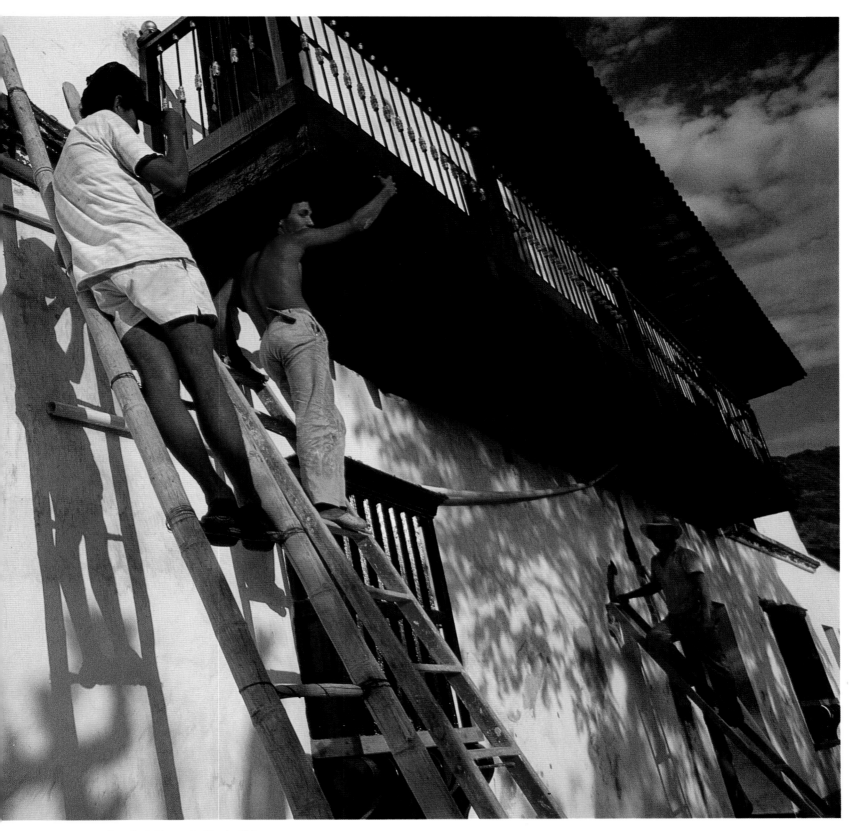

Restoration of a colonial house in Honda, Tolima

Many important Colombian towns have sprung up and flourished as fluvial ports along the navigable stretches of the Magdalena river, which begin a little over 200 kilometers from the source, after the city of Neiva. In the last century, it was almost obligatory for travelers coming from Europe to Bogotá to disembark in Cartagena, then pass by Barranca de Loba, and from there sail up the Magdalena river on a month-long journey until arriving in Honda, another 130 kilometres from the capital.

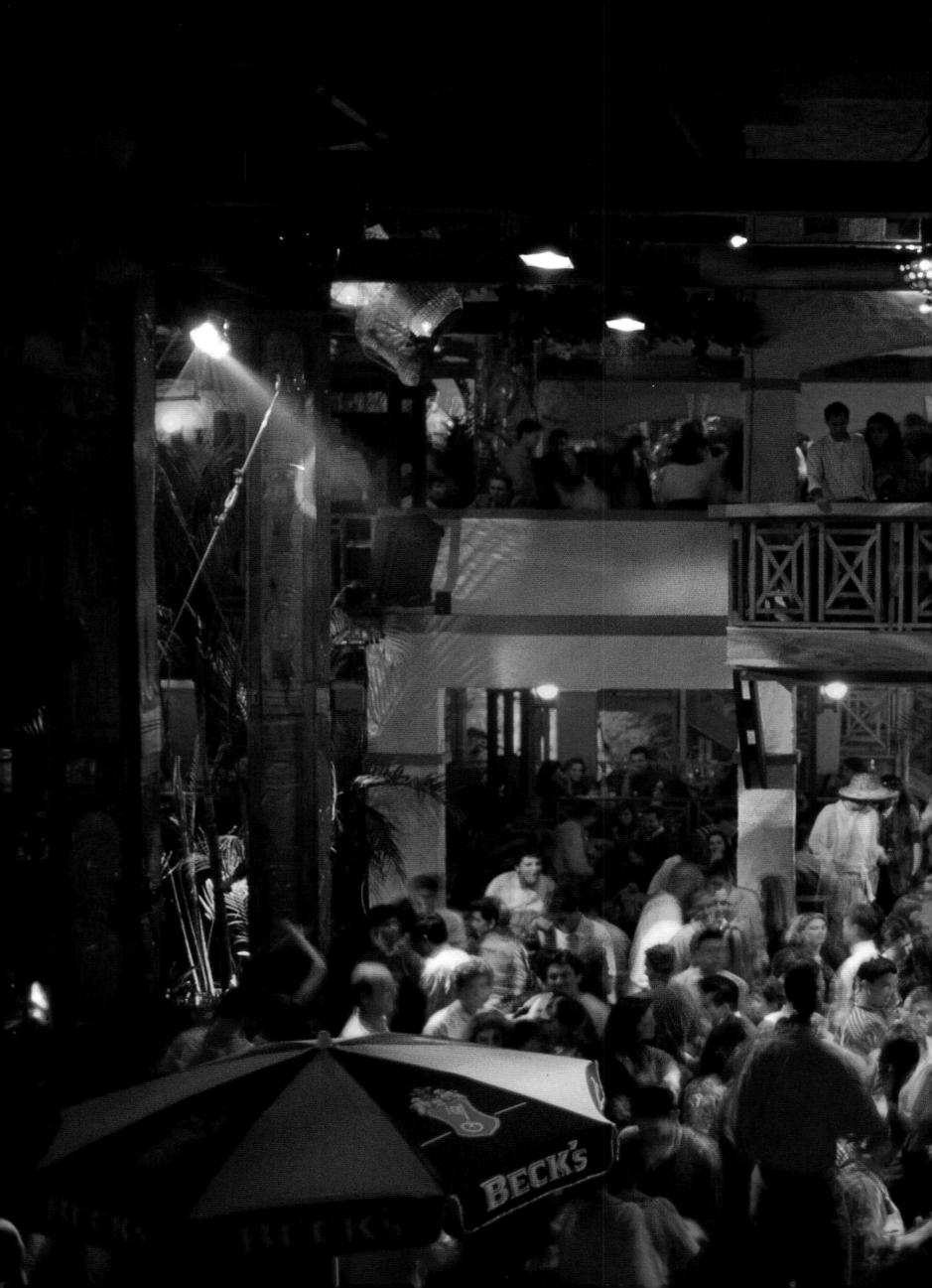

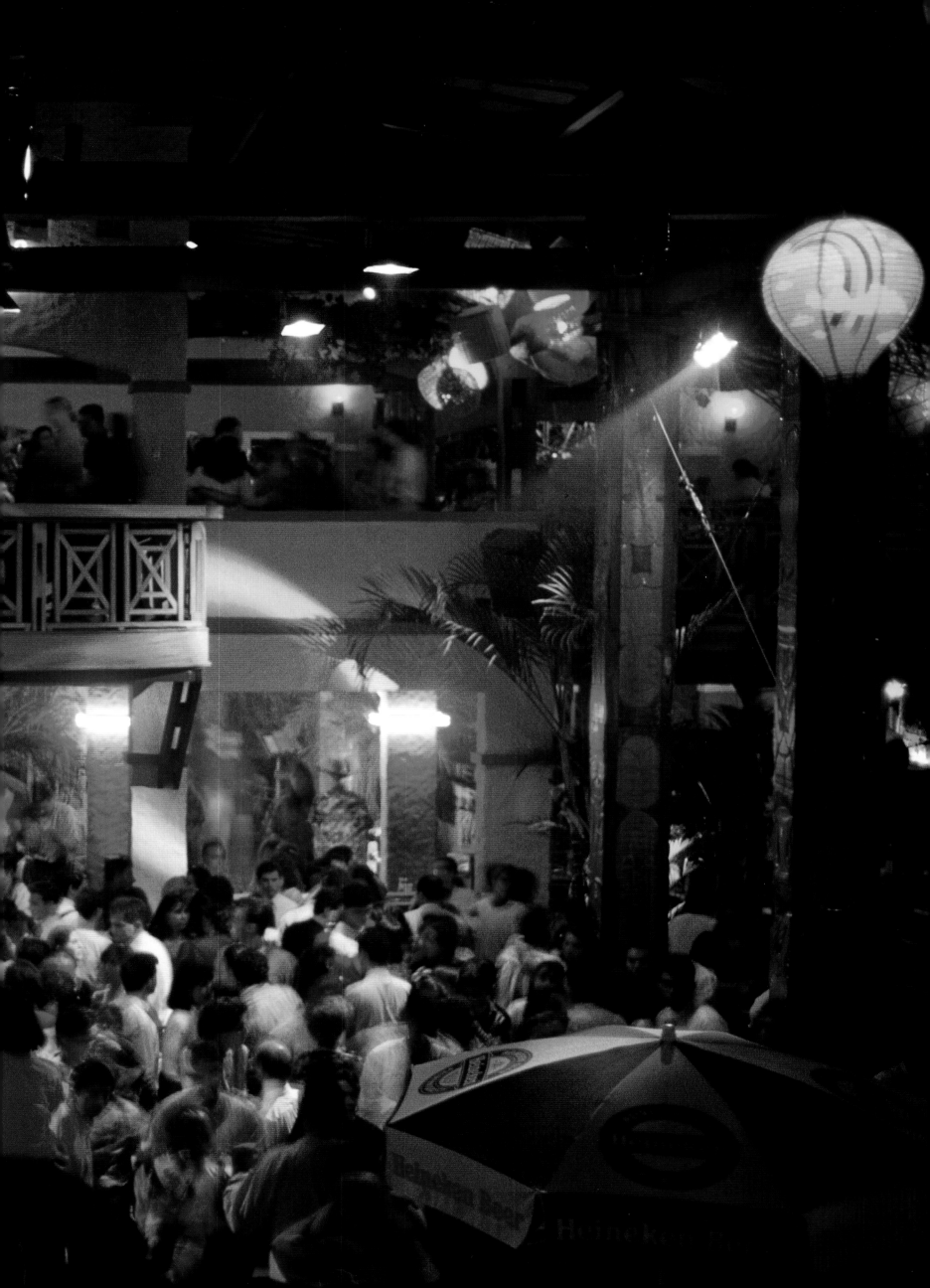

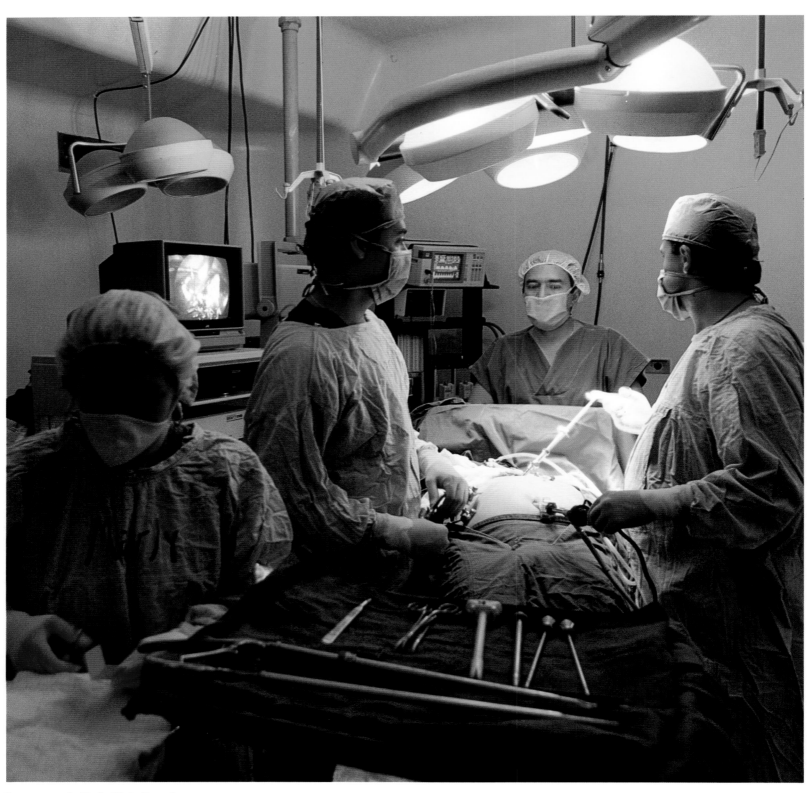

Surgery room in Marly Clinic, Bogotá

Urban growth and industrial development have brought about a new pathological profile of Colombians. Malignant tumours, violent death and cardiovascular disease, which have made medical progress a vital necessity, are among the main causes of mortality in this country. Today, the most complex treatments and operations in Colombia are scientifically and technically possible. At the same time, the country continues to be affected by diseases of the underdeveloped world. But it was a Colombian scientist, Manuel Elkin Patarroyo, who discovered the vaccine against malaria.

Preceding page, Bahía discotheque on the road to La Calera, Bogotá

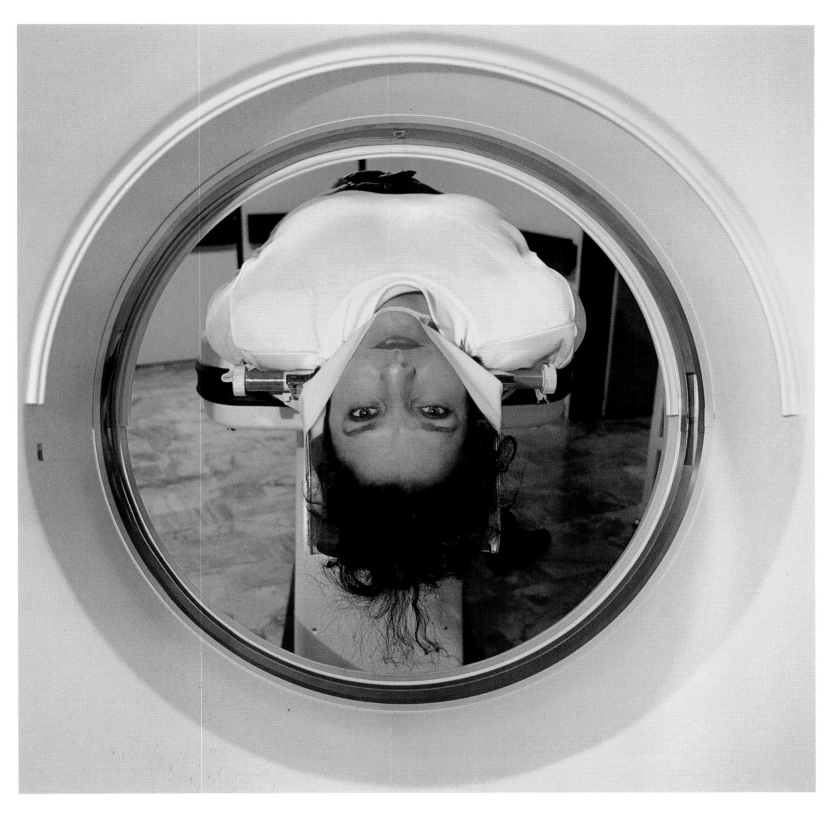

Brain scan in Marly Clinic, Bogotá

If it were possible to "scan" the "collective soul" of Colombians, the result would be complex, contradictory and totally baffling for those who believe in finding linear cause-effect relationships explaining the daily reality of a country which is considered the most violent in the world with no formally-declared war. Meanwhile, in different economic and social domains, in the cities and country, officially or marginally, "factories of hope" emerge daily, models for a civilian society dedicated to open up a horizon of coexistence, democracy and tolerance.

Colombian football team fan in Campín Stadium, Bogotá

"Football is more than 22 men and a leather ball. There is omething more than joy in protagonists and spectators when a good pass is made. In addition, there is more than ephemeral happiness when a goal is scored. Football is a gut-level force that arises from the deepest part of existence, from the dark waters of human conflict". DANIEL SAMPER PIZANO

Dragging out the bull in Plaza de Santamaría, Bogotá

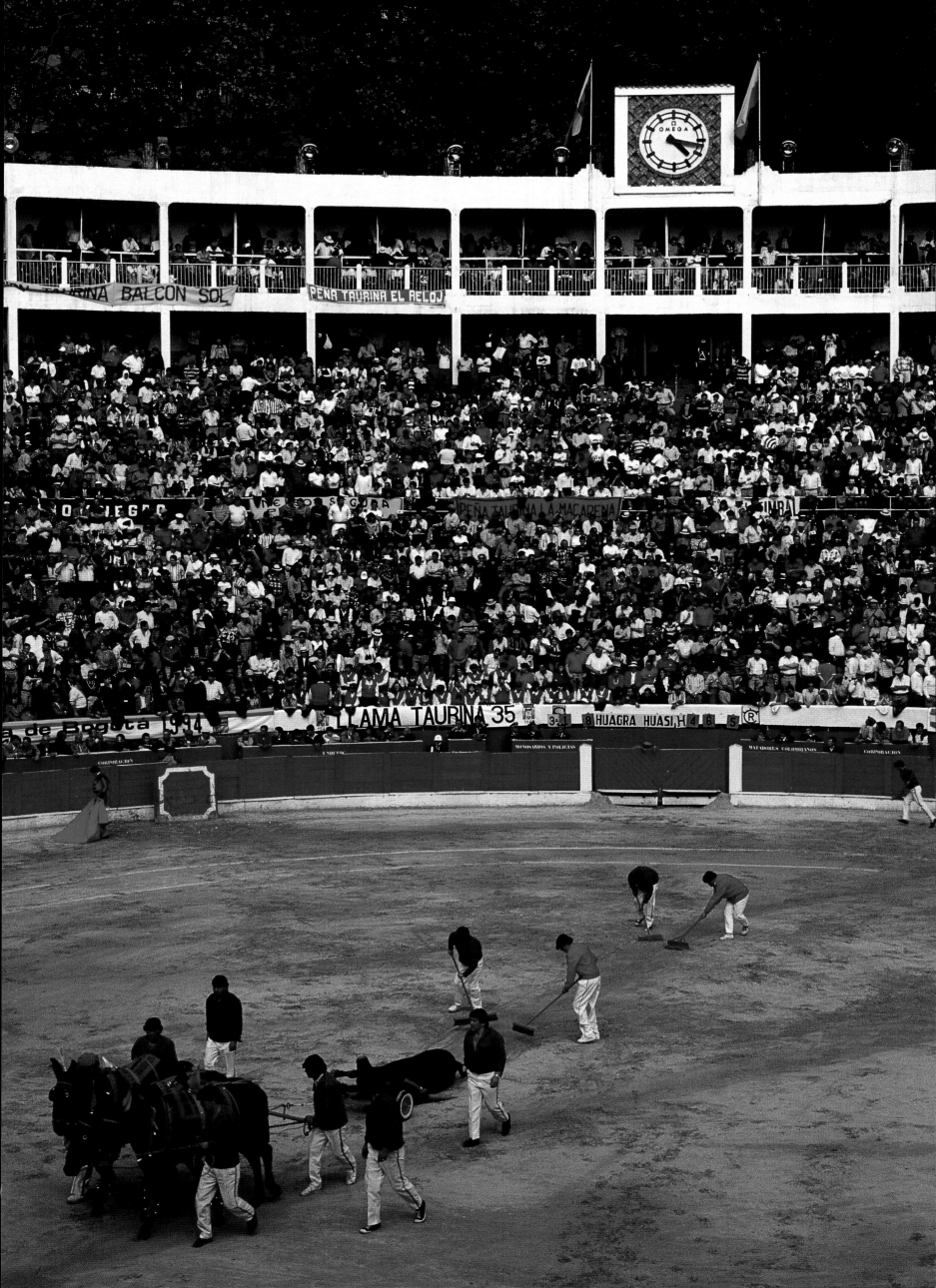

In the middle of the XX century, Colombia shyly begins to approach the new tendencies of international art. Today, there are many Colombian names which not only define avant-garde approaches in plastic arts, but who also explore daring, artistic possibilities in works executed, for instance, for the "forbidden" senses, such as touch and smell.

Museum of Modern Art in Bogotá

124

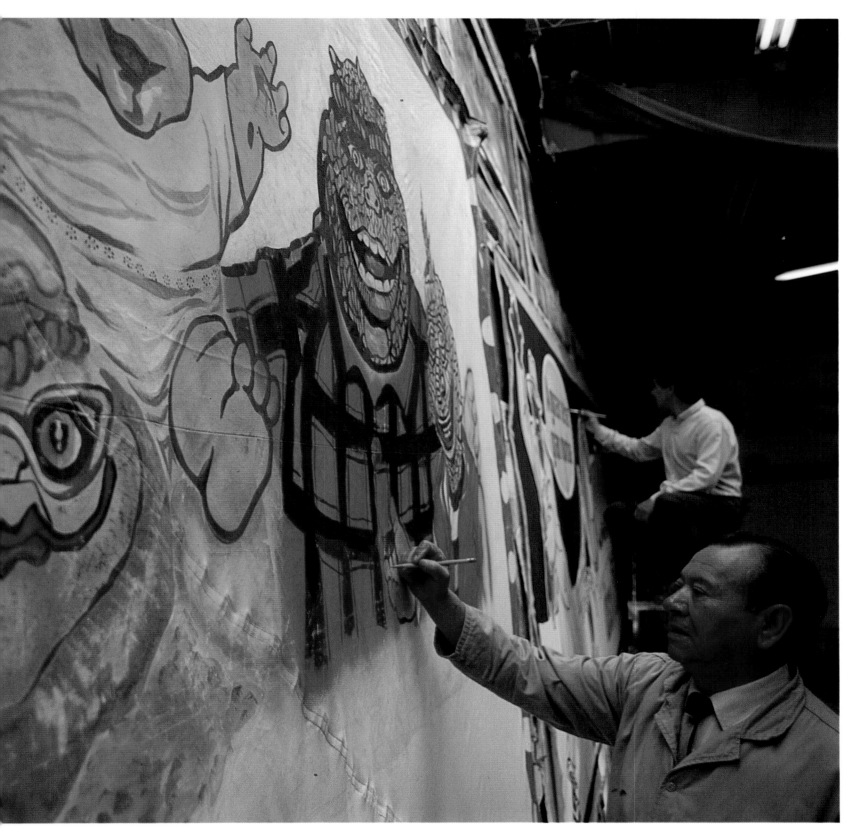

Painters of movie posters in Bogotá

It is not easy to find one's way in the labyrinth of downtown Bogotá to the workshops where billboards are painted to announce the latest movies on the capital's avenues and streets. The urban landscape, where Bogotanos lead their daily life, is possibly determined more by the influence of anonymous artists than by the opinions of architects and planners.

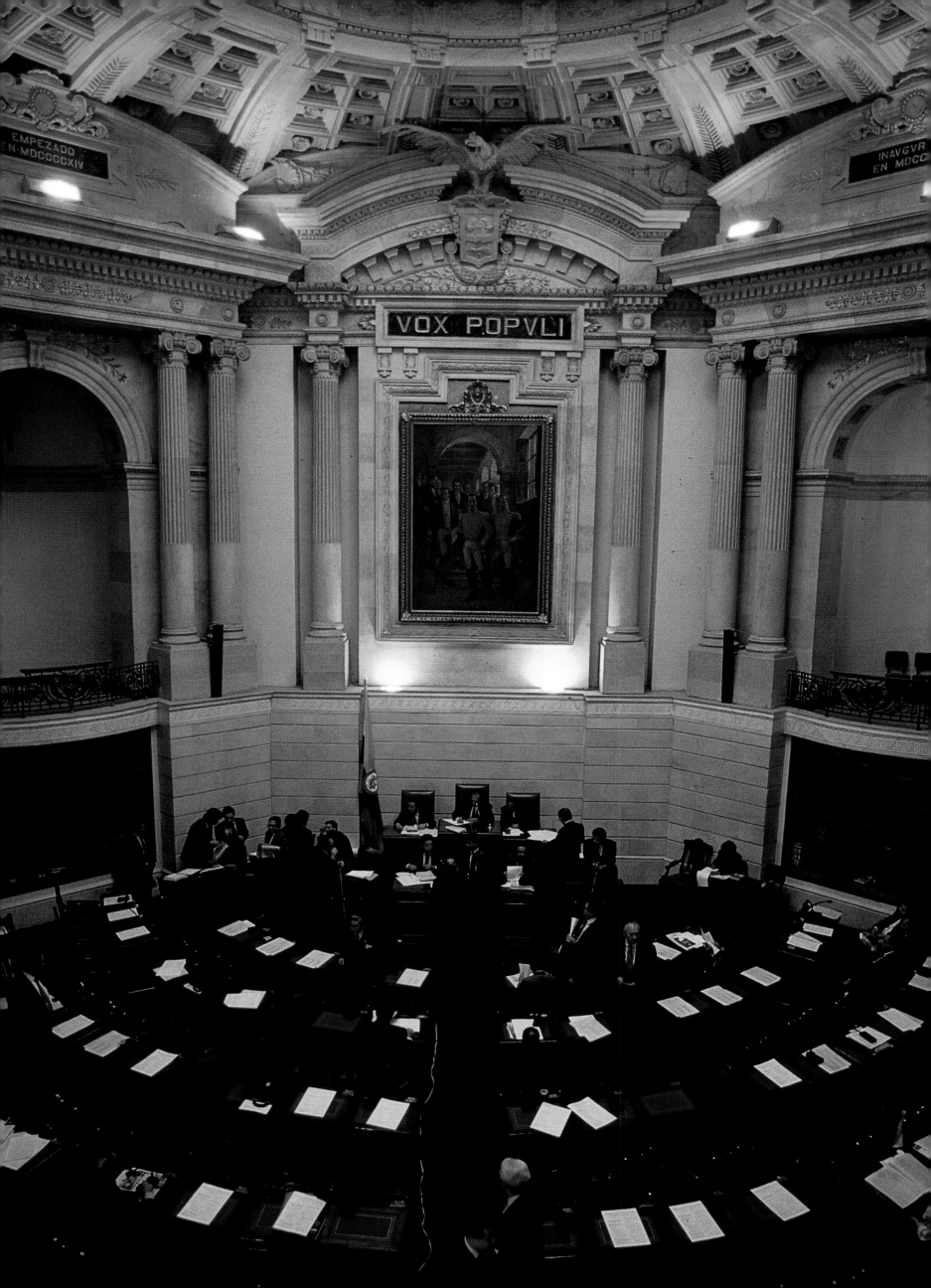

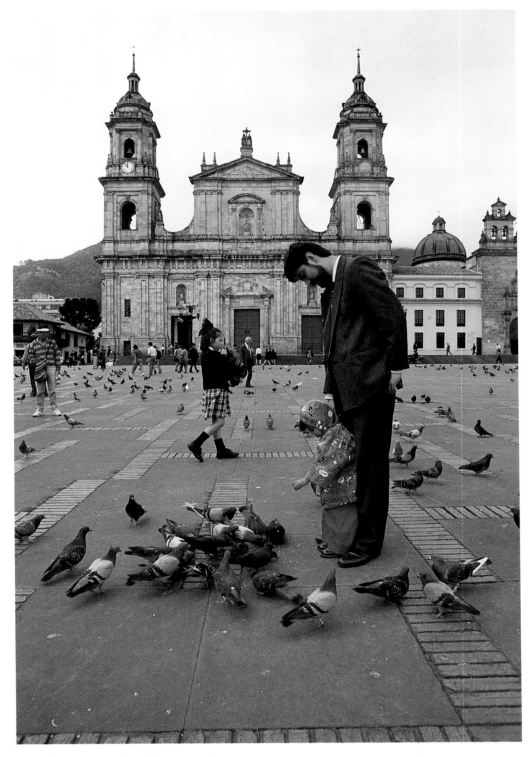

Main Cathedral and Plaza Bolívar, Bogotá

In 1990, as a result of the initiative of different university student groups, the country was summoned to carry out a "Constituent Assembly" to thoroughly revise the basis of the social pact which unites (or separates) Colombians, and to issue a new Colombian Constitution. En 1991, with the unprecedented participation of all social sectors, this Constitution was adopted; among other things, it recognizes and protects the ethnic and cultural diversity of the Colombian nation.

Communications media bring the world to even the most remote parts of the country. Actually, Colombian society struggles between "national uniformity" and the defense of regional ethnic and cultural particularities which are holding their own in the face of "mass culture". On the other hand, and with great difficulties, social communications media, especially films and television, are beginning to explore the enormous possibilities offered by national reality to create dramatic themes. Up to now the film market has been monopolized almost exclusively by commercial productions from the United States.

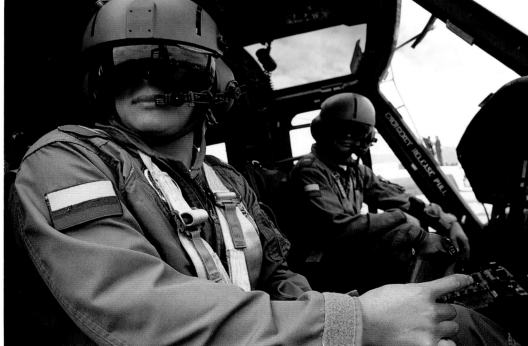

Filming a documentary in Girardot, province of Cundinamarca

Helicopter pilots in Guaymaral Airport, Bogotá

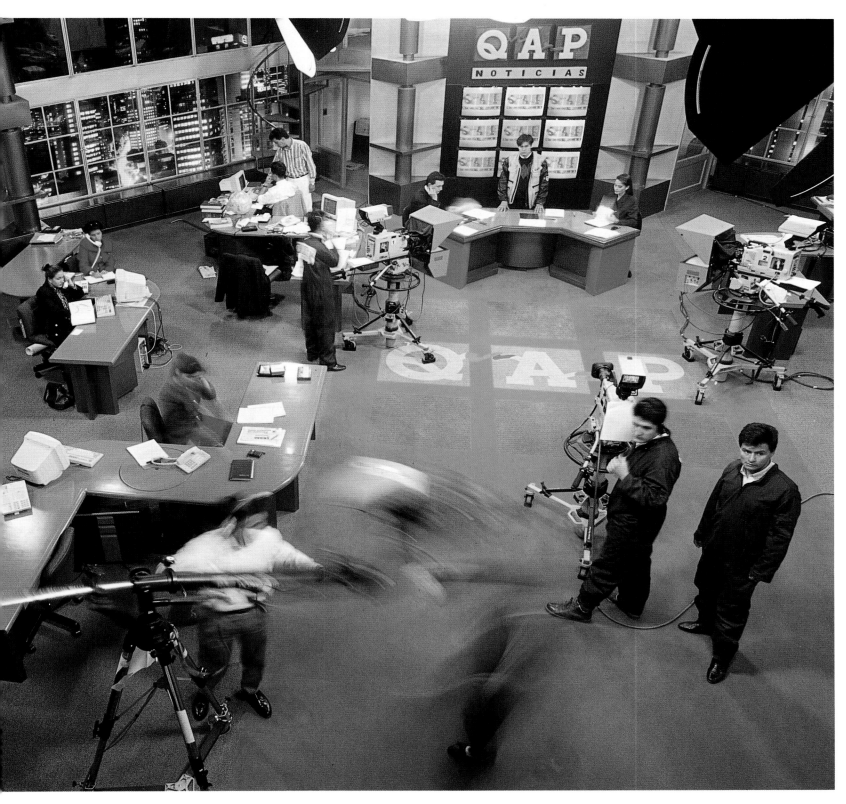

Studio of QAP News, Bogotá

In a country where sensational news occur in dizzy succession, it's not easy for newspapermen or for radio and television news editors to choose the opening item for each program. Just one of the multiple events which hit Colombians in one day would be enough to upheave a less turbulent society for several months.

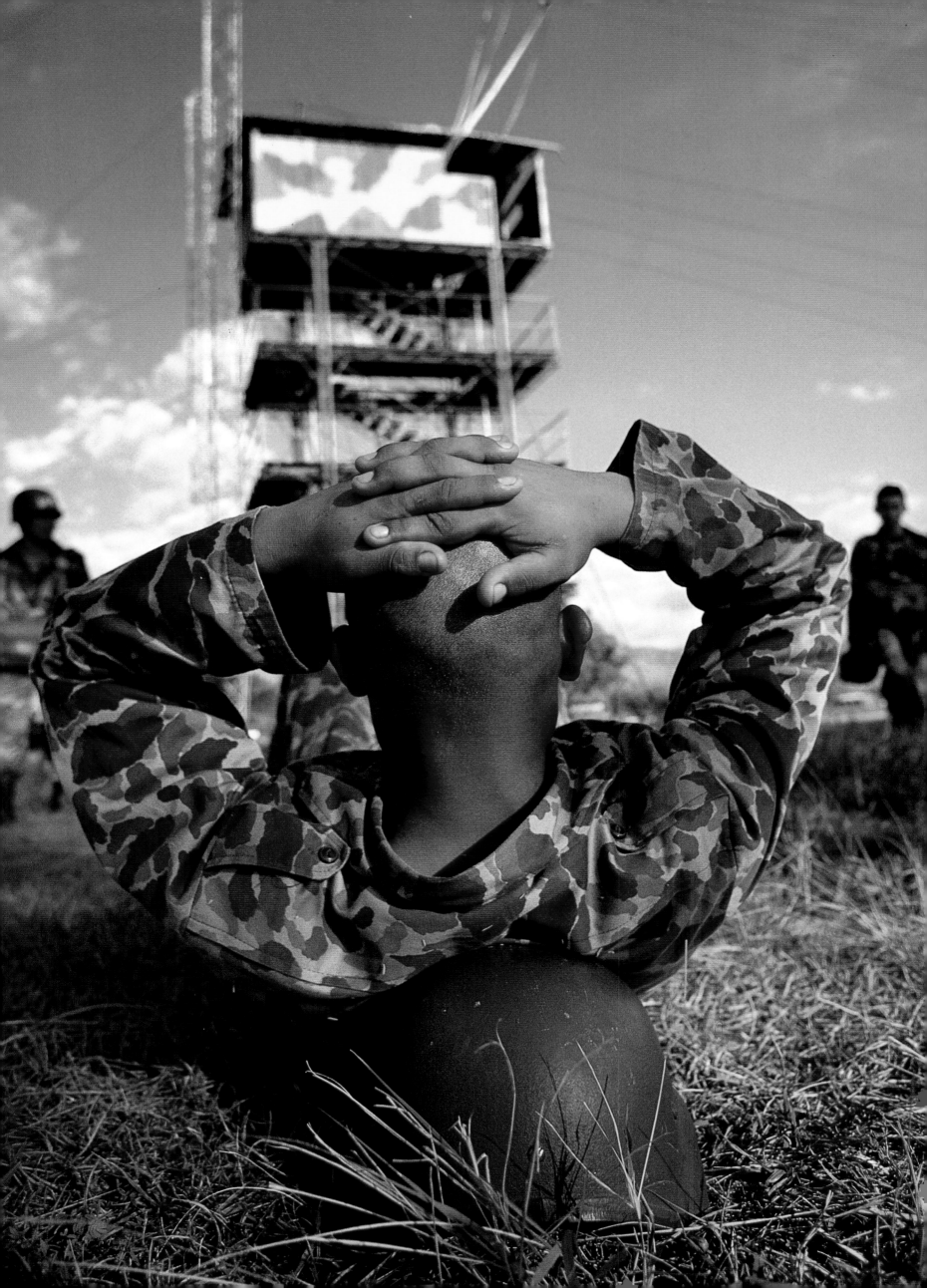

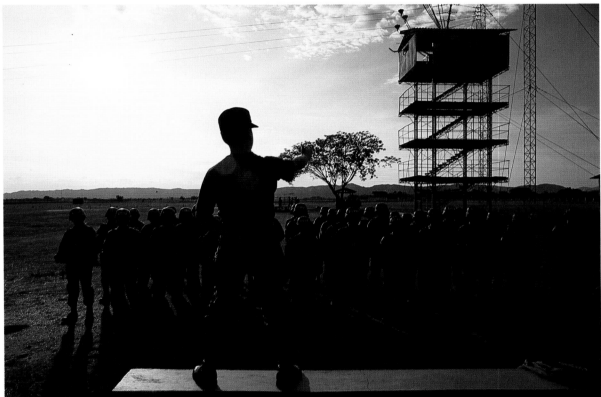

Parachute training in Tolemaida, Tolima

Aside from the War of Independence, nine nation-wide civil wars (the last of which is known as "The War of One Thousand Days" - which started in 1899 and ended in 1902) several "revolutions" and no less than seven coups d'état have been registered in what today is Colombia. We have lived in relative peace in the current century: Colombia has had only one international confrontation (against Peru in 1932) and one military coup in 1953. The decade of the fifties was torn by the Violencia *which was ended by the creation of the "National Front", an agreement to share power between the Liberal and Conservative parties. From then on, the country has almost permanently been under state of siege, with heavy military presence.*

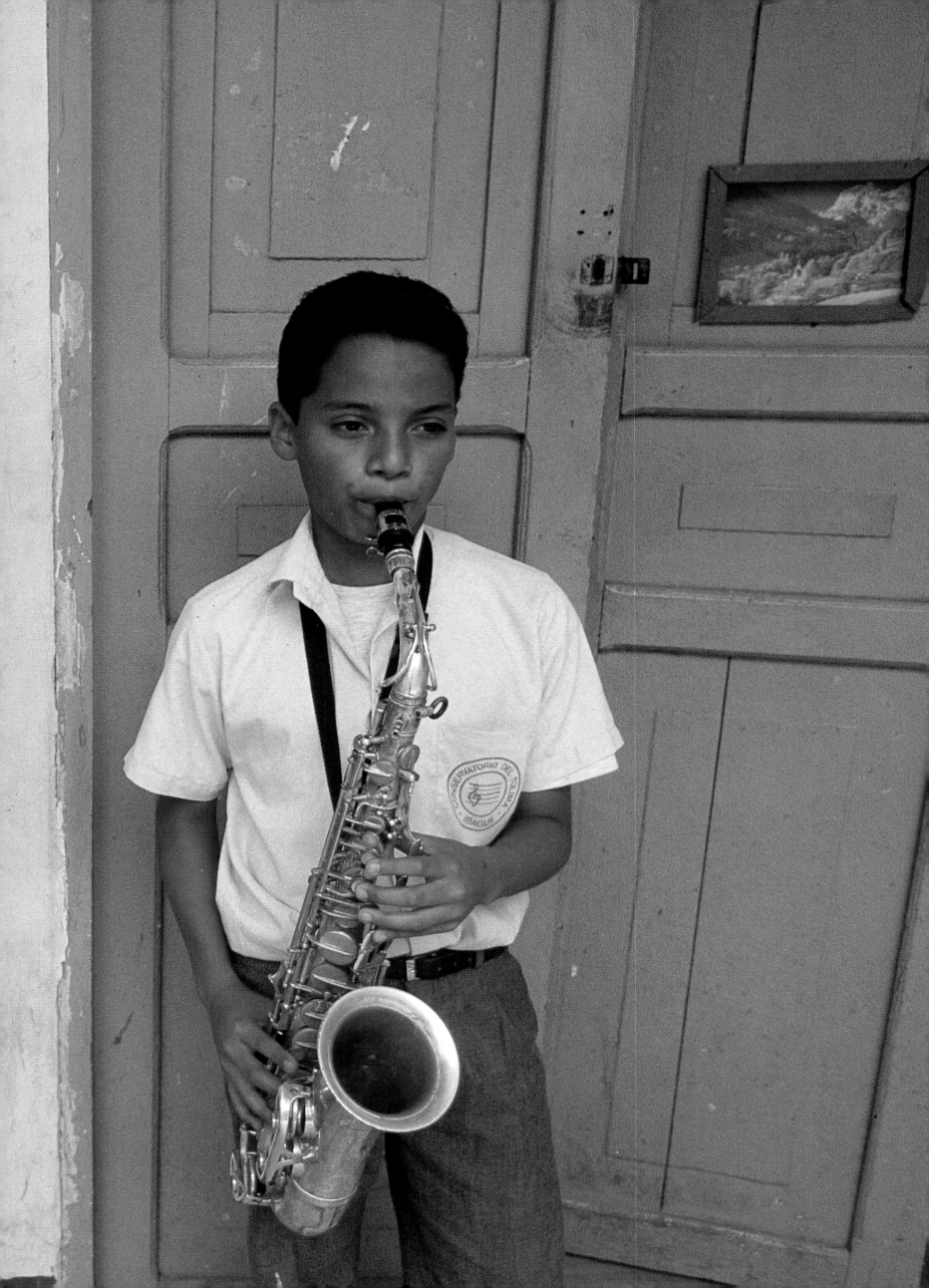

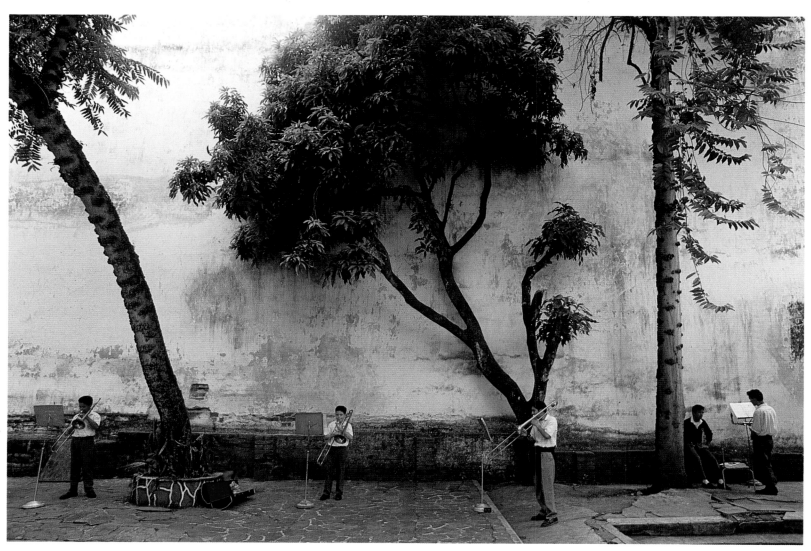

Trombone students in the Conservatory of Ibagué, Tolima

Many Colombian composers who have raised the eminently popular elements of Indian, Negro and mestizo rhythms and melodies to the level of classical music. In almost all the capitals of Colombia, there are schools and conservatories, as well as orchestras, bands and choral groups. Ibagué, the "musical city", excels for its special contribution to the enrichment and diffusion of Colombian music.

Preceding page, Saxophone student in the Conservatory of Ibagué, Tolima

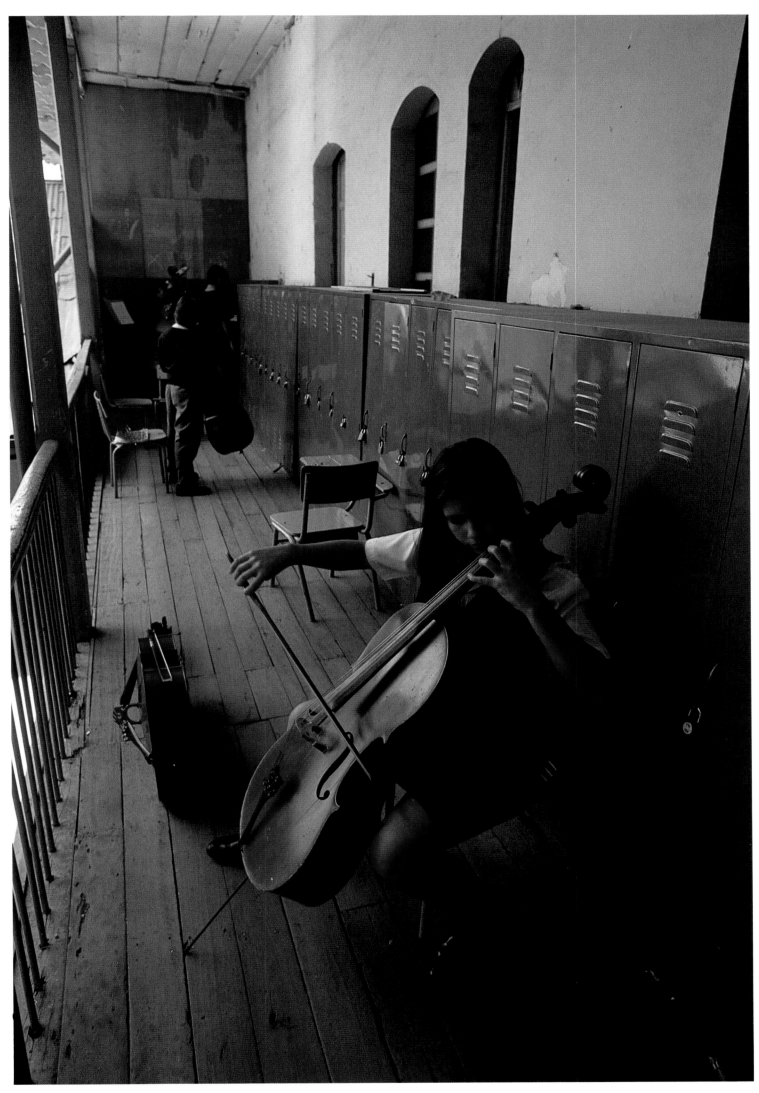

Conservatory of Ibagué, Tolima

135

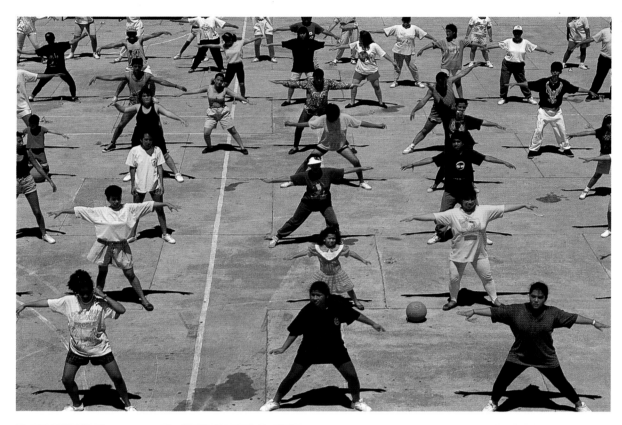

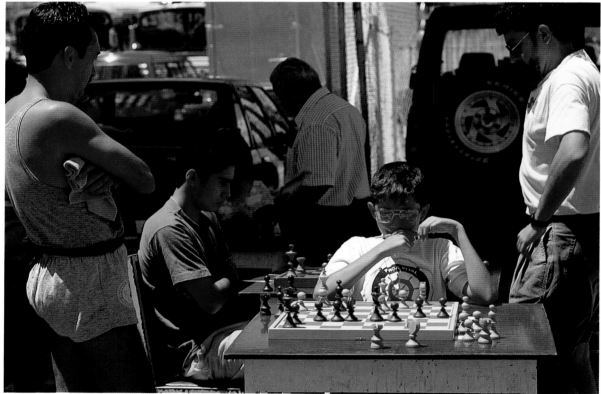

Aerobic gymnastics and chess players in Ibagué, Tolima

Although football and cycling are without a doubt the two "national sports", which along with box-ing and target-shooting have distinguished Colombia in international competitions, other sports captivate Colombians more and more. Sports are not only considered in a competitive fashion, but also as part of human development. The 1970, the National Games, which took place in Ibagué, marked an important milestone in the history of the city. The same thing happened in Cali during the Sixth Pan-American Games.

Olympic swimming pool in Ibagué, Tolima

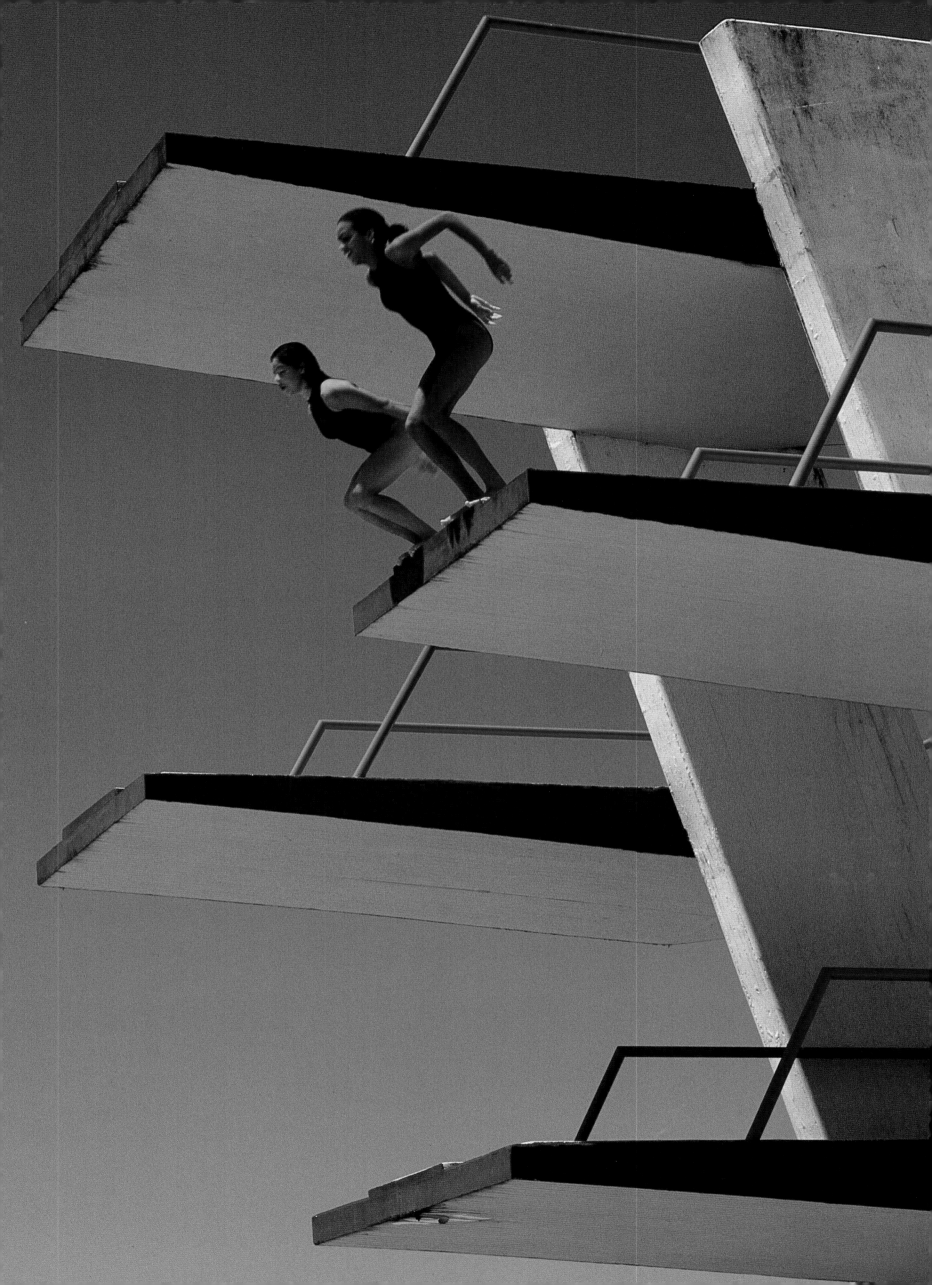

The city of Ibagué was founded in the XVI century where the waters flowing down from the Nevado del Tolima pour into the Magdalena valley. It is the economic capital of a prosperous zone dedicated to the industrial cultivation of cotton and rice; at the same time, the region is severely affected by the massive use of artificial fertilizers and insecticides.

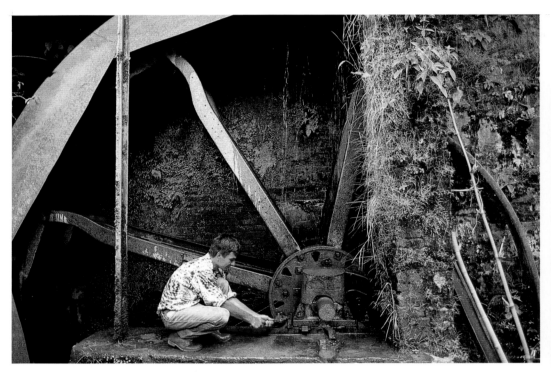

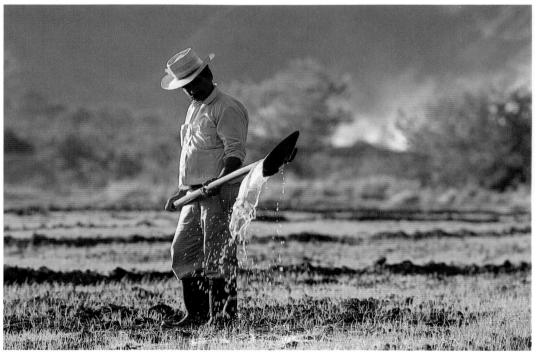

Repairing a mill wheel near Ibagué, Tolima
Rice field in El Guamo, Tolima

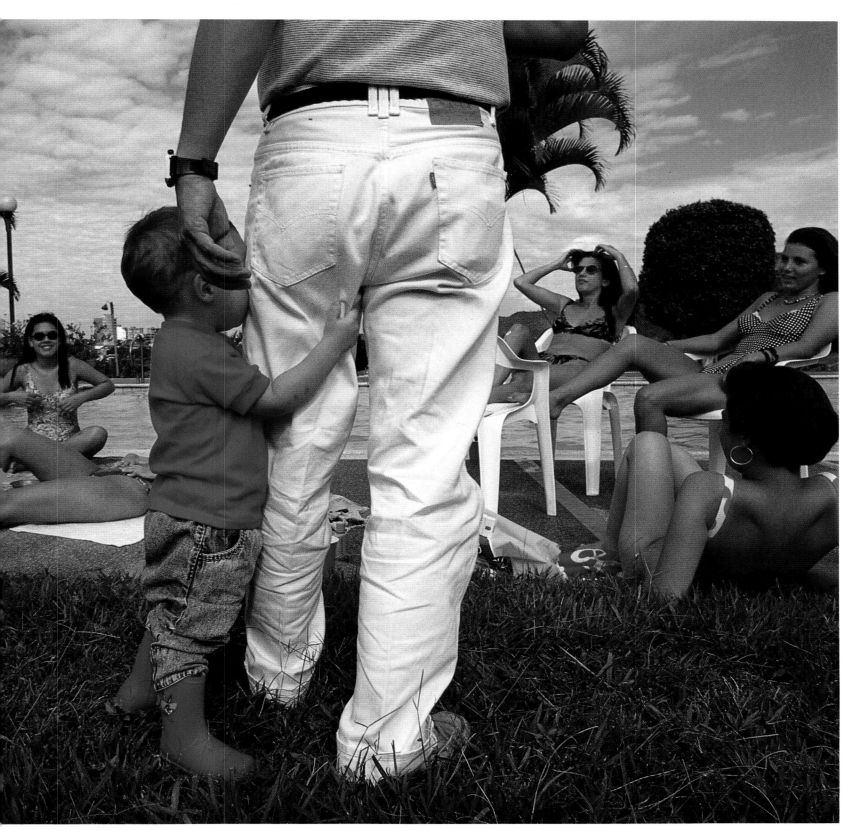

A relaxed Sunday near Ibagué, Tolima

After the eruption of the Nevado del Ruiz volcano and the mud avalanche that buried the city of Armero (which is also Tolima) in 1985, a series of economic incentives for the rebuilding of the zone have been adopted. These measures did not have the expected results in the disaster area. However, in other cities, such as Ibagué and Pereira –also favored by the measures– massive employment opportunities arose through the establishment of new factories and the modernization of machinery for urban and agroindustrial enterprises.

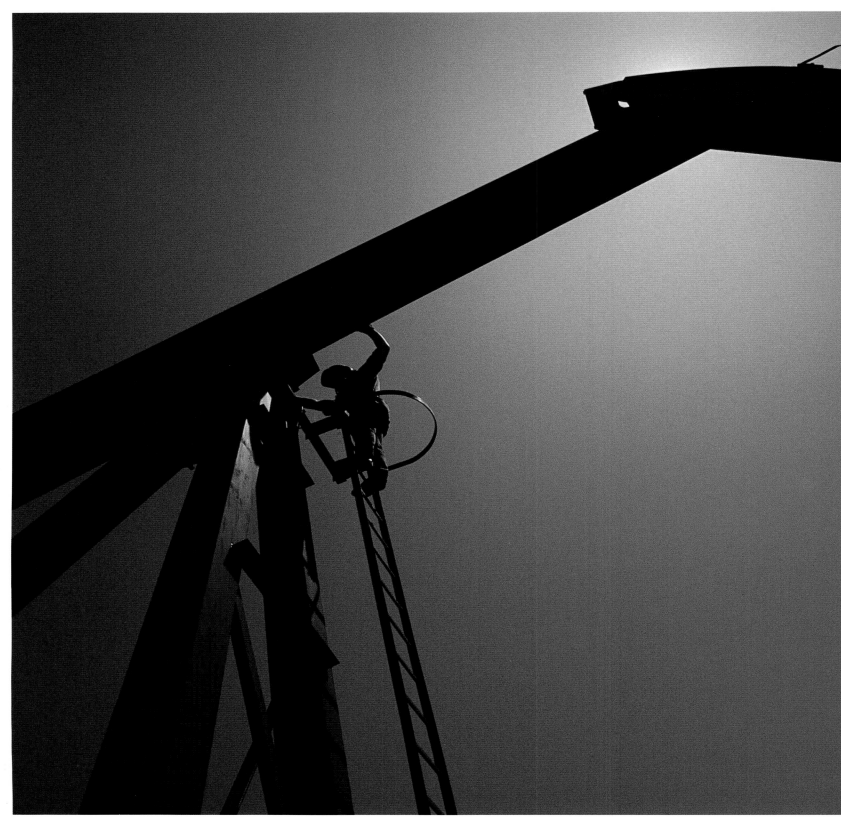

Oil well in the Tatacoa desert, province of Huila

The Magdalena river is born in the Páramo de las Papas and descends into the region known as the Alto Magdalena, where it meets tributaries in Tierradentro, at the foothills of the Nevado del Huila volcano, the highest peak of the Colombian Andes. On its banks, further on, lies the city of Neiva, the capital of the province of Huila, where one finds vast zones of torrid climate, desert on the surface, but rich in oil below.

Up to a few years ago, the economy of Huila was eminently based on agriculture and cattle raising, on small campesino *farms and on great rice* haciendas. *But then oil prospection and hydroelectric development around Betania dam (which intercepts the Magdalena river before Neiva) changed the physiognomy of the province.*

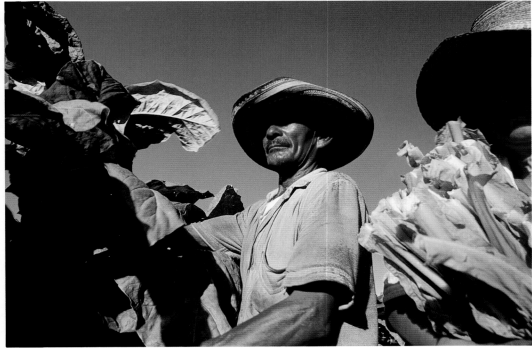

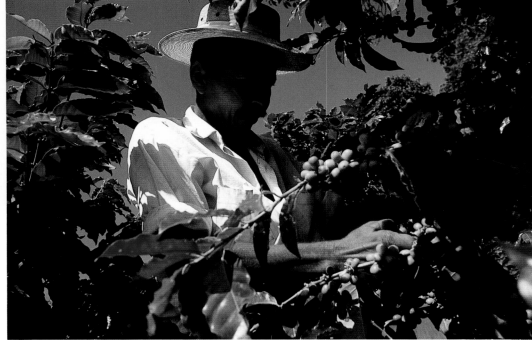

Tobacco and coffee collectors in Huila province

Following page, breeding cage for iguanas in zoo near Neiva, Huila

Mecato *and* parva *are regional terms alluding to food which is customarily eaten between meals with coffee or chocolate. Bizcochos de achira (the etymology of* bizcocho *means "cooked twice") are typical of Tolima and Huila provinces. The rhizomes of* achira *are ground into flour for the* bizcochos *and its seeds are used to make necklaces to protect children from bad spells.*

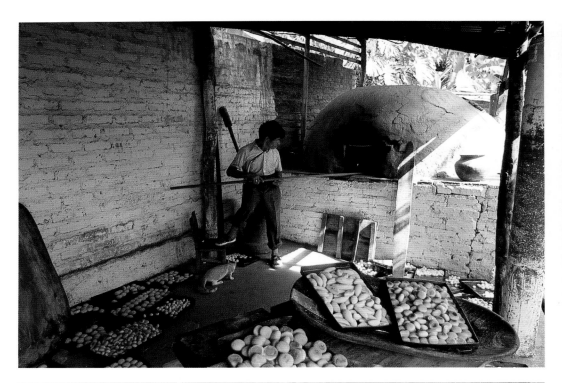

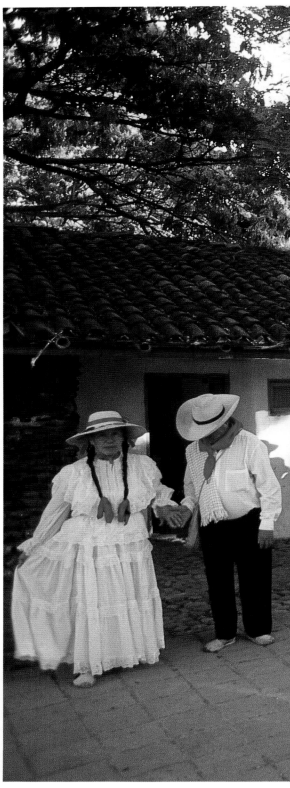

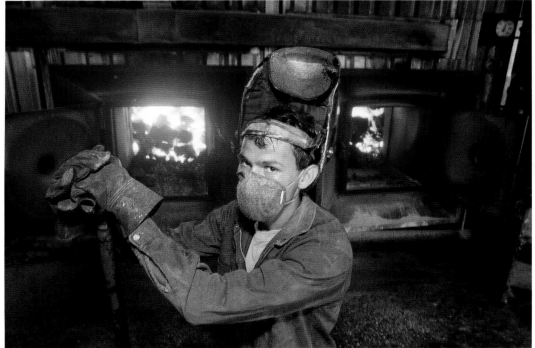

Bakery oven in Neiva, Huila
Worker of an industrial furnace in Neiva, Huila

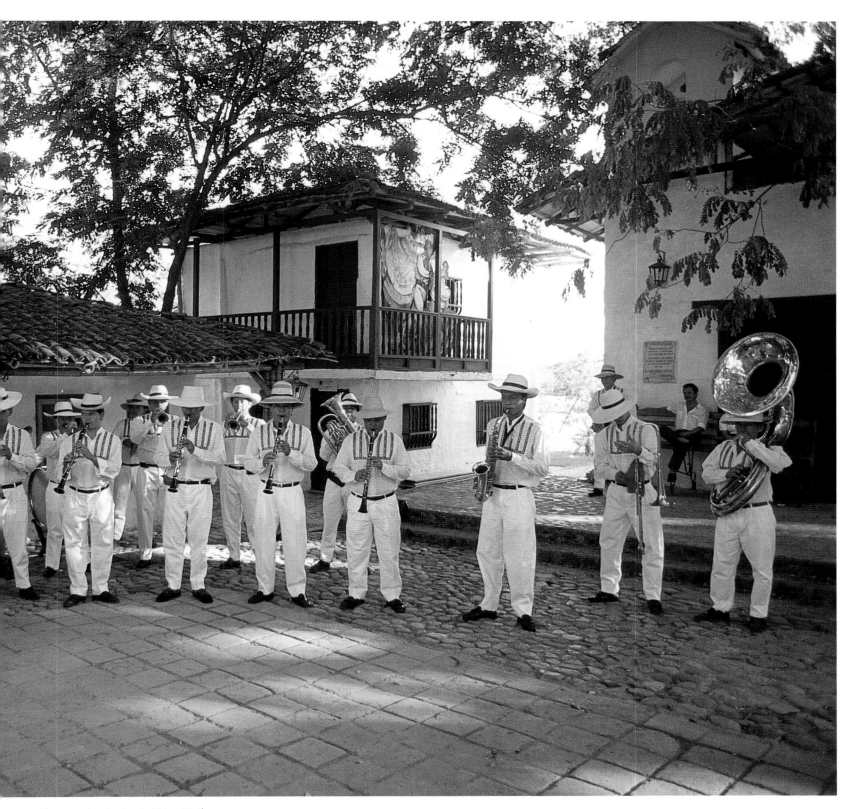

The party is swinging in Neiva, Huila

The bambuco, *the* sanjuanero, *the* guabina, *the* torbellino, *and the* bunde tolimense *are some of the* mestizo *dances, blending Indian and European elements, which are typical of the Colombian Andean region. The traditional fiestas of San Pedro and San Juan are celebrated in June in the provinces of Tolima and Huila, which were formerly one and known as Tolima Grande, and stretch over the Alto Magdalena valley. These festivities are rich in folkloric expressions: music, dances, costumes, handicrafts and traditional meals. The verb* sampedriar *denotes an obligatory activity for the fun-loving Colombians.*

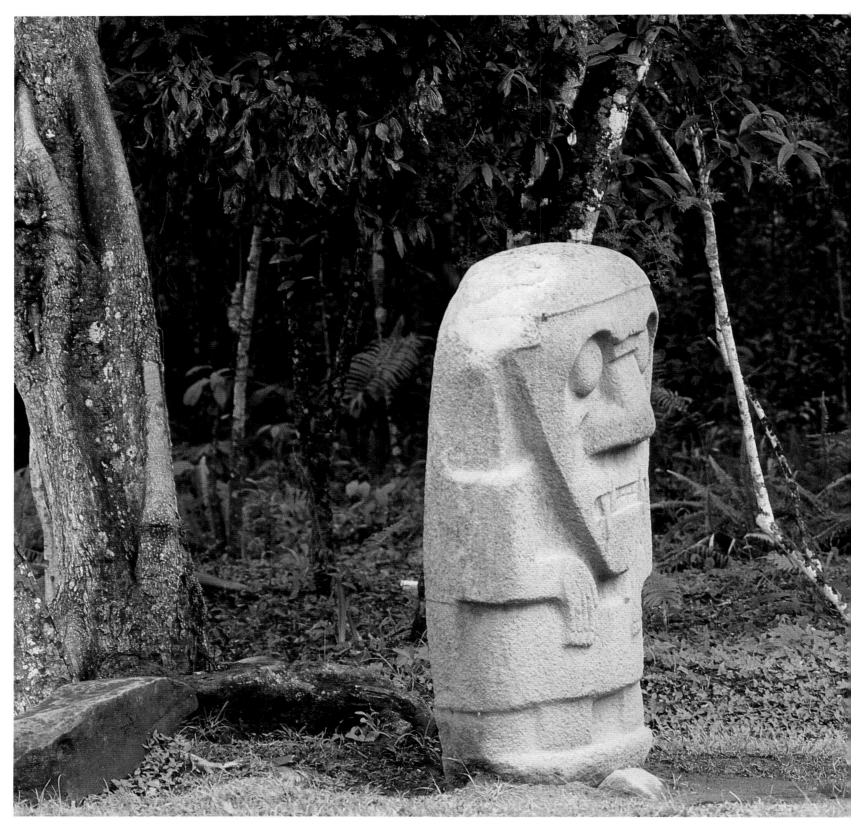

Stone statue in San Agustín, Huila

"Considering that our Colombian massif is a strategic point for the union, intersection and dispersion of cultures, it is believed that the area of San Agustín was a vast ceremonial center, an enormous religious site where people, products and ideas would arrive from other horizons (...) Sculpture was particularly guided by the desire to represent life after death for things and people; what one believes and what one has a premonition of, without seeing". Mauricio Puerta, archaeologist.

Graves or underground chambers were excavated in volcanic rock by an unknown culture that lived in the region of Tierradentro between the seventh and ninth centuries of our era. One descends into the graves down a stone stairway to a lateral chamber of various niches decorated with anthropomorphous and geometric shapes, where the dead were buried with their belongings.

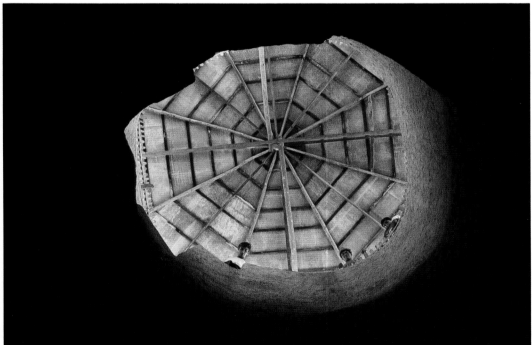

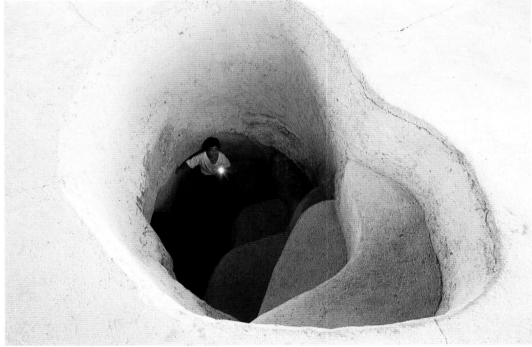

Indigenous underground chambers or graves in Tierradentro, Cauca

San Agustín is a mestizo village situated in one of the most important archaeological zones of America. A few minutes from here one finds the stone sculptures which have made it famous around the world and which were first described by Brother Juan de Santa Gertrudis in the XVII century.

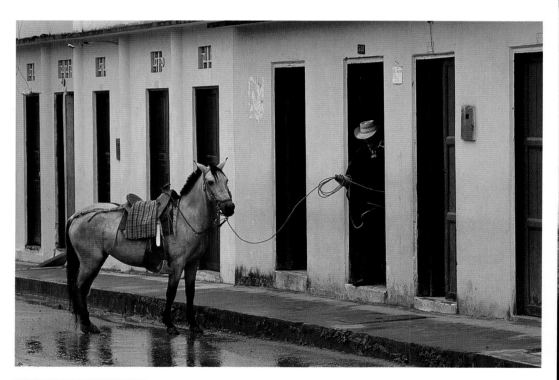

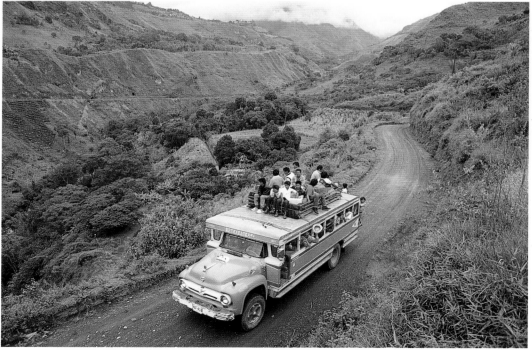

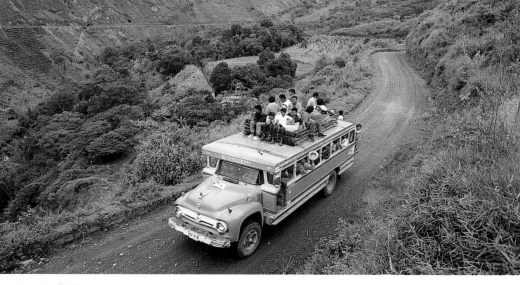

San Agustin, Huila
Chiva, *a typical rural bus, on the small winding roads of Huila.*

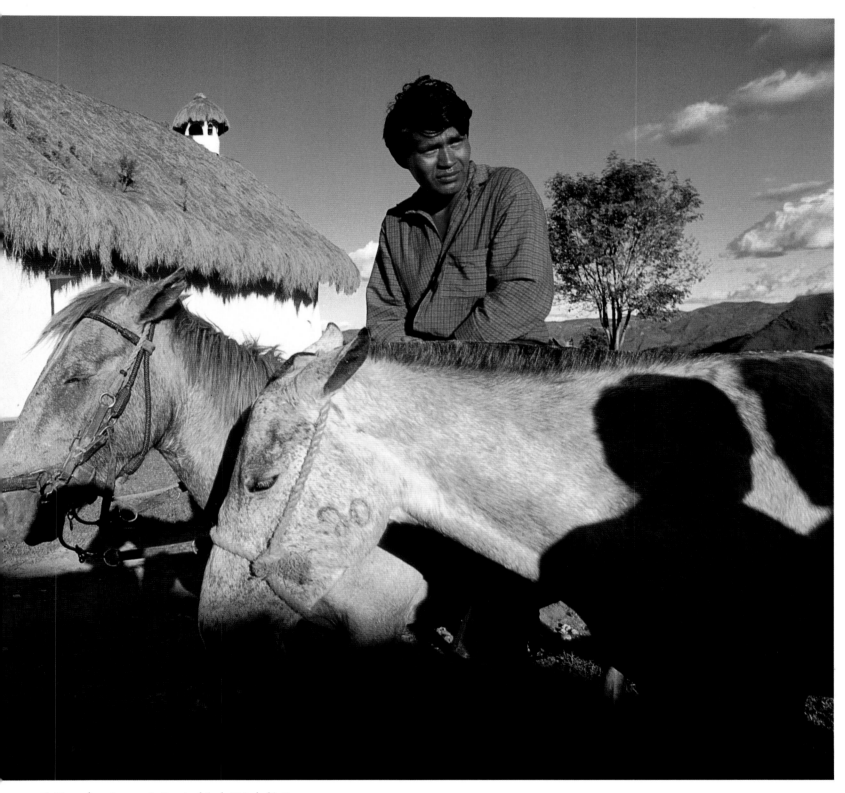

Cutting a horse's mane in San Andrés de Pisimbalá, Cauca

San Andrés de Pisimbalá, in the Tierradentro municipality of Inzá, is one of the many eminently indigenous settlements of Cauca province. The chapels of the zone are a tangible expression of the syncretism between the Catholic religion and pre-Columbian cultures. The toponymy of Tierradentro is full of suggestive sonorities: Chinas, Mosoco, Tálaga, Taravira, Vitoncó, Tumbichucue.

Following page, street on Good Friday morning, Popayán, Cauca

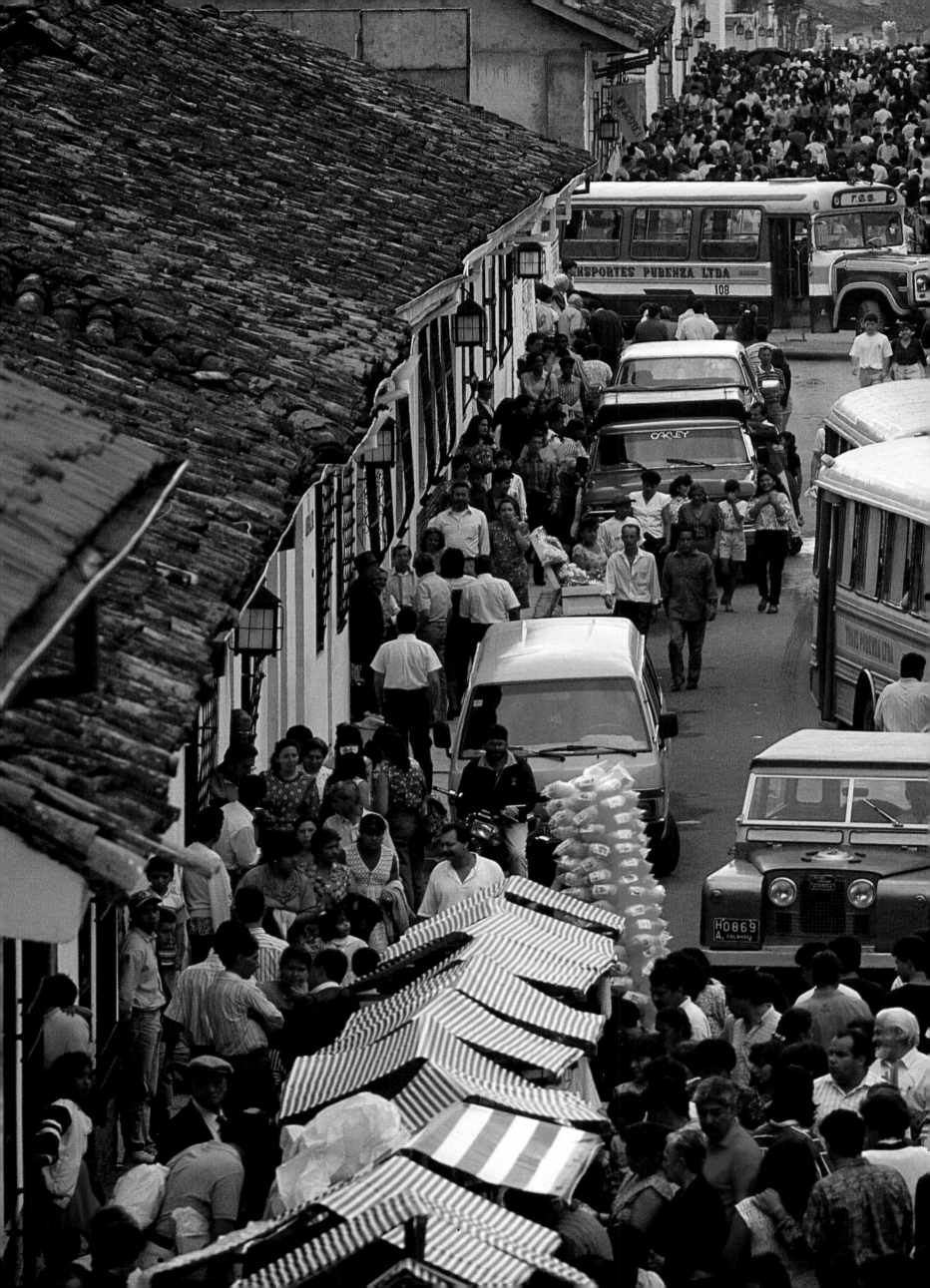

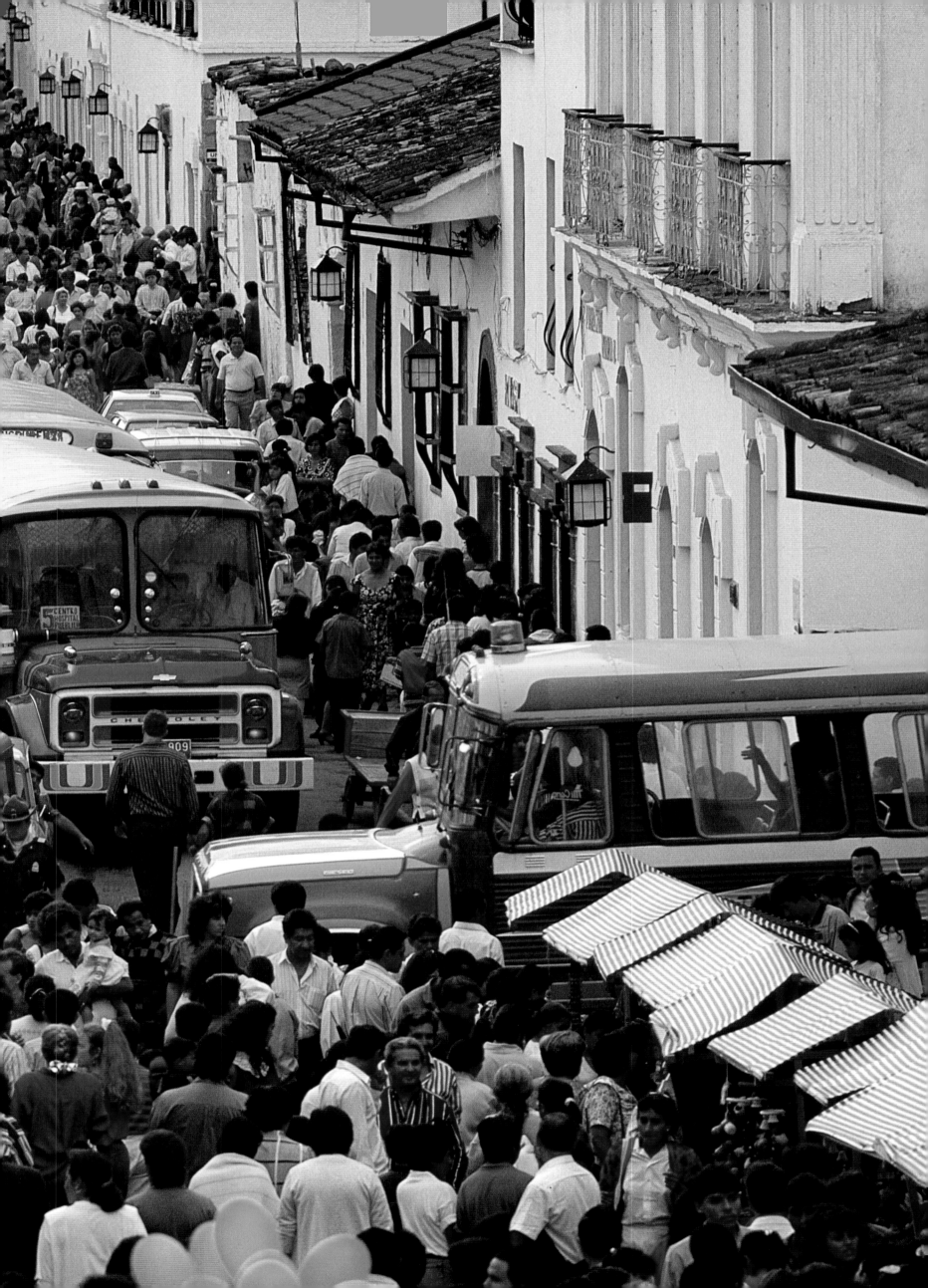

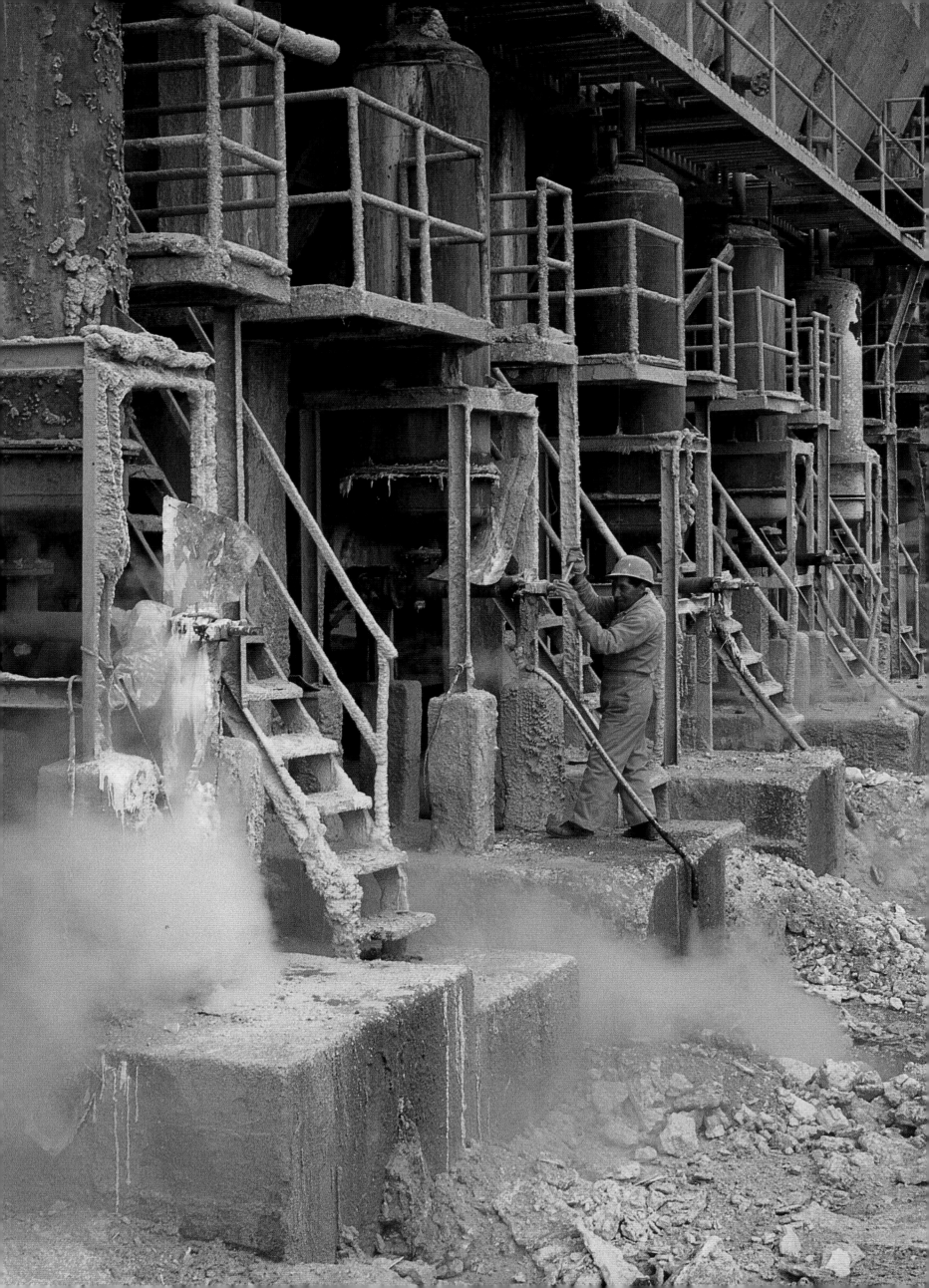

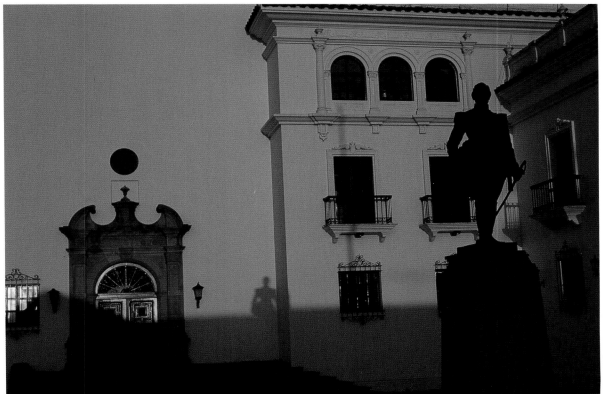

A street in Popayán, Cauca

Palacio Nacional in Popayán, Cauca

The city of Popayán was founded in 1537 by Don Sebastián de Belalcázar, and, during the Colonial era and the first century of the Republic, it was one of the country's main centers of political decision-making, and the hub of the area's economic activity. Indigenous and slave labour worked on the large haciendas and in the gold mines of the Gran Cauca which generated the relative wealth that the Popayán oligarchy used to flaunt arrogantly, and that one can still feel in the physiognomy of churches and mansions and in the rigidity of urban design.

Wood-carver in Popayán, Cauca

Reconstruction of San Francisco bell tower, Popayán, Cauca.

Despite the high cost of material damages and the loss of human lives, the earthquake that destroyed Popayán in 1983 was paradoxically an opportunity to rescue the city from a decline that seemed inevitable. Many years after the catastrophe, not only the Historical Downtown Area and popular neighborhoods have been reconstructed, but also many of the elements that make up the valuable cultural heritage of Popayán's inhabitants (religious images, art works, historical documents) have been recovered and restored.

Historical Record "José María Arboleda Llorente", Popayán, Cauca

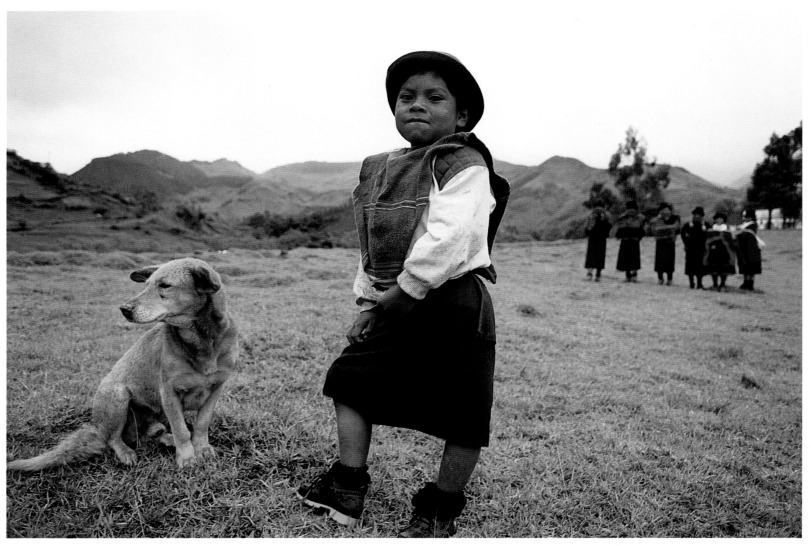

Guambiano boy, Silvia, Cauca

One of the provinces in Colombia with the highest Indian population is Cauca. Guambianos, Paeces and Yanaconas live in different mountain valleys, among other communities descending from different linguistic groups of more confusing origins; and on the province's Pacific coast live the Embera Indians. Also present are important concentrations of Black communities: on the Pacific, in the Patía river valley, and at the head of the level geographical valley of the Cauca river. Most of Cauca's inhabitants are Mestizos, resulting from various mixtures between Indians, Blacks and Whites. The new Colombian Constitution has had a special meaning for this province of 30,500-square kilometers by establishing the foundations for new forms of intercultural and interethnic coexistence which strengthens the participation of previously-ignored communities in national decisions.

Preceding page, Guambiano Indians in a funeral, taking cover from the rain under a plastic sheet in Silvia, Cauca.

Guambiano Indians, Silvia, Cauca

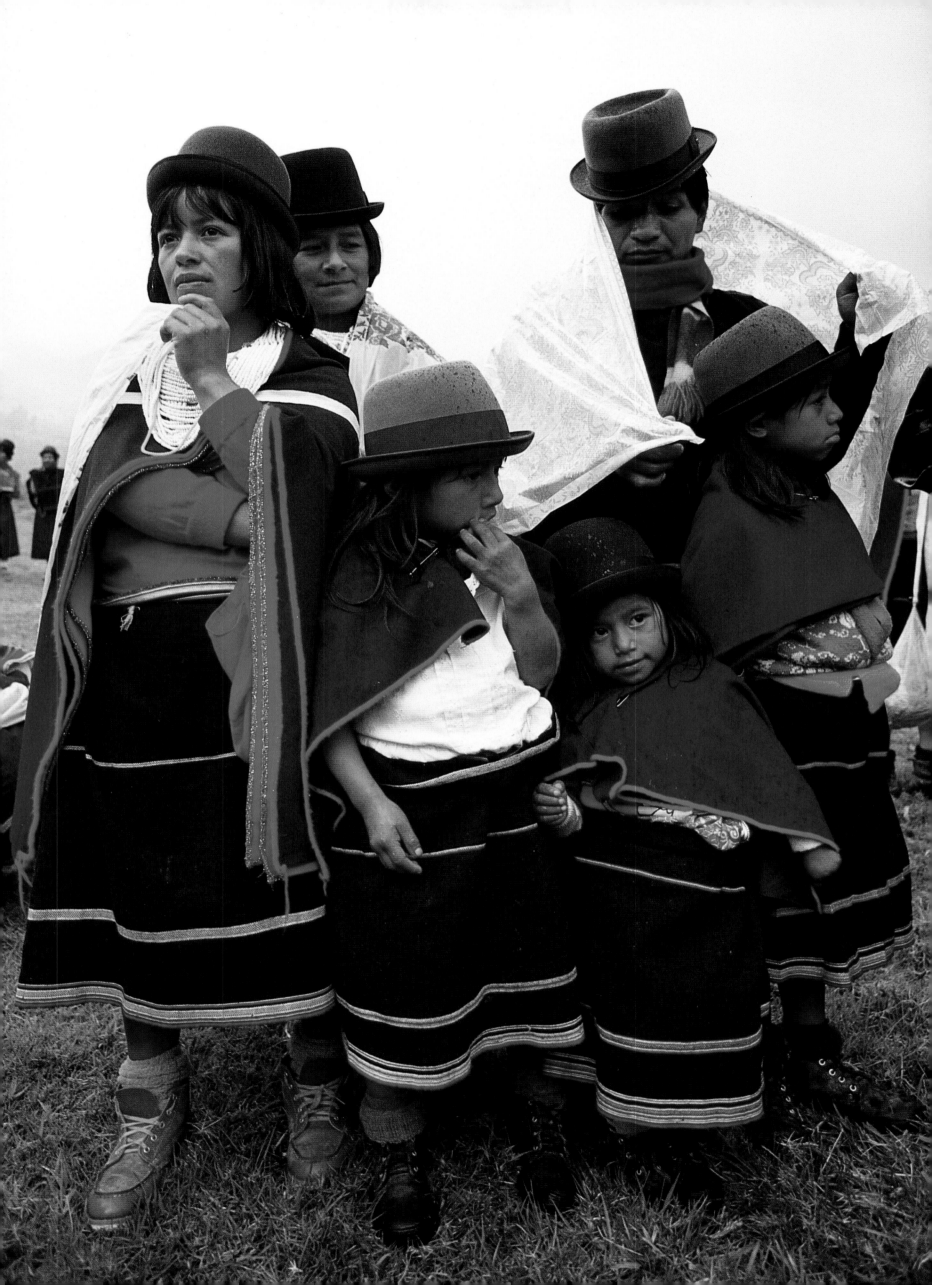

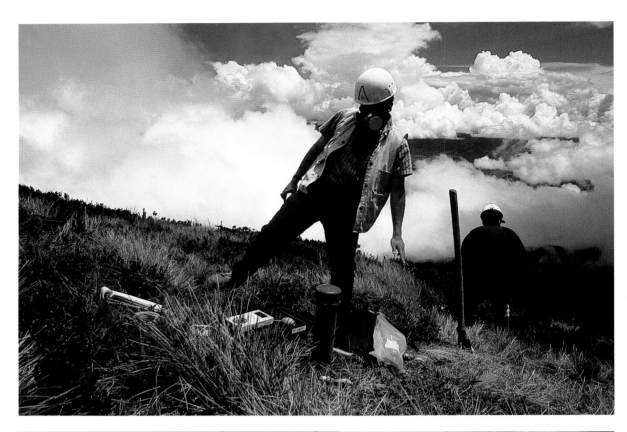

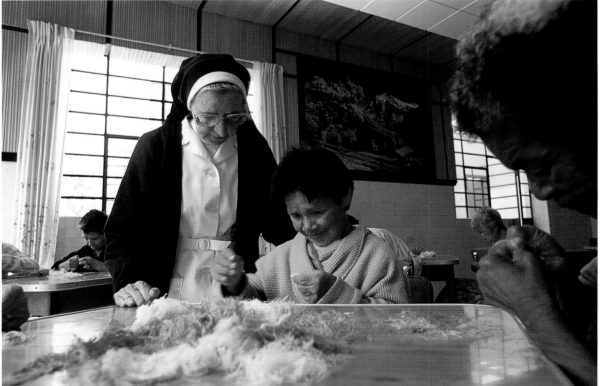

A volcanologist measures gases near the crater of the Galeras volcano, near Pasto, Nariño

Manual therapy in the psychiatric hospital of Pasto

The city of Pasto, capital of the province of Nariño, stretches over the Atrís valley, at the bottom of active volcano Galeras, dubbed "volcano of the decade" by scientists. Craftsmen from Pasto, influenced to an equal degree by the colonial school of Quito and their own Indian ancestors, have attained national fame for their skill with wood, for their exquisite "Pasto varnish", and for the carvings in tagua, *ivory nut palm. The famous "Panama hats" are actually woven in Sandoná, Nariño, with* iraca *fiber.*

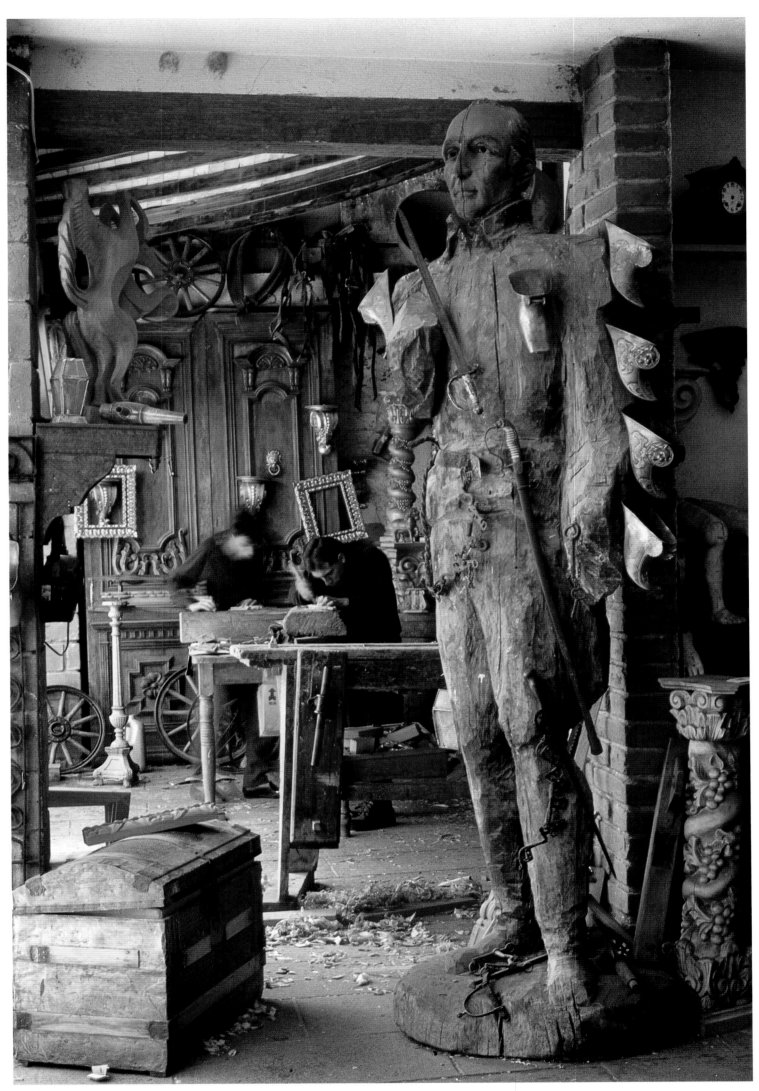

Wood sculpture workshop in Pasto, Nariño

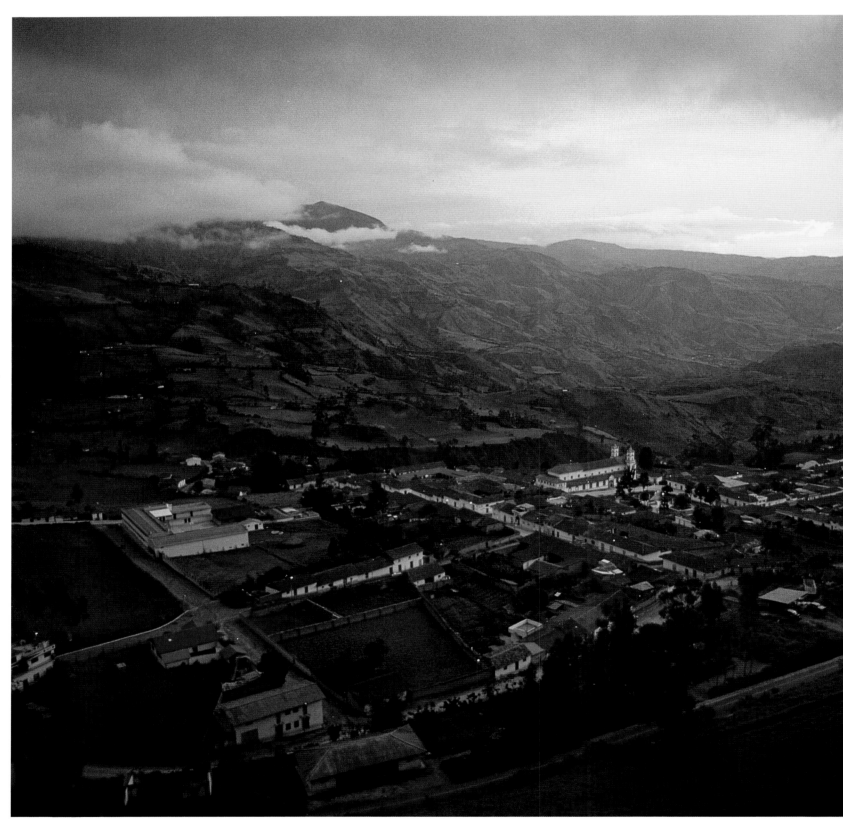

Late afternoon in the town of Tangua, Nariño

The province of Nariño can be reached to the North from Cauca, crossing a tributary of the Patía, the Mayo river. Then oner plunges into the canyon of Juanambú, before ascending to a land of fertile soils and bitter-cold winds extending to the frontier with Ecuador in the city of Ipiales. To the west one climbs to the Meseta de Guachucal and the town of Túquerres (where people worship San Emigdio, the patron of earthquakes), from where one descends again steeply to the port of Tumaco on the Pacific.

Nariño is full of volcanoes: Chiles, Cumbal, Azufral, Morasurco, Galeras. They all have inhabited and planted foothills (fertilized for centuries by the volcanoes themselves). This province also has an Amazon region, which is seen from Lake Cocha, the biggest natural water reservoir in Colombia, almost 3,000 meters high.

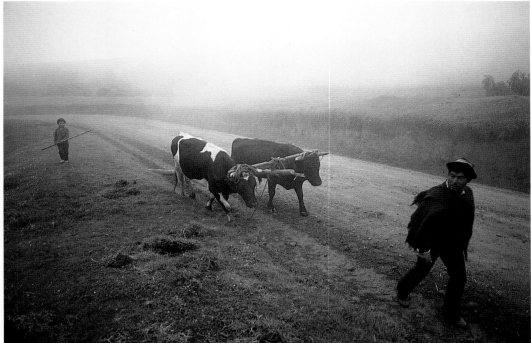

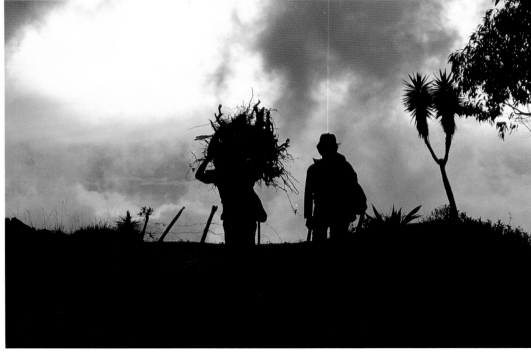

Peasants from Yacuanquer, on the southern slope of the Galeras volcano, Nariño

Following page, peasant home in Yacuanquer, Nariño

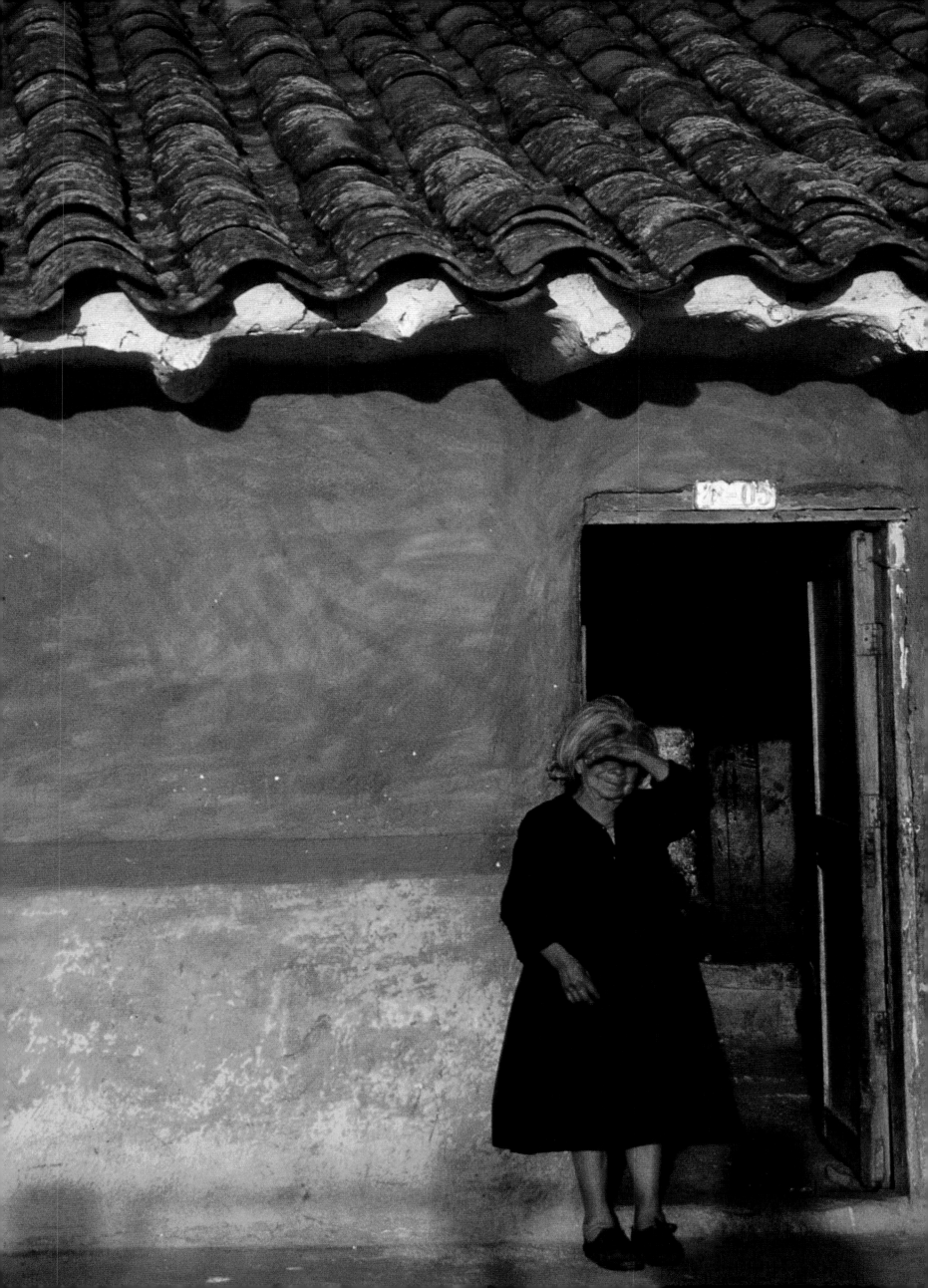

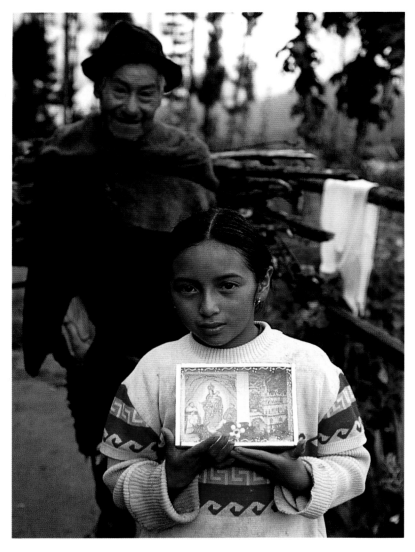

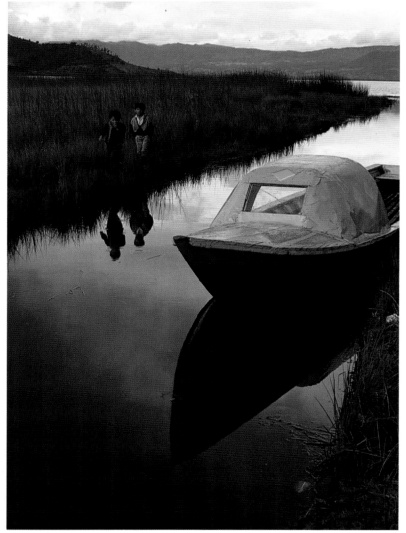

Peasants of Lake Cocha, Nariño

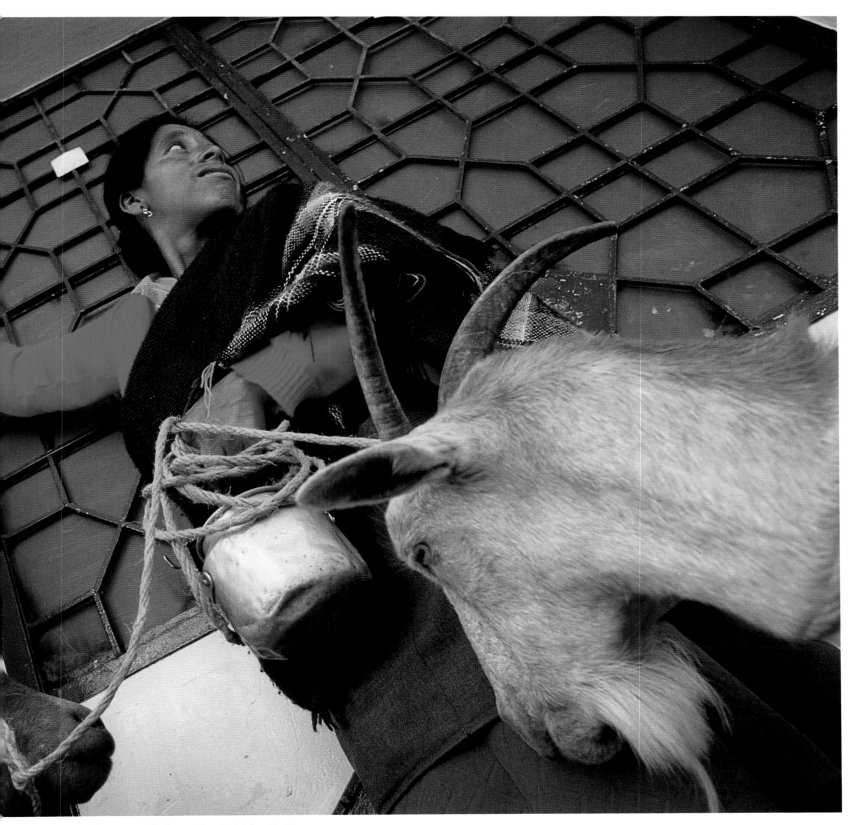

Woman selling goat milk door to door in Ipiales, Nariño

Peasants around Lake Cocha, who used to support themselves by making charcoal and lumbering, have understood that, within a few years, the most profitable activity is going to be water production. Around the lake, more and more "private natural reservations" are emerging, farms where landowner peasants preserve significant areas of forests and páramos. Each one has a special attraction for the visitor: a legend, a mysterious spot, an organic vegetable garden, a waterfall...

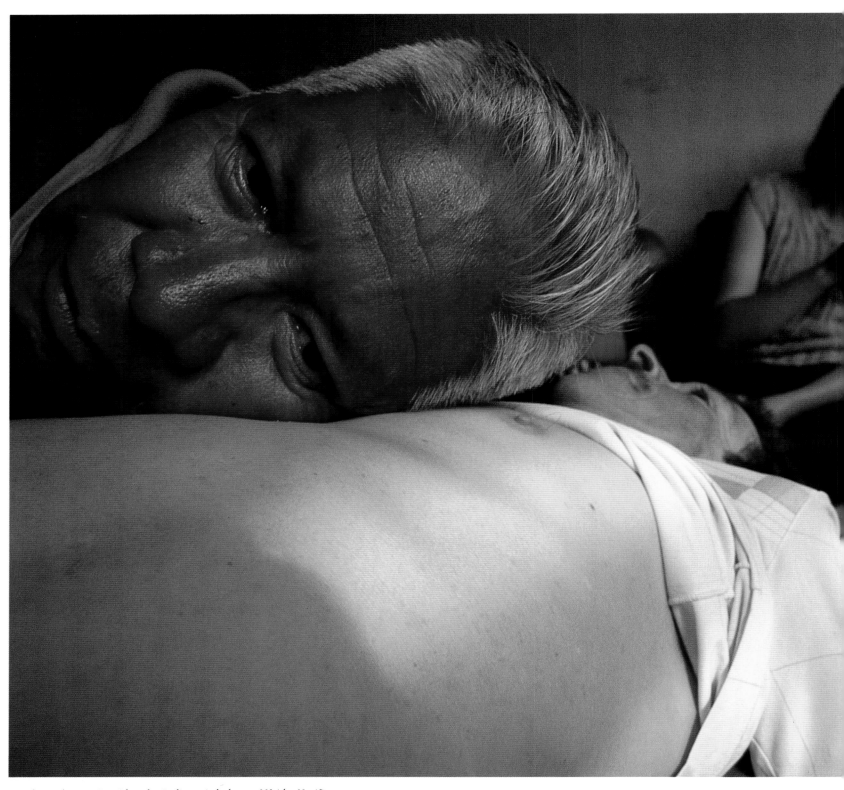

"Traditional Doctor" or Sibundoy Indian witch doctor, Mérida, Nariño

All over Colombia, especially in rural zones, but also in cities, the so-called "traditional medicine", practiced by Indian witch doctors and shamans, still maintains its power in wide sectors of the population, to the extent that several institutions have started to recognize it as an important factor for guaranteeing the health of Colombians. In every market place worthy of its salt there is a Sibundoy Indian selling curative herbs, spangle necklaces, armadillo shells, love incantations and amulets against bad spells.

The Sibundoy community is composed of more than 700 families –around four thousand Indians– living in the Sibundoy valley in the province of Putumayo, whose capital is Mocoa. In their language, they call themselves tabanoy, which means "to the people", and camëntsá, which means "all the same" or "for themselves".

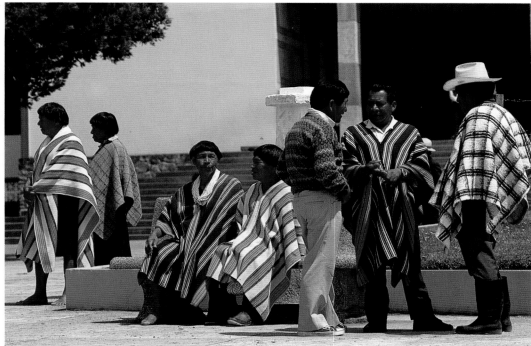

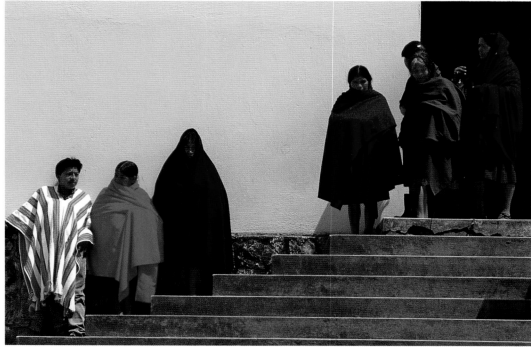

Indians from the Sibundoy valley, Putumayo

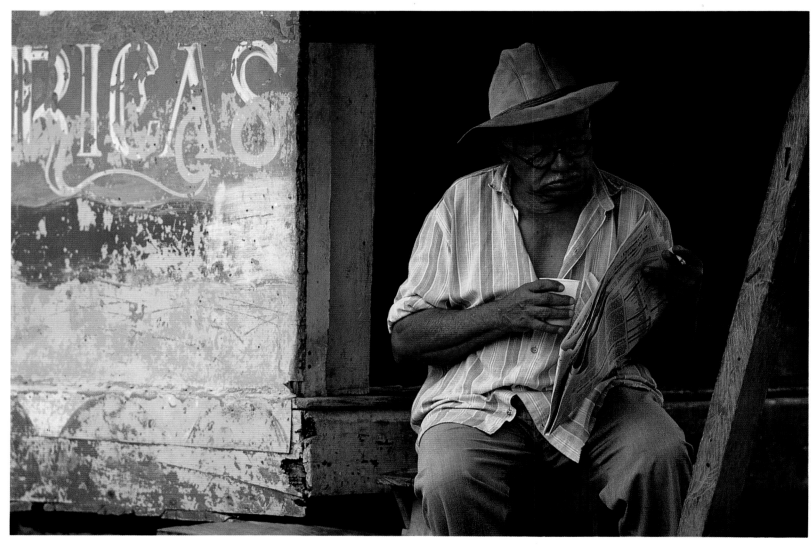

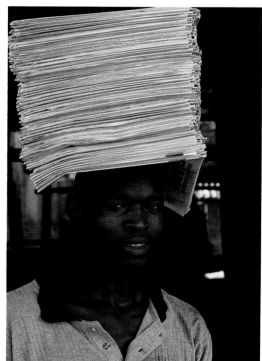

Reading the newspaper in Tumaco, Nariño

Newspaper vendor in Buenaventura, province of Valle del Cauca

The "Biogeographic Chocó", a name given to the Colombian Pacific coast which also comprises part of the coasts of Ecuador and Panamá, has one of the highest rainfalls on the planet. It is mostly inhabited by Blacks whose ancestors arrived with the Spanish in the XVII century to work as slaves in the gold mines, or were cimarrones, runaway slaves from their masters in the Andean zones. The main cities on the Pacific coast are Quibdó (capital of Chocó province), Buenaventura, (the most important Colombian port on the Pacific), Guapí in Cauca and Tumaco in Nariño.

Girl from Guapi, Cauca

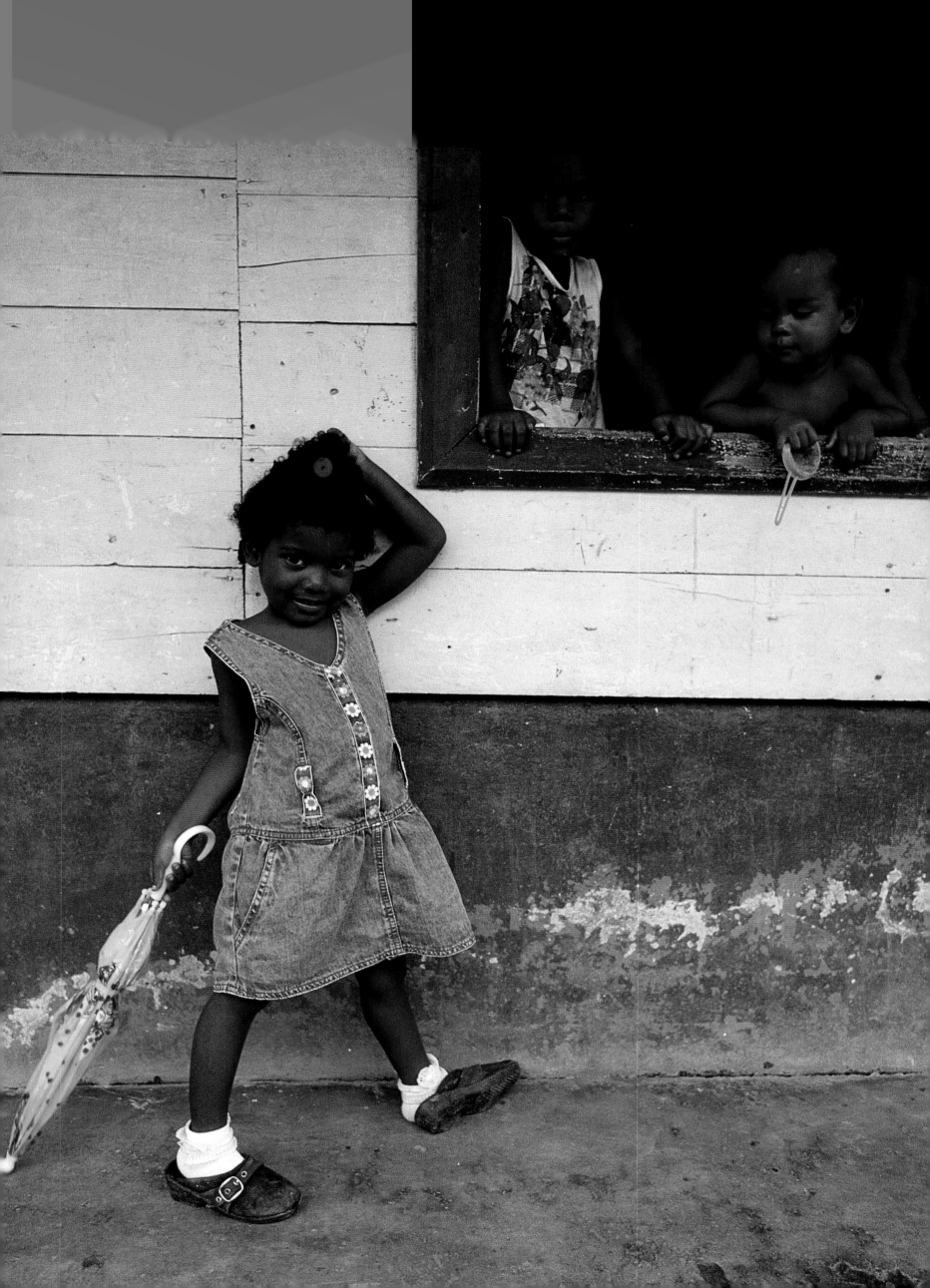

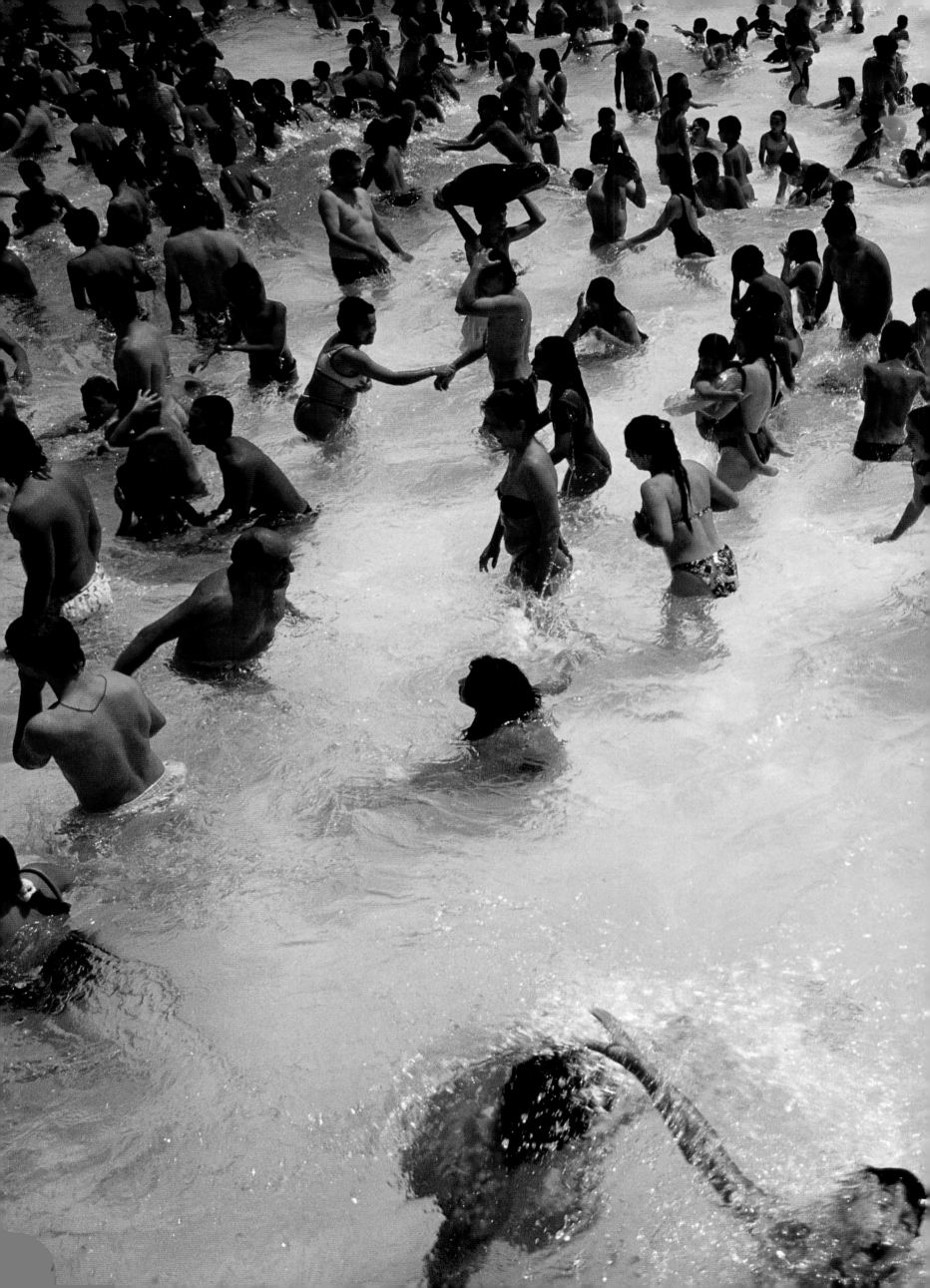

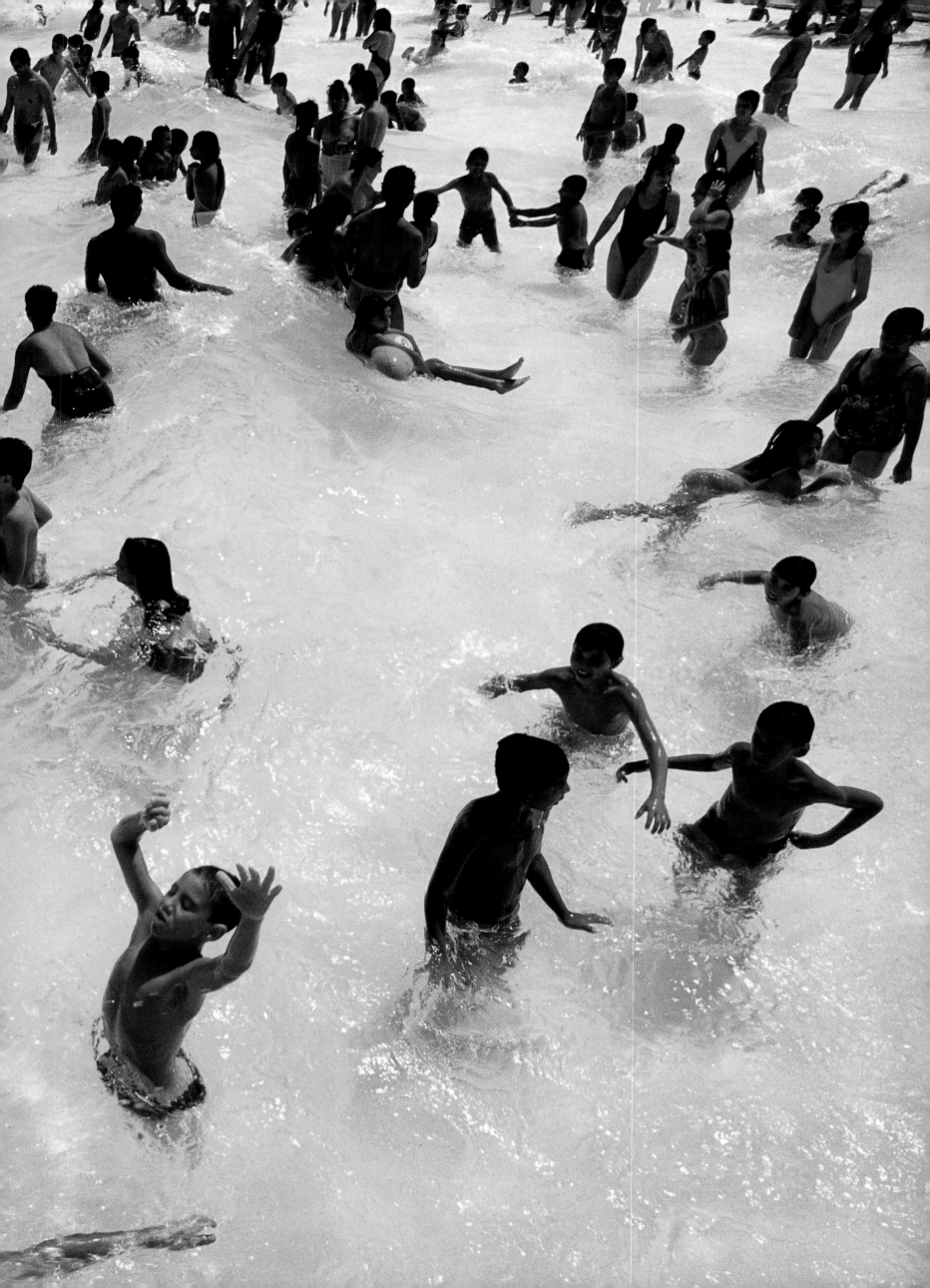

Flying a kite in the San Antonio neighbourhood of Cali, Valle del Cauca

Preceding page, swimming pool with artificial waves in Parque de la Caña, in Cali, province of Valle del Cauca

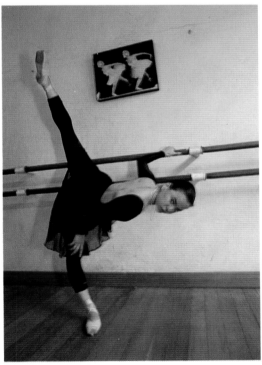

Candy vendor in front of La Tertulia Museum, Cali, Valle del Cauca

Ballet school in Cali, Valle del Cauca

Cali, the capital of the province of Valle del Cauca, is the main economic and cultural center of southwest Colombia. It is a thousand meters above sea level and stretches along the whimsical meanders of the Cauca river, under the watchful eye of Los Farallones, the highest point of the western cordillera in that zone. "The capital of salsa" is a city with a Caribbean atmosphere despite the fact that it is located in one of the Pacific provinces.

175

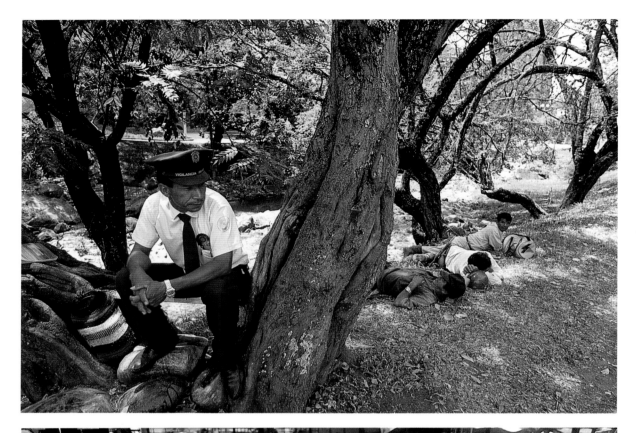

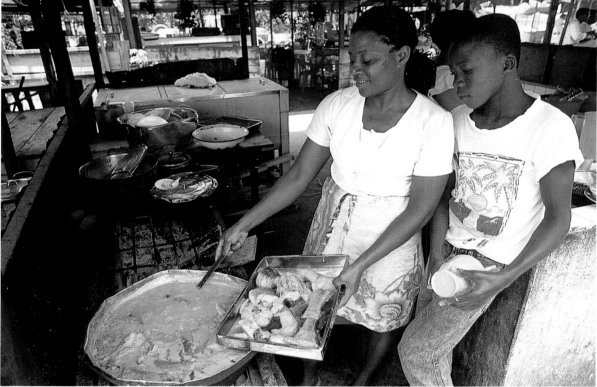

Resting after lunch in front of the Cali river, Valle del Cauca

Cooking fish in Cali, Valle del Cauca

Cuisine from the provinces of Valle and Cauca includes dishes from the Pacific coast and the Andean region. In the first case coconuts, fish, and bananas prevail, in the second, corn and potatoes. Combinations and forms of preparation exceed all imaginable possibilities.

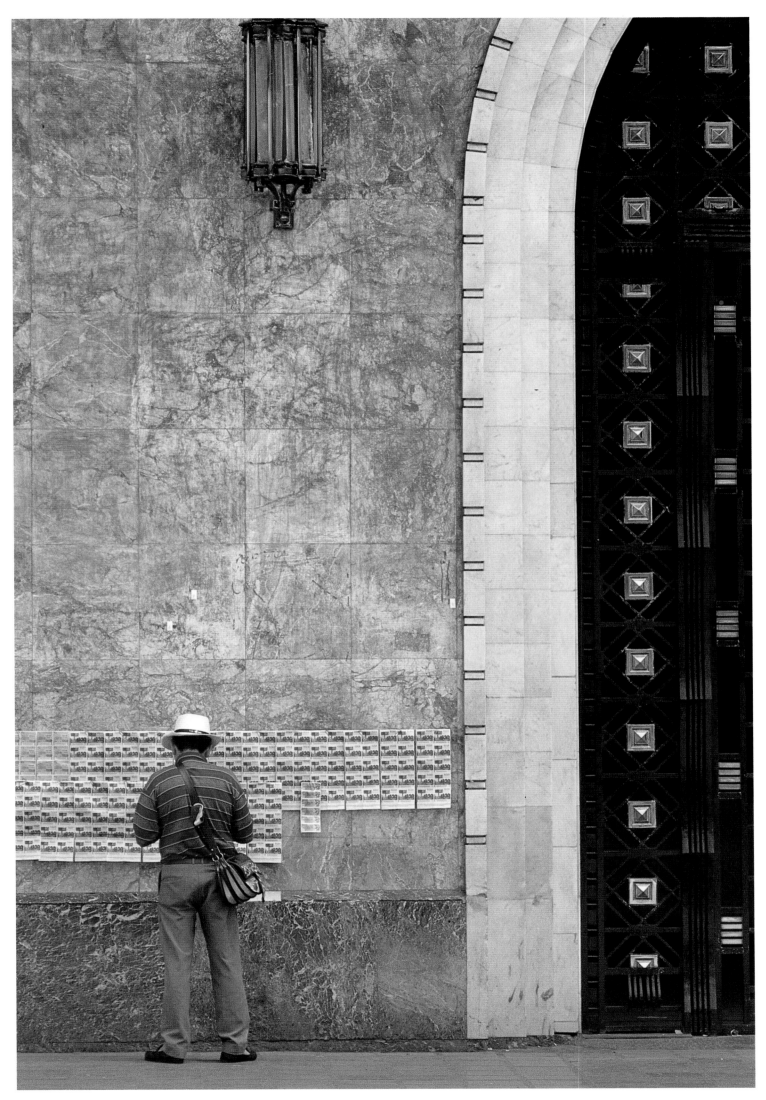

Lottery ticket vendor in Cali, Valle del Cauca

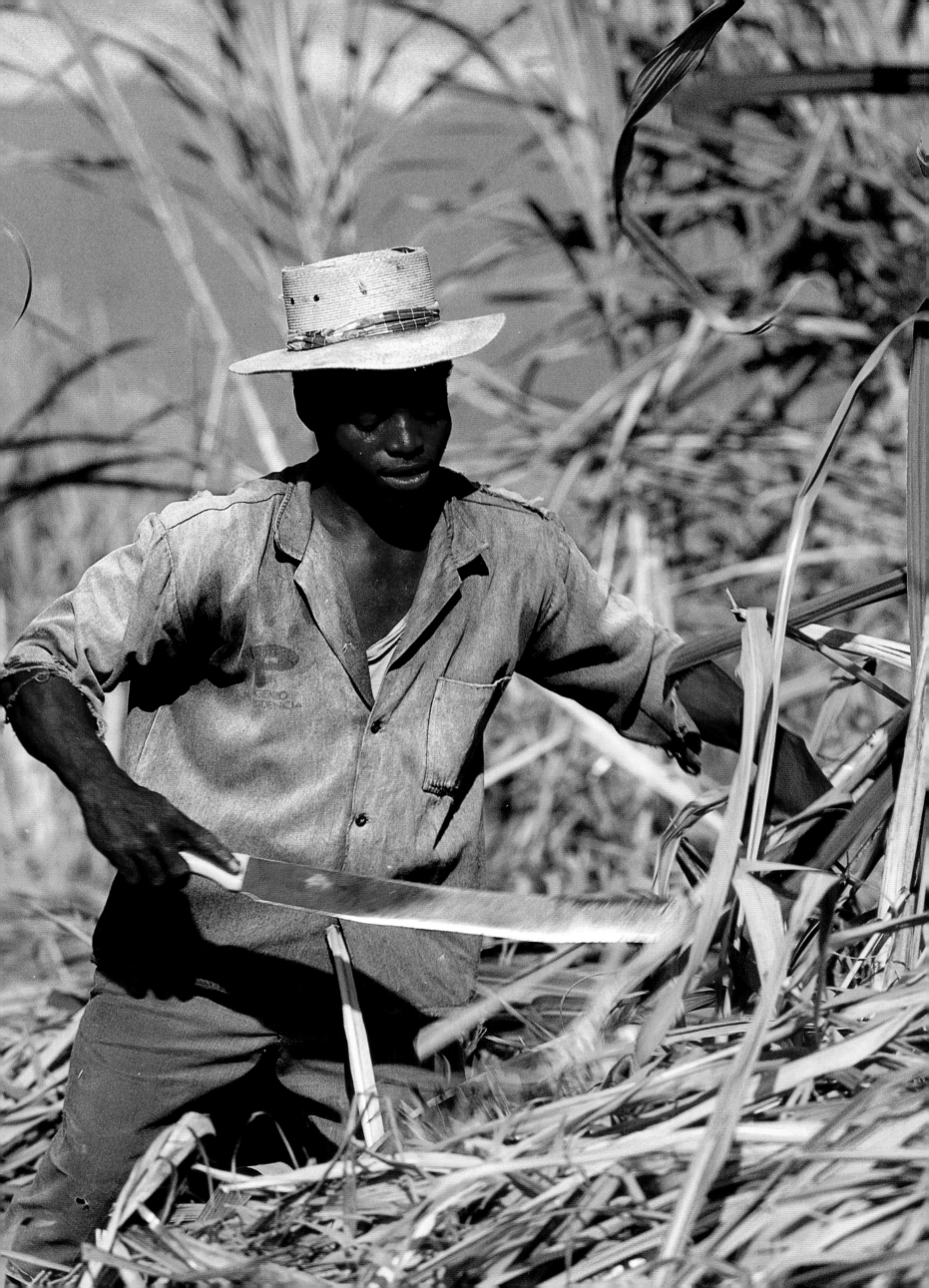

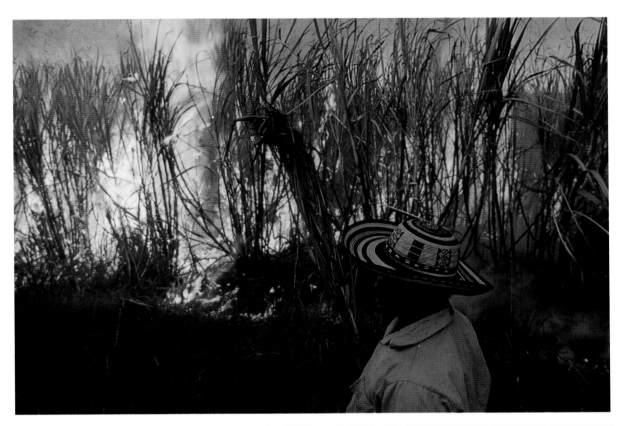

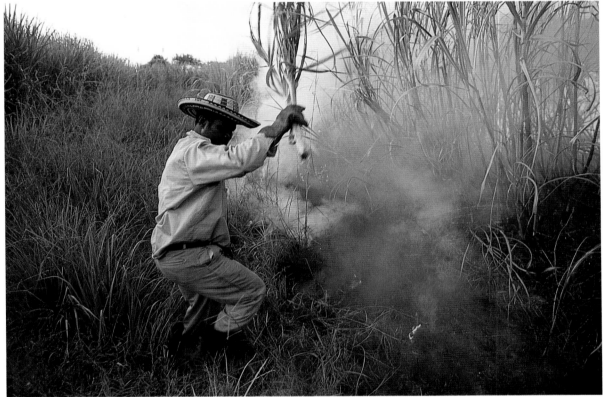

Sugarcane cutter, Valle del Cauca

On the one hand, the sugarcane agricultural industry (together with the Buenaventura seaport - possibly the one handling most cargo on the South American Pacific Coast) has been the main cause of the enormous economic prosperity of the Valle del Cauca. On the other hand, its uncontainable expansion has created many problems for the environment: loss of genetic diversity, impoverishment and salinization of soils, pollution due to agrochemicals and air contamination.

Burning before the sugarcane harvest, Valle del Cauca

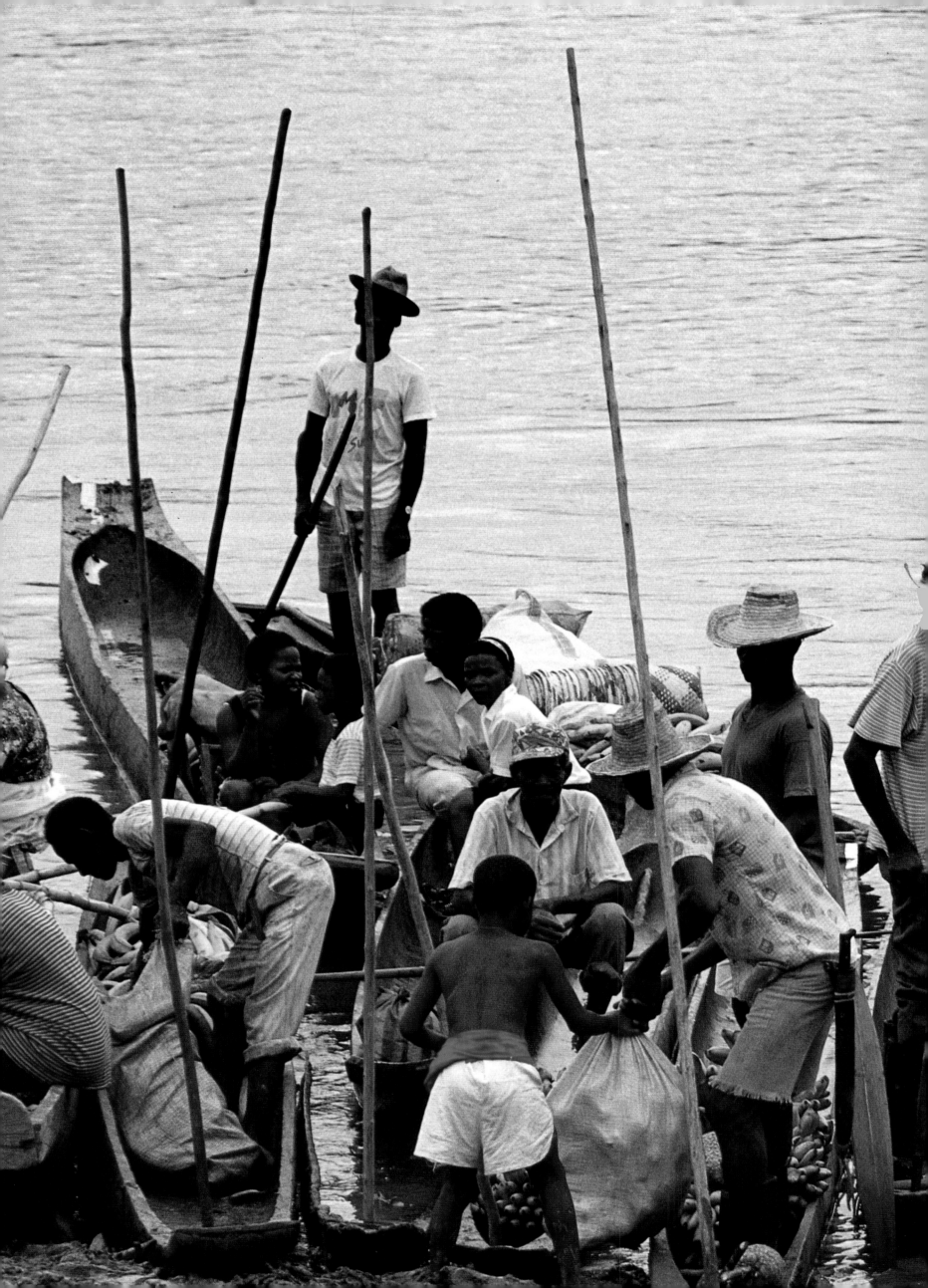

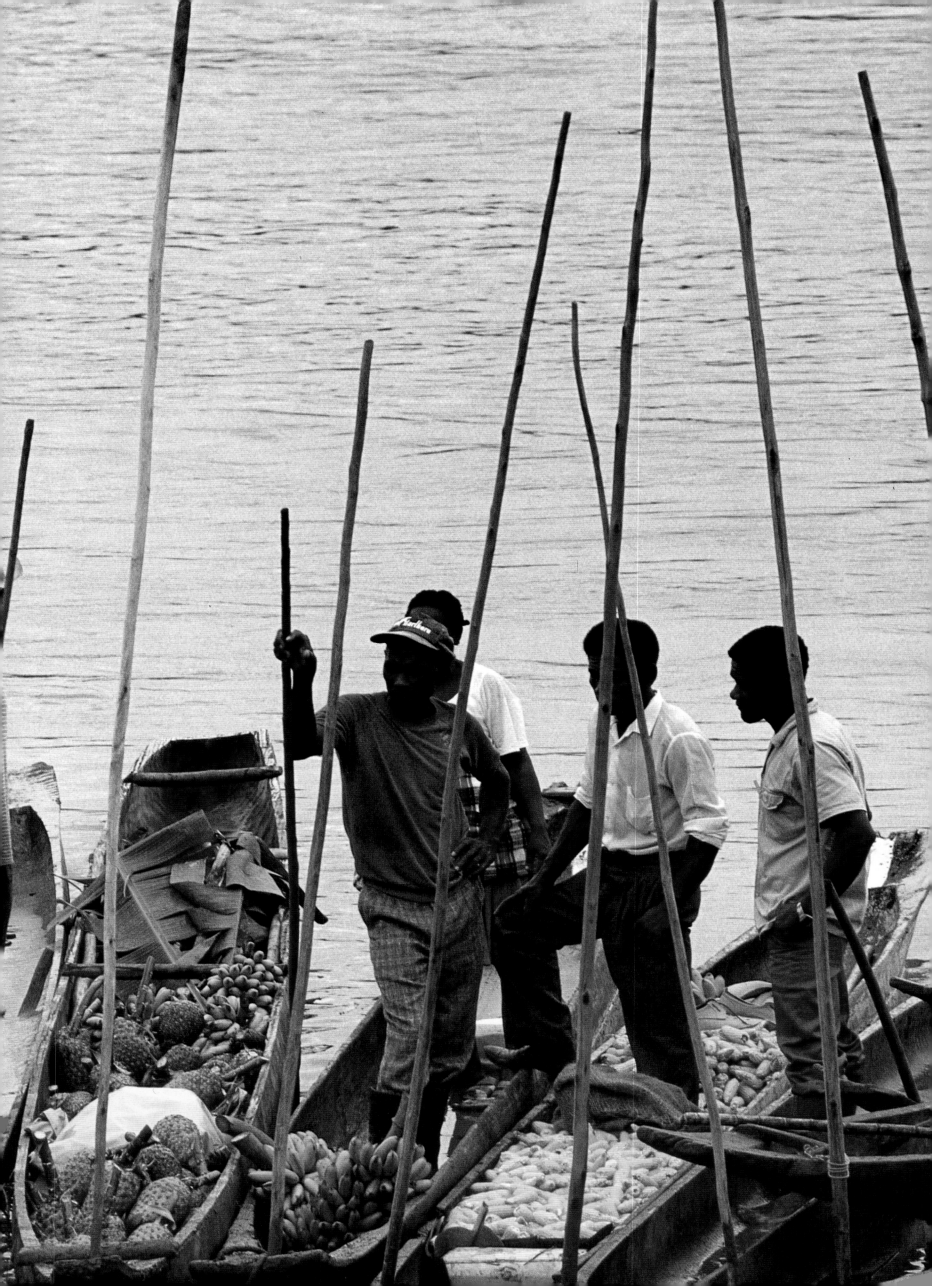

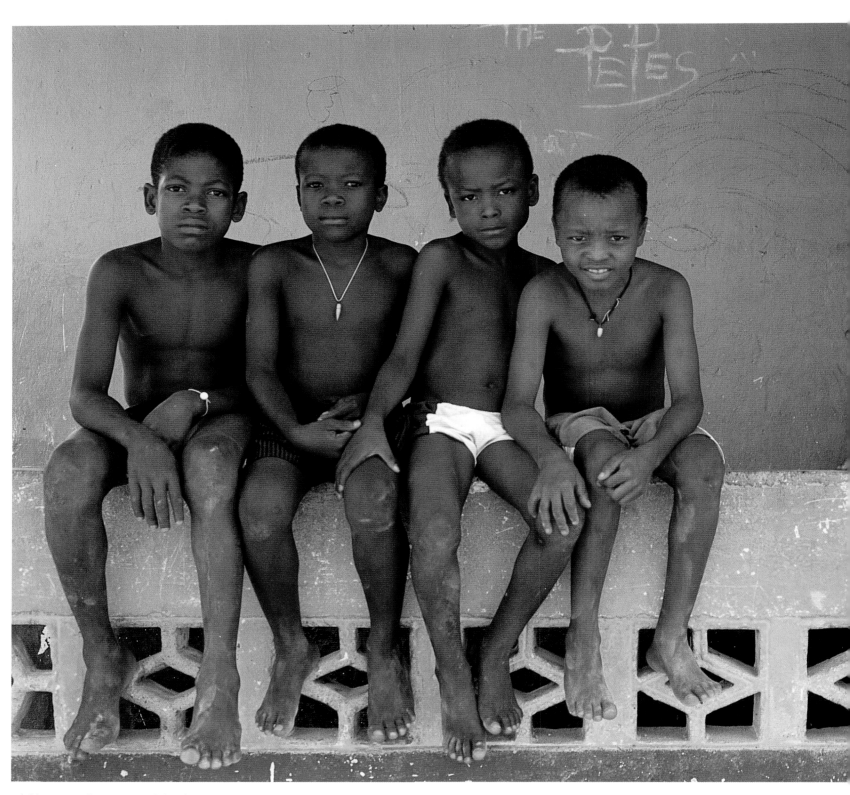

Children in a village, near Quibdó, Chocó

The economic and social physiognomy of Biogeographic Chocó is reaching a changing point: from a region which has been traditionally ignored, it has become one of the main centres of national interest over the last few years, due to the so-called "opening towards the Pacific", to the process of organization of Black communities and to land reform encouraged by the New National Constitution. While, on the one hand there are plans to develop "megaprojects" for ports, roads and tourist sites, on the other hand there is emphasis on the need to develop the Pacific coast with respect for the fragile tropical ecosystems and to strengthen the ethnic and cultural characteristics of Indian and Black communities in the region.

Preceding page, fluvial market on the Atrato river, Quibdó, Chocó

In Quibdó it can easily rain 365 days a year, but its inhabitants are used to this. No rain for more than three days in a row is a reason for concern. The city was founded by the Jesuits en 1654 under the name of Citará and then was moved and re-christened as San Francisco de Quibdó at the beginning of the XVIII century. There, on the shores of the abundant Atrato, the recently formed Pacific Research Institute will be located. This institute will be in charge of studying biodiversity in Biogeographic Chocó in coordination with universities, environmental organizations and local communities.

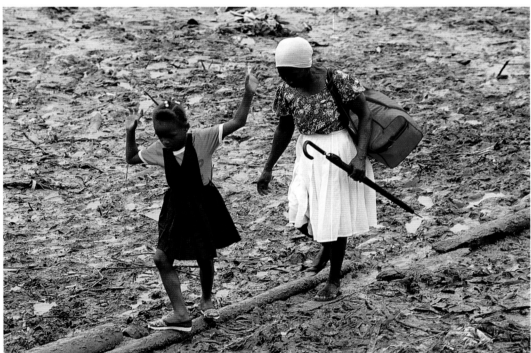

After the rain in Quibdó, Chocó
Toy gun made of cane, Quibdó, Chocó

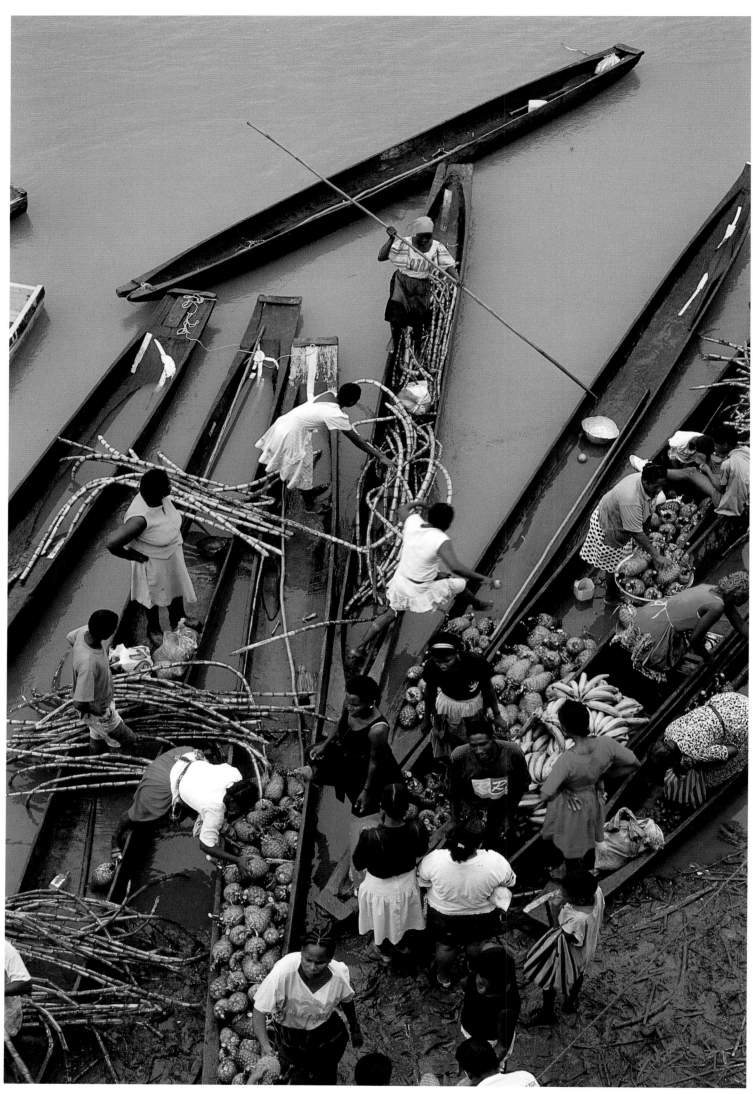

Embankment market, Quihdó, Chocó

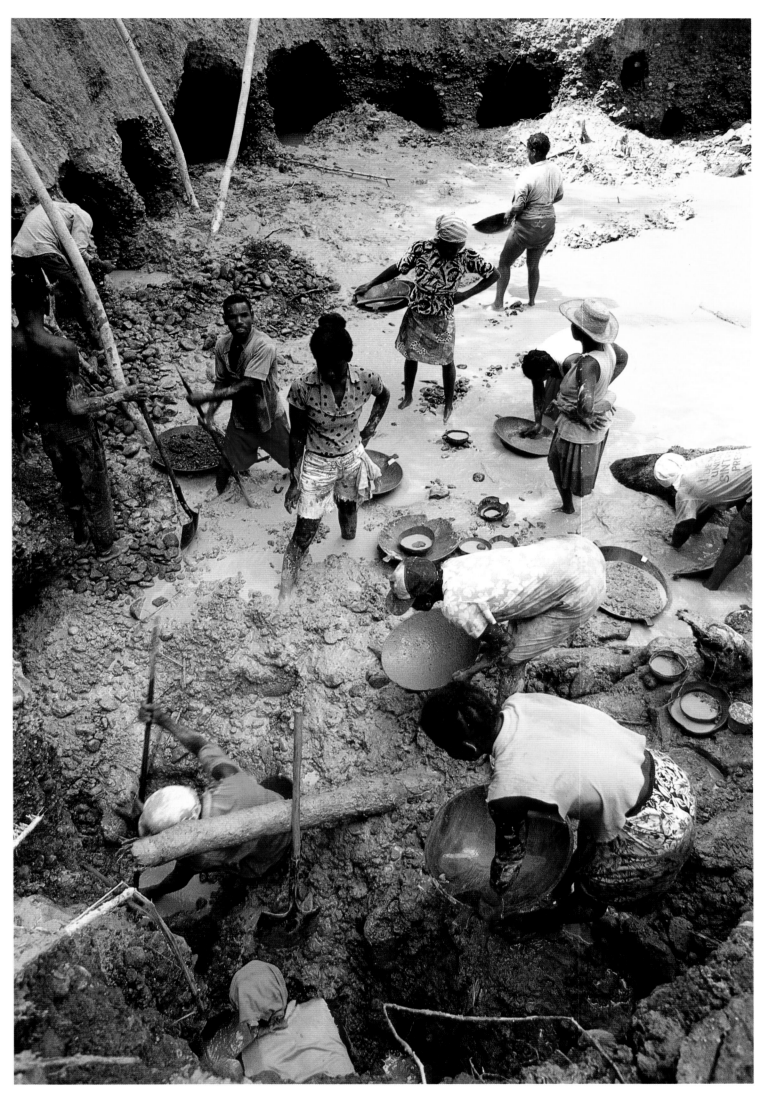

Mazamorreo or "gold washing" in Chocó

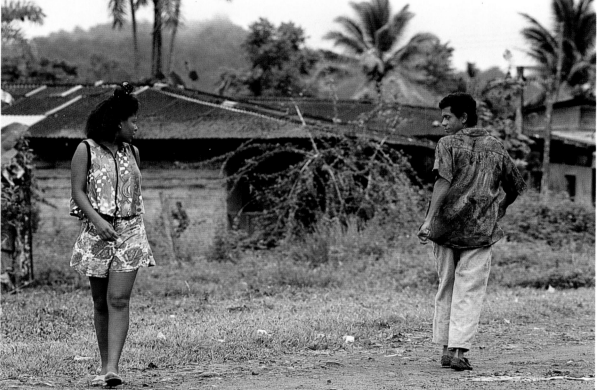

Bahía Solano, Chocó

In the last few years, the eyes of the world have turned to biogeographic Chocó; this is an unequaled region of the Earth in the upper corner of South America where high precipitation and violent geological processes, among other things, have caused a very high biodiversity and endemism (existence of unique species in this part of the planet). Most of the Black communities, who have settled down on the shores of the rivers, have learned to live in harmony with the rich, but fragile ecosystems, via a "multiactive" exploitation of an environment that does not permit only one profession; they are part-time fishermen and hunters, part-time wood dealers, part-time miners, part time agriculturists... a bit of everything.

Children in Utría, Chocó

Coastal people in Bahía Solano, Chocó

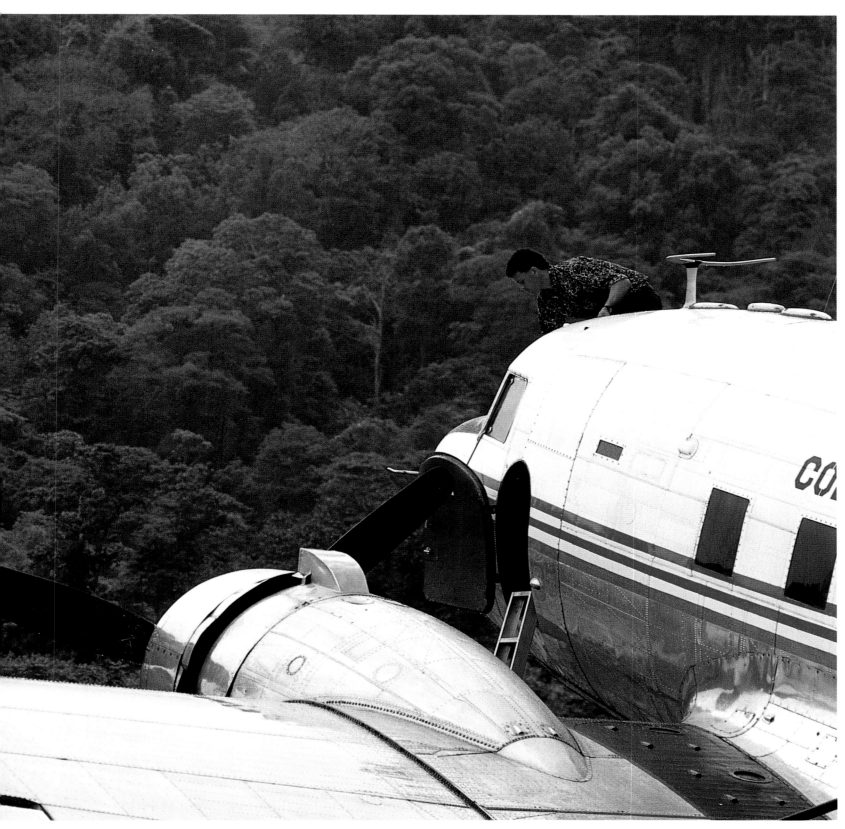

Airplane in Bahía Solano or "Ciudad Mutis", Chocó

The Colombian Pacific coast is full of gulfs, inlets, capes, coves and bays, most of which can only be reached from inland by canoe or by air. The 1991 Constitution established criteria for the territorial restructuralization of this region and authorized the collective granting of property titles to Black communities occupying riverside territories. Besides these regulations, an unprecedented process of organizing communities for the defense of their culture and environment is taking place.

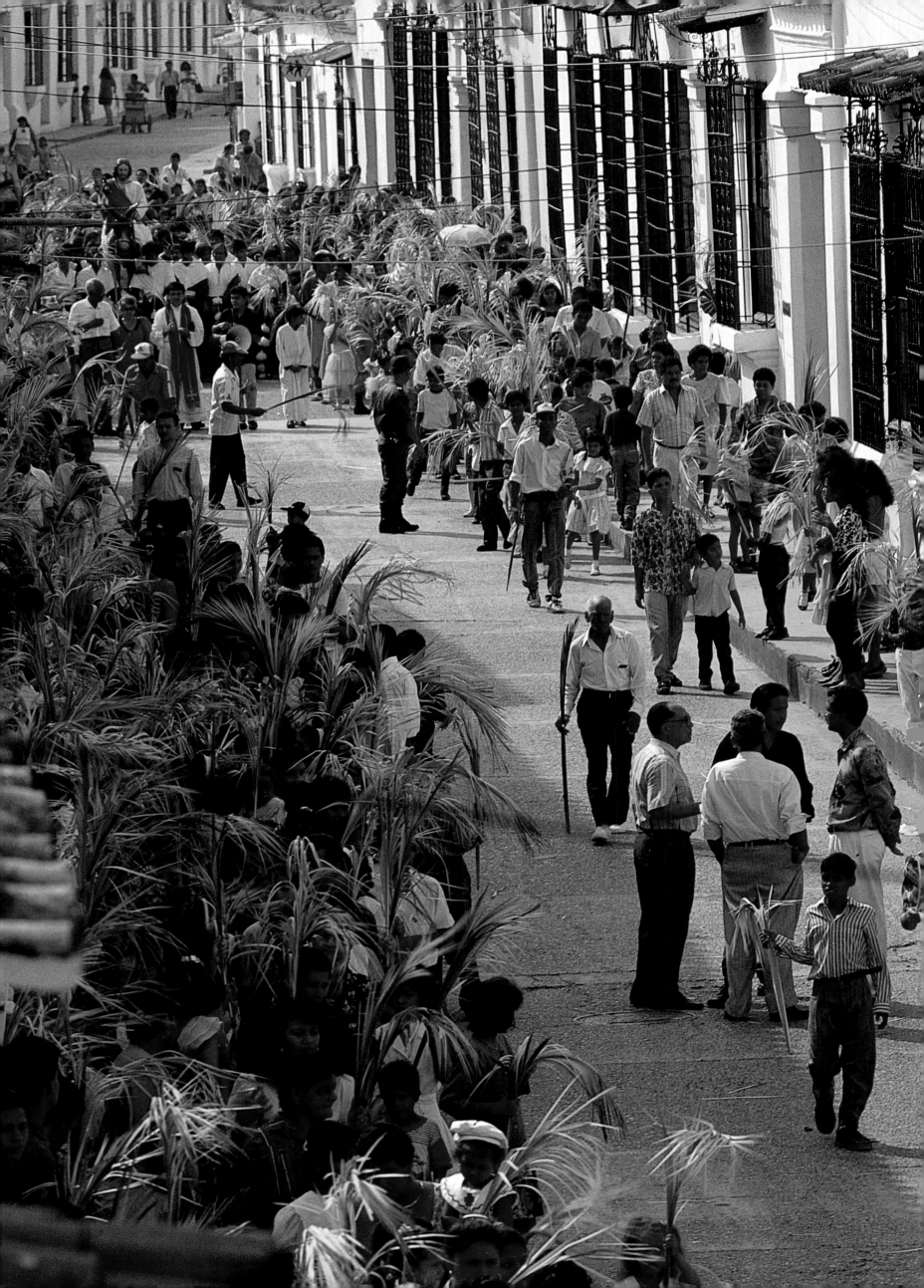

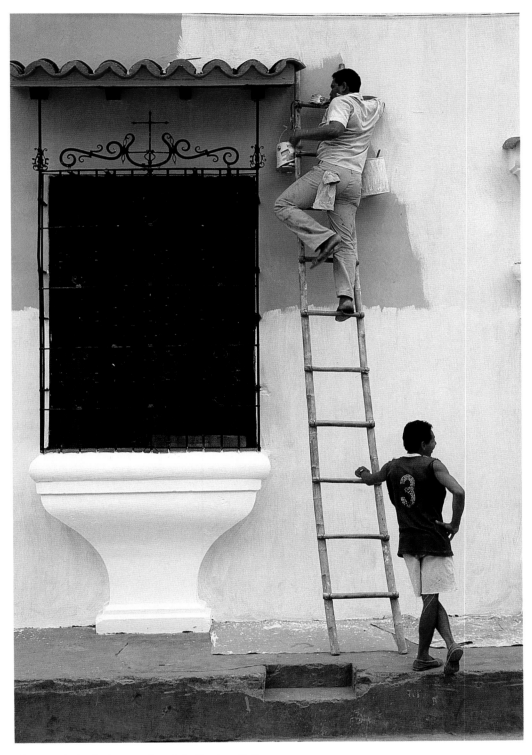

Giving a dash of colour to a façade in Mompox, Bolívar

It is not easy to imagine some European court marquisates on the hot tropical shores of the Bajo Magdalena, but this is what happened in the city of Mompox or Mompós in the province of Bolívar, near Cartagena. Sociologist and historian Orlando Fals Borda tells of the existence of the "chain houses" in Mompox where the marquises of Santa Coa and Torre Hoyos lived in the XVIII century, representative of the Latin American seignorial system. Any fugitive who would grab a chain hanging from the main lintel of such houses would become untouchable by ordinary powers of justice and would immediately be under the protection of the house owners.

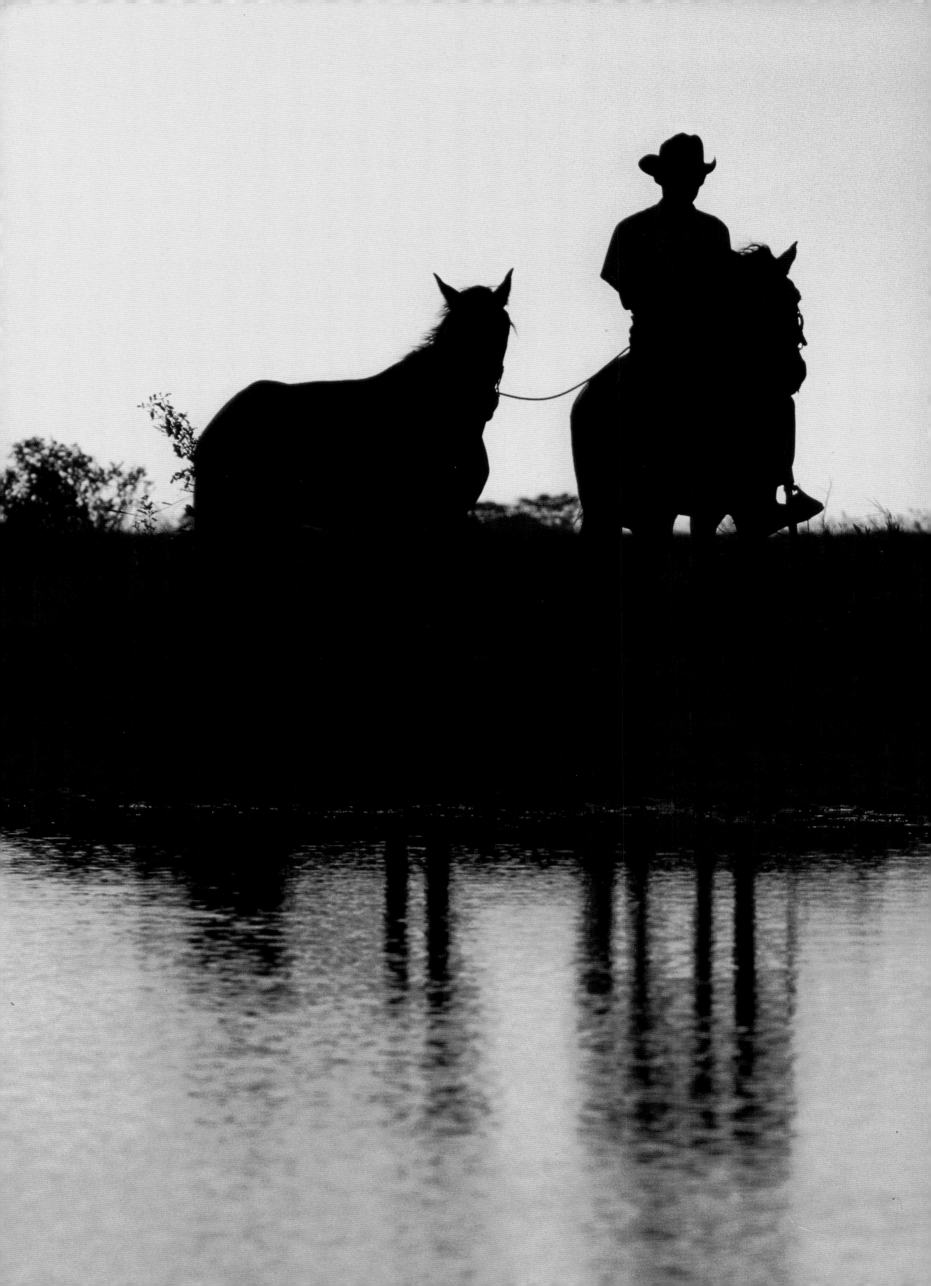

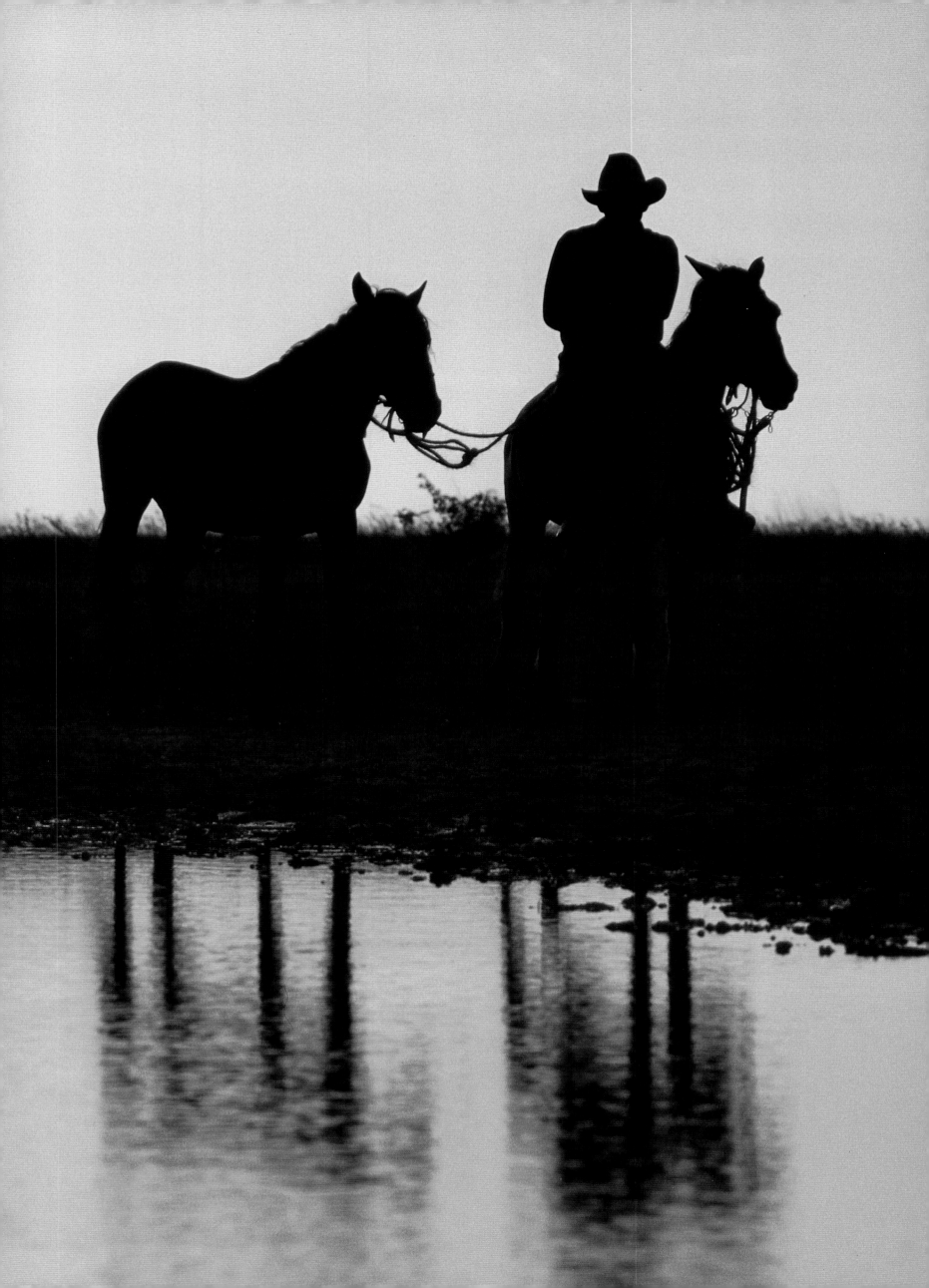

Colombia's so-called Llanos Orientales occupy a territory of 250,000 square kilometers and its waters run into the Orinoco river. They are mostly covered by grass, palm groves, flooded savannahs, forests growing on river shores and patches of jungle. Since the XVI century, when the llanos began to be settled, and up until a few years ago, the main economic activities in this unpopulated region were agriculture and cattle breeding. Today, these activities still produce food for the Andean region, but the oil boom from the provinces of Arauca and Casanare is completely transforming the zone.

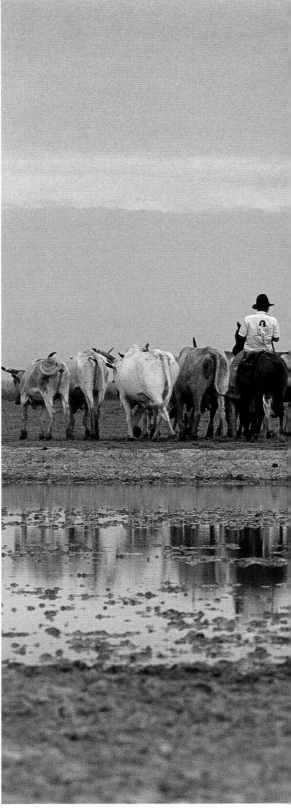

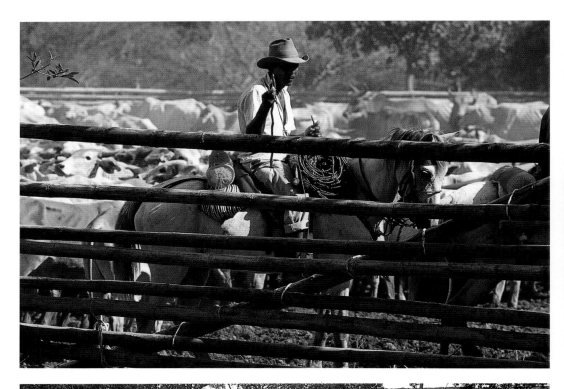

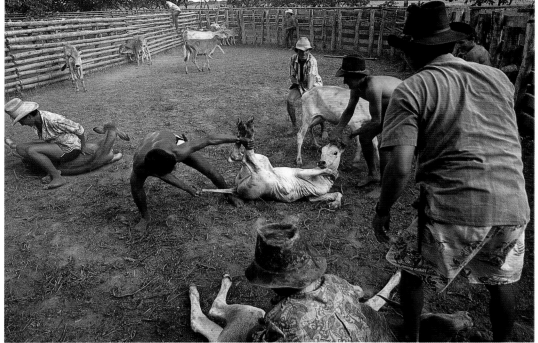

Preceding page, cowboys at dusk in the Llanos Orientales, Casanare

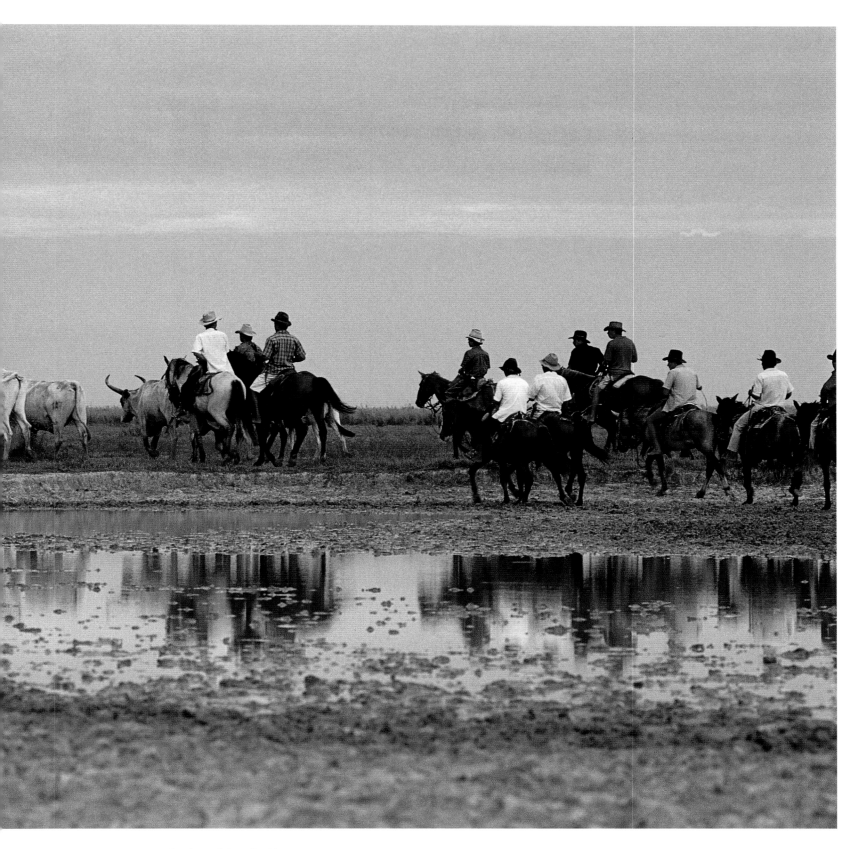

Cattle breeding activities in the Llanos Orientales, Meta

The physiognomy of Colombia would have been very different if its gate to Europe had remained the port of Orocué, as was the case until the end of the XIX century. This port, via the Meta and Orinoco rivers (which empty in the Caribbean), handled most of the trade with the Old Continent. When the Atlantic coast began to acquire the importance it has today, the country turned its back on the Llanos Orientales and Colombians concentrated in the Andean region and the Caribbean plains.

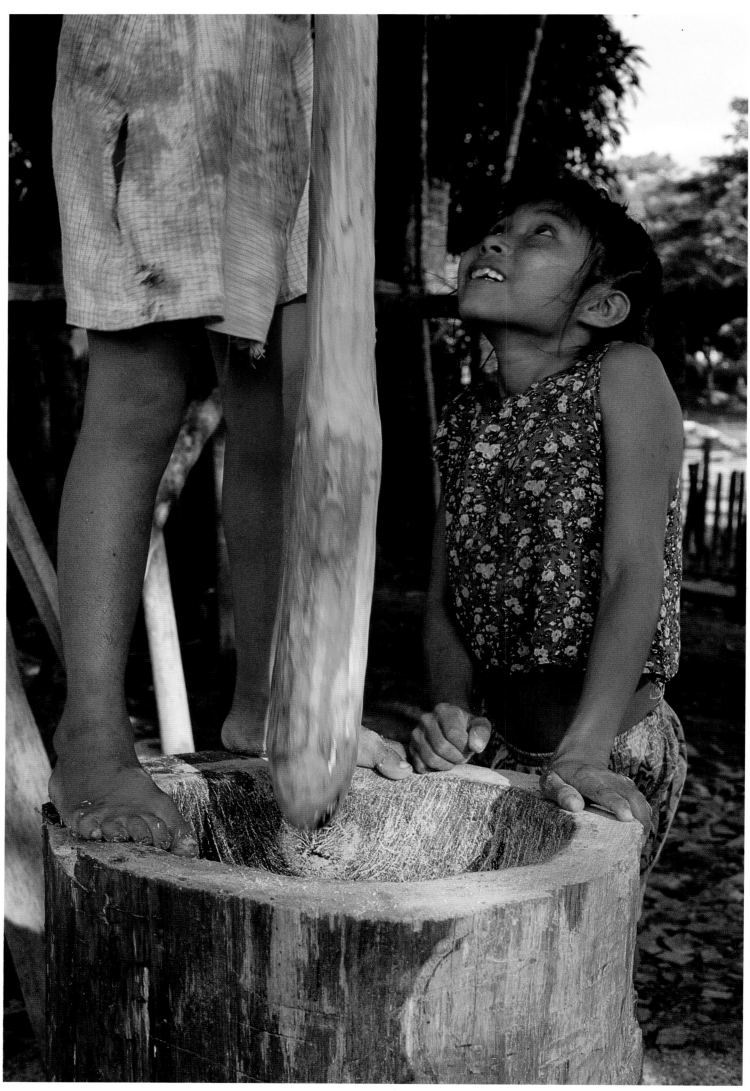

Pounding corn in Puerto Nariño, province of Amazonas

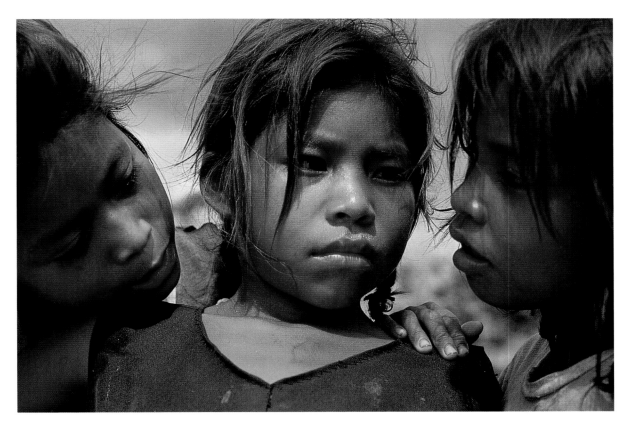

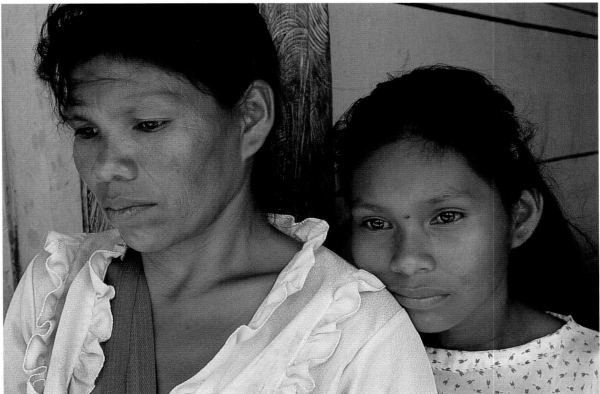

Indian and Mestizo *women from Amazonas*

The Llanos Orientales and the Amazon region cover half of the surface of Colombia. 80 different ethnic groups inhabit our Amazon jungle territories; almost half of these (approximately 180 thousand square kilometers) fall in the "national natural park" category and are the communal property of 50 of these groups. Here one can find, together with the jungles on the Pacific, one of the main reserves of Colombian biodiversity.

The clues for the viable development of Amazonian territories can be found among the traditions of local culture. For centuries the inhabitants have learned to coexist with nature in a relationship of mutual respect, adapting themselves creatively to its cycles. In many cases, unfortunately, colonization from the Andes has shattered such a relationship.

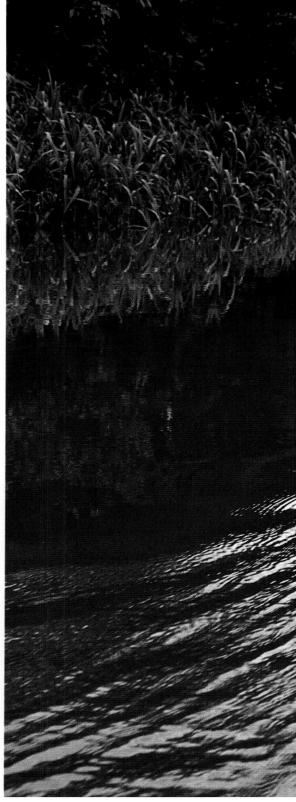

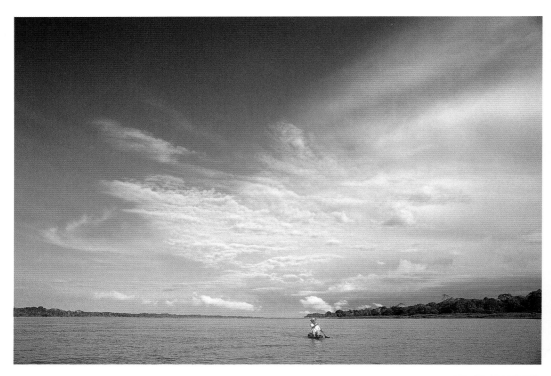

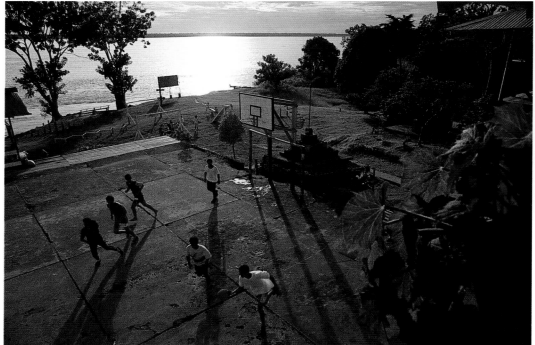

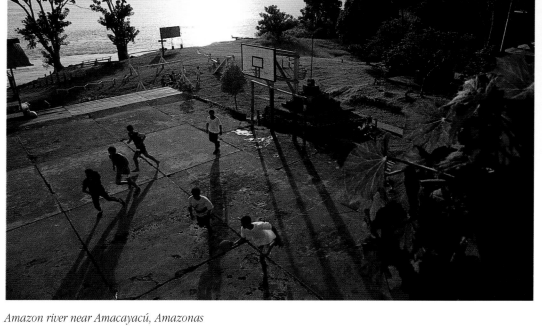

Amazon river near Amacayacú, Amazonas

Sports field in Leticia, on the shores of the Amazon river, Amazonas

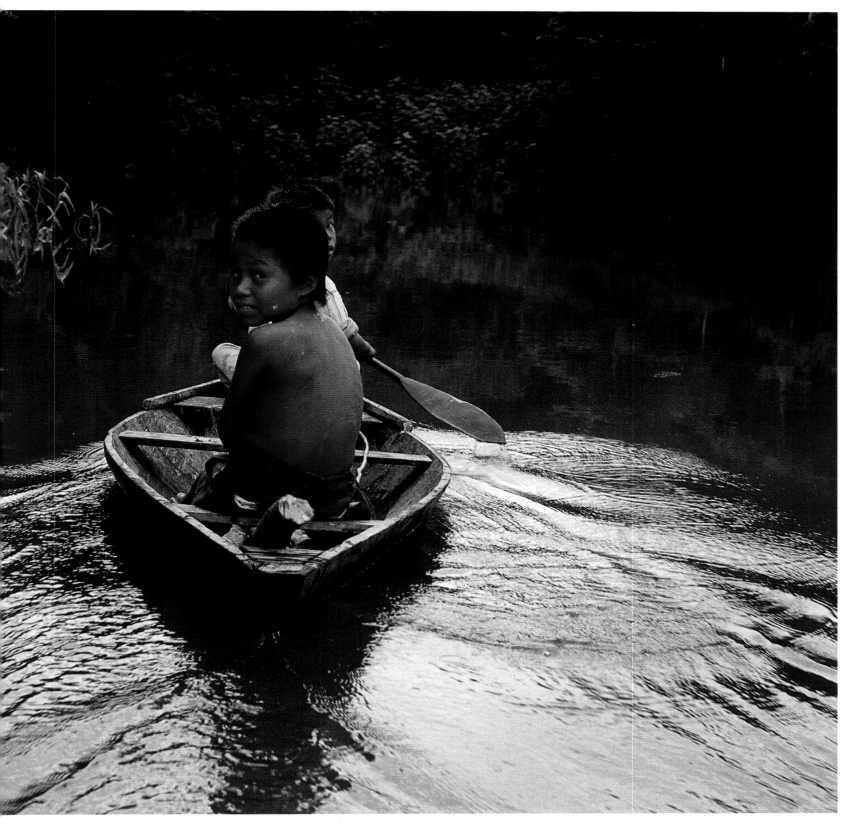

Children boating on a tributary of the Amazon River, Amazonas

The Guainía, Vaupés, Caquetá (born like the Magdalena, Cauca and Patía in the Colombian massif) and Putumayo rivers (receiving the waters of La Cocha through the Guamués) empty into the Amazon, after irrigating 400,000 square kilometers of Colombian jungle. In the extreme south of the "Amazon Trapezium", bordering Brazilian territory, is the city of Leticia, inhabited mostly by immigrants from other regions.

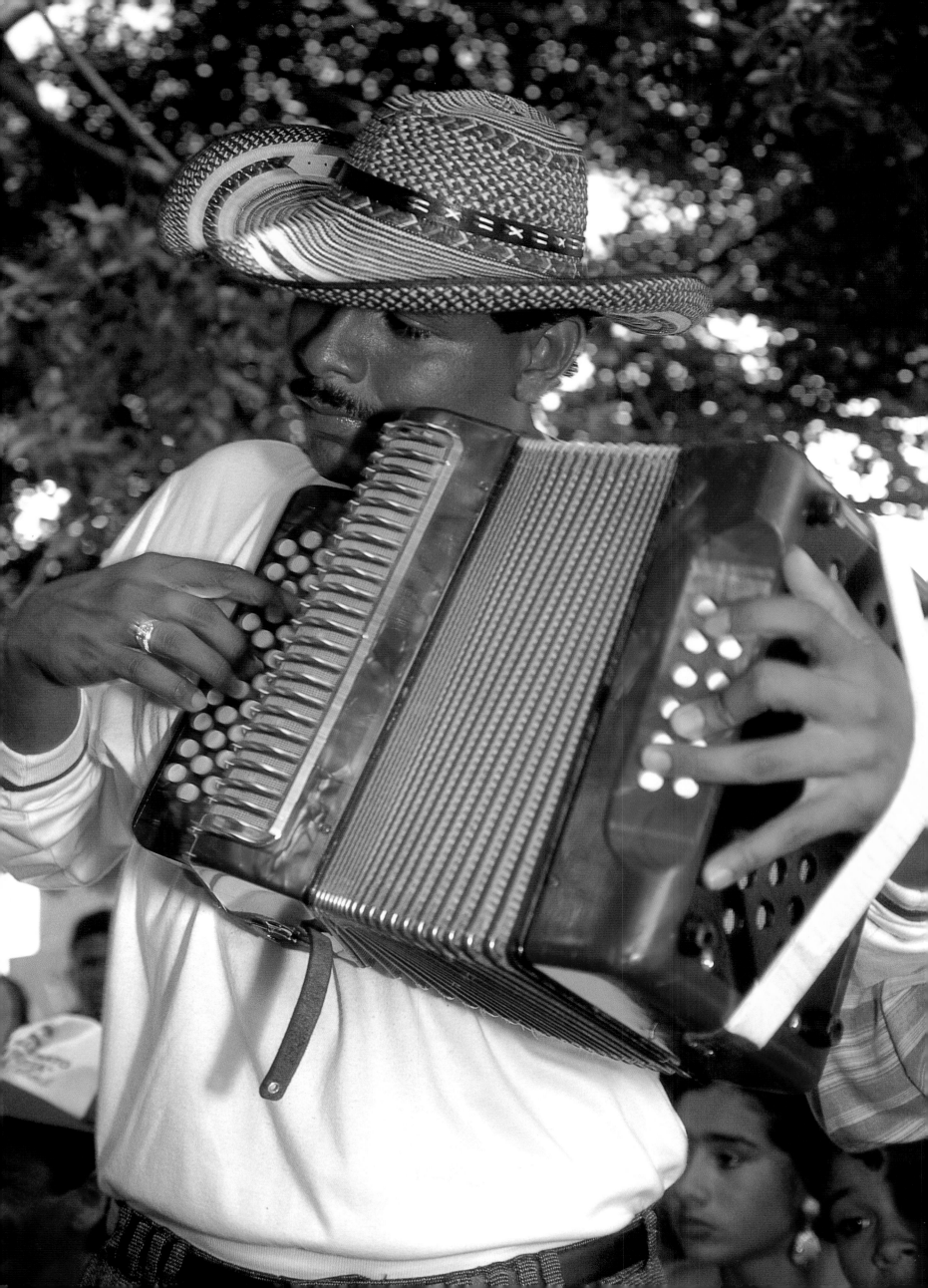

COLOMBIA

Jeremy Horner

*I*t was with some trepidation that I ventured to the land of Gabriel Garcia Marquez. In the realms of his fiction, Colombia is a mysterious and seductive land, spiced with dream-like images: but in the everyday news reports, it seemed a dangerous and frightening criminals' playground, where the law of the jungle ruled and the drug kings ran freely. The Colombia I discovered is closer to the ethereal images of Marquez than to the doom-ridden prophecies of the international media, a land laced with its own surrealities, where the truth is often as strange as the fiction it spawns: and from the ashes of my own gutted preconceptions arose a phoenix-like vision a world apart from the criminal circus I had expected. It is a world of variety and life, and of craggy, distant mystery, where the dreams of the great author blend into reality more often than I had ever imagined.

As dream-like as any fiction was the couple I met on the shores of Lake La Cocha, an ancient man and an ancient woman still entranced by their love for each other, living in a hut on the edge of nowhere. They were married, Don Pepe and Doña María: but not to each other. They were married, respectively, to each other's sister and brother: but there they were, both utterly, beautifully mad, living with each other and caring for each other through the last days of their lives.

And as surreal as any fictional story was the time I was standing inside an empty grave in a sodden field near

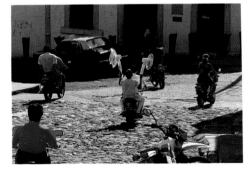

In the province of Tolima, on the Magdalena river is Honda, "the city of bridges". During the eruption of the Nevado del Ruiz volcano in 1985, the city had to endure the sudden river swelling produced by the melting of the volcano's ice-cap.

Popayan, drinking *aguardiente* and chatting to some Guambiano Indians. We had all crammed inside a makeshift tent to escape a downpour during the funeral of a 23-year-old Guambiano, who had been killed on his motorcycle. Unfortunately the tarpaulin was rather low, and I am more than 1.90m. tall, so one of them good-naturedly suggested I stand inside the (as yet unused) grave because I looked so uncomfortable. So I did, a lone foreigner standing inside a large hole, sipping a glass of firewater, surrounded by mourning Guambiano wearing blue. Soon a couple of them joined me inside the hole, to make me feel more at home: local people entertaining a complete stranger at the funeral of one of their loved ones.

The Guambiano had been circumspect at first, when I started walking alongside the crowds heading for the funeral, but quickly one of them, a 32-year-old human rights student at the University of Cauca, befriended me, and soon his friends and relatives followed. We talked a long time, of their lives and my work, and their friendliness grew almost with every sentence we spoke, particularly when I was standing in the hole and everyone was huddled around. That is part of the undefinable skill of the Colombians: to allow you to feel at home in their country, wherever you may be.

I think of the time in Manaure when I was trying to capture images of a salt mine, while most of the miners and their families were packed inside their homes, glued to their televisions and engrossed in the historic football match that saw a 5-0 victory for Colombia over Argentina in Buenos Aires. Each time a goal was scored, I ventured outside to try and take some photographs of the mine, certain that I would be safe: minutes later, I would run back to the hut as it rattled to thunderous applause and whoops of delight. Since historic moments only appear as such with the benefit of hindsight, it was not until later, when I drove back to Riohacha, that I realised I had been witness to a defining moment in the life of a country. The town was aflame with celebration and festivity. "You can't go to bed, you have to party" said a pretty girl with a wonderful smile. She barred my way into the hotel, and, giving me a hug, said: "Tonight, you are Colombian." But it has to be said that not all inhabitants of Colombia were as cooperative. Lucas, an Amazonian monkey, did his best to try and make sure one section of this book could never be published.

I was in the Amacayacu National Park, at the end of an exhausting but productive day photographing in the jungle. Having shared a beer with my guide and boathandler, Carlos, I retired to my hut. Laying my cameras on the bed, along with sixteen rolls of precious film, I undressed, and slumped across to the showers next door. The idea that anything might happen to my equipment never entered my head. Thieves are an uncommon species in the Amazon rainforest.

Well, there may be no human thieves in the rainforest, but I hadn't taken Lucas into account. Ten minutes later, striding back from the shower, I was amazed to find a roll of film, bereft of its plastic container, lying on the edge of the walkway just centimetres from a sheer drop into a tributary of the Amazon. Bursting into the room, I was greeted by the sight of a monkey sitting on my Nikon, holding a roll in his hand and trying to find a way to rip the exposed film out of its metal cannister. Stunned – this was a kind of media censorship I hadn't come across before– I screamed at the creature to get away, retrieved my film (just in time) and then set about the task of recovering the 14 other cannisters

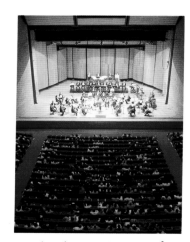

Near the administrative center of La Alpujarra, where Antioquia's government building and town hall are located, the Teatro Metropolitano is one of the recent works destined to renovate Medellín's old railway station and market place area.

which he had strewn about every corner of the room. I found them all, but it was a close call. Carlos told me later that Lucas was infamous for his intelligence and his wanton mischievousness.

In the four months I travelled the country, I never encountered such wilful obstruction from my human hosts: indeed, Colombia is a rich mine of photographic potential. One of my favourite photographs in the book arrived almost by accident, a superb coincidence starring an unwitting, but ideally cast, roll of subjects.

It was on the Paramo de Berlín, Norte de Santander, on a windy Wednesday afternoon. I had found the shot I wanted: a soldier in camouflage standing by a Red Indian motif in an advert for *Pielroja* cigarettes painted on the side of a shop. I smiled to myself that all that was needed to turn an ordinary scene into an extraordinary image would be a *campesino* arriving on horseback. Normally, these things only happen in movies: it's a thousand to one chance to get such a perfect frame in real life. I had waited for more than half an hour, chatting to the soldier, when, like a mirage, he arrived, a real *campesino*, complete with hat and poncho, on a real horse. He dismounted and went into the shop. As he came out, the camera whirred, and there it was: cowboy, horse, Red Indian motif, soldier, perfectly placed. Clint Eastwood couldn't have directed it better.

Such experiences contributed to the feeling that it was a privilege to be able not only to photograph but to experience Colombia's rich tapestry of lifestyles. A million miles away from the swanky, cosmopolitan northern suburbs of Bogotá was the little Indian settlement on the edge of Lake Tarapoto. The innocence of the beautiful Indian children was touching: "The dolphins are our friends" they told me, a statement I wish I could have captured for eternity on film.

But it is the cities that epitomise the spirit of a country striving for greatness. Tell an Englishman that you attended an exquisite rendition of Mozart's Clarinet Quintet in A in the centre of Medellín, and he will probably laugh at you. And yet I did, in the Teatro Metropolitano Hall, which was as packed with lovers of Salzburg's musical prince as any in London.

One December day, I had the privilege of touring Bogotá in a helicopter, a mode of transport that casts a totally new gloss on familiar sights. It was breathtaking to see the Sunday pilgrimage to Monserrate from the air, the city glistening in the morning sun, the crowds dwarfed by God's creations, the mountains and valleys stretching into the horizon. The rest of Bogotá looked quite different: with the traffic jams reduced to harmless, shimmering snakes, the city shrunk to a quarter of its size, with none of the tension of the streets rising a couple of hundred metres into the atmosphere. The sourthern suburbs became almost beautiful in the crystalline light, with the endless rows of houses undulating over ridges.

We almost came undone, though, when our veteran Russian pilot buzzed past the top few floors of the InterContinental Hotel. What none of us in the helicopter knew was that Pablo Escobar's family was staying in one of the suites, and the event almost caused a national incident as the police, fearful of an assassination attempt on the recently widowed Mrs. Escobar, urgently radioed us to get away. They had a few words with us when we landed, too, and although the misunderstanding was quickly cleared up, it was an item on the evening news bulletin.

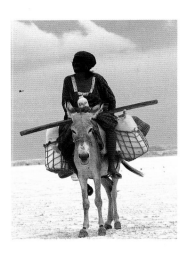

The Wayúu are used to the drastic ecological conditions of La Guajira. For generations they have herded goats, extracted sea salt, and dived for pearls. Today, many Indians work in the coal mines of El Cerrejón.

Every single day of my four months in Colombia brought me closer to the Colombian people, a relentless cascade of experience I felt increasingly priviliged to be part of. There is a trio of indelible memories printed in my mind though, perhaps for ever.

The first comes from the Llanos, whose dramatic backdrops and technicolor sunsets make for some spectacular photographs. But more than the scenery and breathtaking night sky, it was the everyday smells and sights of the Llanos which I found captivating. Time has stood still on the great savannah for 150 years, and the plains still witness groups like the 50 *ganaderos* I rode with, who herd thousands of cattle daily around a couple of the eight cooperatives that make up a 50,000 hectare farm. They were not just living off the land but living on and with their evironment every day, adapting their own needs to the ruthless reality of nature. I remember the sad, gentle death of a cow they slaughtered for a meal: its neck slit, the animal slowly bled to death, uncomplaining, seemingly without pain, with a dreamy, mystified look in its dying eyes, while a *ganadero* held the animal's head down, firmly but without any hint of cruelty. They fed the blood to the pigs, and used every piece of meat on the animal, eating the muscle, fat, entrails and vital organs, and drying the skin to be cut into coils for tough ropes and lassos.

I almost met my own end in the rough rat-race of life of the *ganadero*. It was the second of the five days I spent there, and we were riding our last leg before setting down for the night, with the sun disappearing over the horizon in an explosion of flame and lustres, and the first stars of night-time splashing the eastern sky. Weary from travelling on what seemed increasingly like a cast-iron horse, I was trotting, half-sleep, when suddenly my mount spotted a crocodile in a lush patch of grass ahead, and threw me off. I sailed through the air in a great arc and landed, rather fortunately, on my bottom. The sight in the very late dusk of the "walking razor mouth" as some Africans call crocodiles, was enough to prompt me back onto my saddle within seconds.

The second recollection comes from Quibdo. I was in an open-cast goldmine with my guide, Ramón, who never took off his pair of wraparound shades in all the two days I saw him, and trying to get some photographs of the miners at work. Suddenly, one of the walls, loosened by heavy rainfall, began to subside, creaking towards what looked like a total callapse. We ran for our lives in what was a perfect cross between an orderly withdrawal and total panic; people were scrambling furiously, but didn't forget each other in the ruckus, and helped colleagues climb out before the wall came creashing down on where we had just been standing. I stood at the top of the pit and glanced down into an adjacent mine: there was no way they could have heard the wall collapsing, at the other end of the other mine, but somehow word had spread and they were scrambling out too. Or they were trying to, but a massive earth-mover, with a huge scoop attached to a metal arm, was rumbling towards them, looking, to all intents, like it was going to swoop on some of the unfortunate miners and devour them. The digger did descend on the miners and scoop a couple of dozen up in its jaws: but they climbed in quite willingly. This I realised, was their way of hitching a lift to the surface.

The third memory always makes me smile (and that is how I left Colombia –smiling, and wondering how I could return as soon as possible), because it so contradicts the perception of Colombia

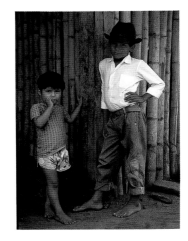

The Liberation campaign which achieved total independence from Spanish domination was fought by llaneros *using rudimentary weapons, who were not accustomed to the climate of Andean heights where battles were waged. "Soldiers with no armour won victory. Their virile breath was their shield", to quote a stanza of the national anthem.*

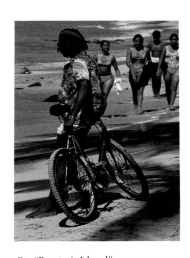

*On "Rooster's Island",
Providencia, part of the
archipelago of San Andrés, pirates
and corsairs from France and
Spain used to hide in order to take
Spanish galleons loaded with gold
by surprise.*

I had before I arrived. I was bidding goodbye to the white sands of Providencia, which is one of the few places I have been to anywhere in the world where I would be happy to leave my camera bag by the side of the road, secure in the knowledge that it would still be there an hour later. After a last stroll down the beach, I returned to my hotel to pay the bill. Or rather, to try and pay the bill. There was nobody there who wanted to take my money. I had already checked out and handed in my key, and could easily have climbed into a taxi and flown out: no one seemed particularly bothered. "The owner will be back soon" an old man fanning himself outside the entrance told me. "Just leave the money somewhere he'll see it: it'll be fine". In England, they take your credit card details when you check in, because they don't trust you to pay when you leave.

I spoke at length with Ana María Jiménez, the urbane patron of the arts who devoted so much time showing me around Medellín, about Colombia's image abroad and why it was so one-sided. We agreed that it was not because of some media conspiracy, but because of the universal "bad news syndrome". Whenever some horrific event happens, it makes the news: but editors believe (unfortunately with some justification) that few people on the other side of the world want to read that nothing much happened in Medellín yesterday, that people carried on their normal lives in offices, shops, or in their homes, or, indeed, that someone did a good deed.

This is by no means unique to the reporting of Colombia, but because of the spectacular nature of the darker side of this country, it has been exploited to the full. Western media pundits I have spoken to put it down to the remains of a primal human bloodlust, revelling in other people's misfortunes. In the mass media, bad news is good news, and unfortunately the tidy industriousness of the vast majority of Colombians is all too frequently overlooked in favour of the antics of the nastier side.

This book is, in part an attempt to redress that imbalance.

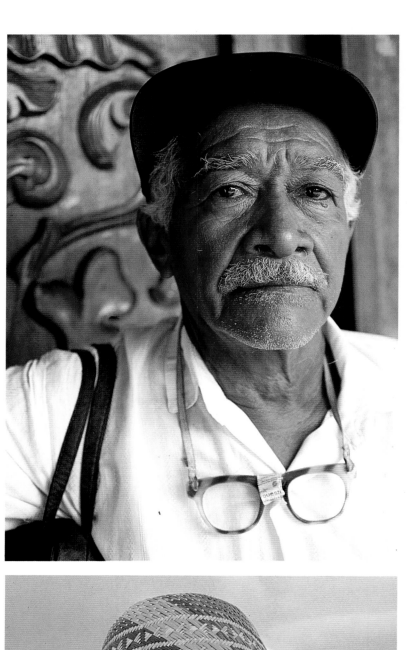
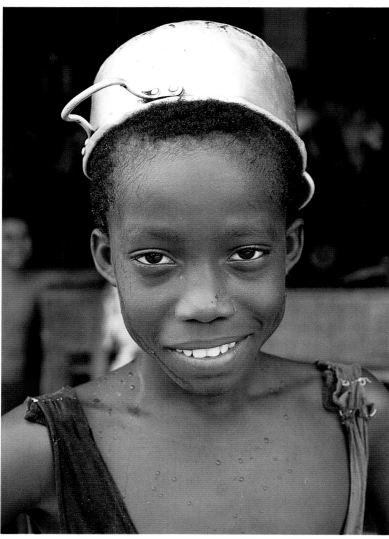
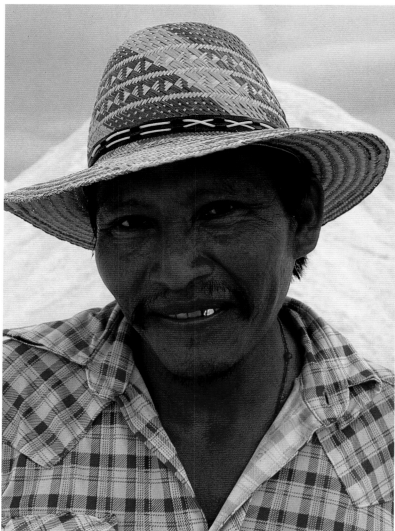

Multi-ethnic and multi-cultural Colombia